Degas
The Dancers

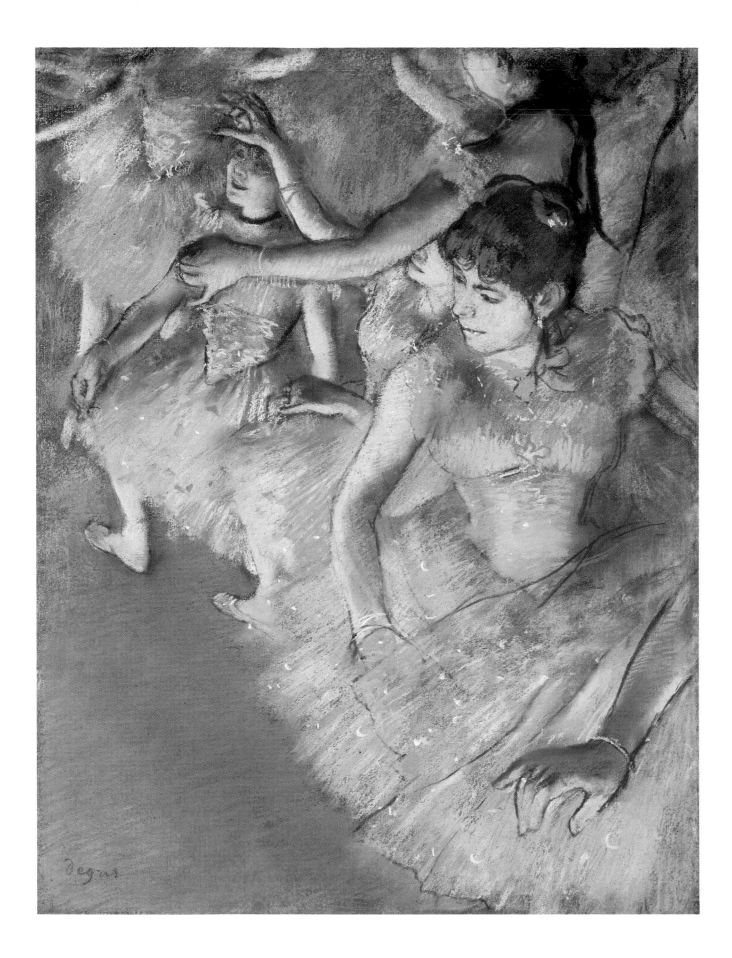

Degas
The Dancers

GEORGE T. M. SHACKELFORD

National Gallery of Art, Washington

Copyright ©1984 Board of Trustees, National Gallery of Art, Washington. All rights reserved. No part of this publication may be reproduced without written permission of the National Gallery of Art, Washington, D.C. 20565.

This catalogue was produced by the Editors Office, National Gallery of Art, Washington. Printed by Schneidereith & Sons, Baltimore, Maryland. The type is Janson, set by Hodges Typographers, Silver Spring, Maryland. The text paper is eighty-pound Warren Lustro Offset Enamel Dull, with matching cover.
Edited by Amy Pastan
Designed by Melanie B. Ness

Published in connection with the exhibition *Degas: The Dancers* held at the National Gallery of Art, 22 November 1984–10 March 1985.

This exhibition is supported by a partial indemnity from the Federal Council on the Arts and the Humanities.

Cover: *Four Dancers* (*En attendant l'entrée en scène*) (detail), 1895–1900, oil on canvas, National Gallery of Art, Washington, Chester Dale Collection (cat. no. 49).
Frontispiece: *Dancers on the Stage* (*Un coin de scène pendant le ballet*), c. 1885, pastel, Mr. and Mrs. Frank Bartholow and the Dallas Museum of Fine Arts (cat. no. 8).

The quotations beginning each chapter are from the following sources:
Chapter 1: Guérin 1945, 64; Chapter 2: Guérin 1945, 22; Chapter 3: Reff 1976b, 134 (Nb. 30:65); Chapter 4: Guérin 1945, 119; Chapter 5: Guérin 1945, 241.

The clothbound edition of this catalogue is published by
W. W. Norton & Company, Inc., 500 Fifth Avenue, New York, N.Y. 10110
W. W. Norton & Company Ltd., 37 Great Russell Street, London WC1B 3NU

Library of Congress Cataloging in Publication Data
Shackelford, George T. M., 1955–
Degas, the dancers.
Catalogue of an exhibition held at the National Gallery of Art, Nov. 22, 1984–Mar. 10, 1985.
Bibliography: p.
1. Degas, Edgar, 1834–1917—Exhibitions.
2. Dancers in art—Exhibitions. I. Degas, Edgar, 1834–1917. II. National Gallery of Art (U.S.) III. Title.
N6853.D33A4 1984b 709'.2'4 84-20585
ISBN 0-89468-077-3 (paper)
ISBN 0-393-01975-6 (cloth)

Contents

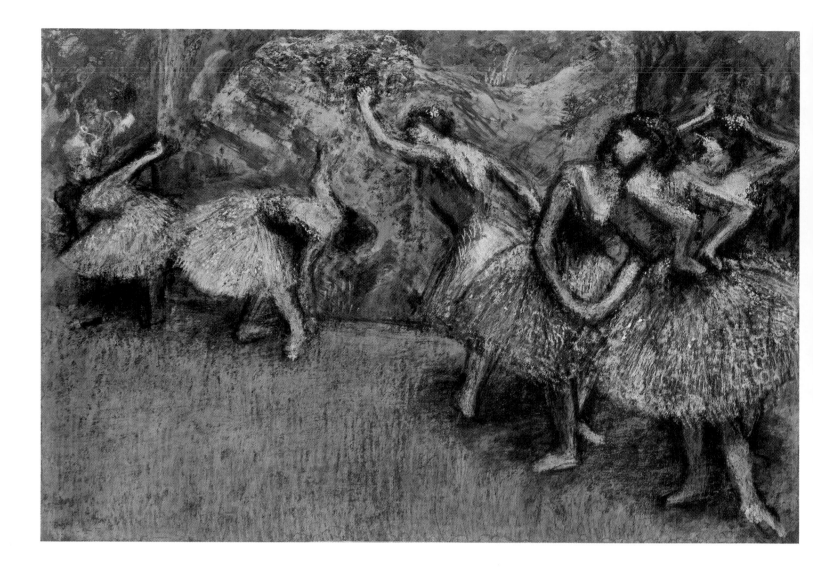

Preface

THIS CATALOGUE, and the exhibition that it accompanies, mark the sesquicentennial of the birth of Edgar Degas. An artist basically urban in outlook, perhaps the most Parisian of all the impressionists, he is here represented by the most Parisian of his subjects, the dancers of the Opera ballet. The exhibition offers an extraordinary survey of Degas' works on this theme, certainly the most important of his subjects, while at the same time providing a remarkable opportunity to investigate the complex relationships among the many drawings of dancers and the paintings, pastels, and sculpture with which they are here grouped.

George T. M. Shackelford, a former David E. Finley Fellow of the National Gallery's Center for Advanced Study in the Visual Arts, has chosen the works in the exhibition and written its catalogue. We are indebted to him, and to the staff of the National Gallery of Art, for their cooperation in bringing this celebratory exhibition to completion—a project almost as elaborate in choreography, in design, and in performance as one of the spectacles of the Opera itself.

We are most grateful to the museums and private collectors, in this country and abroad, who have agreed to lend their works to this show, especially in light of the fragility of some of Degas' drawings and pastels. Their trust and generosity have enabled us to assemble a distinguished group of works, most of which have not been seen together since Degas' death. By seeing the artist at work as we have never seen him before, we hope to come closer to an understanding of Degas' great achievement.

J. CARTER BROWN
Director

Left: cat. no. 47. *Ballet Scene (Scène de ballet)*, c. 1900, pastel. National Gallery of Art, Washington, Chester Dale Collection.

Lenders to the Exhibition

The Allen Memorial Art Museum, Oberlin College, Oberlin, Ohio
The Art Institute of Chicago
The Art Museum, Princeton University
Mr. and Mrs. Frank Bartholow and the Dallas Museum
 of Fine Arts
Sterling and Francine Clark Art Institute, Williamstown,
 Massachusetts
The Corcoran Gallery of Art, Washington
The Dixon Gallery and Gardens, Memphis
M. Charles Durand-Ruel, Paris
Foundation E.G. Bührle Collection, Zurich
The Evergreen House Foundation, Baltimore
The Syndics of the Fitzwilliam Museum, Cambridge, England
The Fogg Art Museum, Harvard University
Frau Sabine Helms, Munich
The High Museum of Art, Atlanta
Kunsthalle Bremen
Henry P. McIlhenny, Philadelphia

Mr. and Mrs. Paul Mellon, Upperville, Virginia
The Metropolitan Museum of Art, New York
Musée Bonnat, Bayonne
Musée d'Orsay, Galerie du Jeu de Paume, Paris
Cabinet des Dessins, Musée du Louvre, Paris
Narodni Muzej, Belgrade
Nasjonalgalleriet, Oslo
The Ordrupgaard Collection, Copenhagen
The Lord Rayne, London
Bernice Richard, New York
Staatliche Kunsthalle Karlsruhe
The Toledo Museum of Art
The Virginia Museum, Richmond
Wallraf-Richartz Museum, Cologne
Yale University Art Gallery, New Haven, Connecticut
Private Collection, on loan to the Museum Boymans-
 van Beuningen, Rotterdam
Private Collections

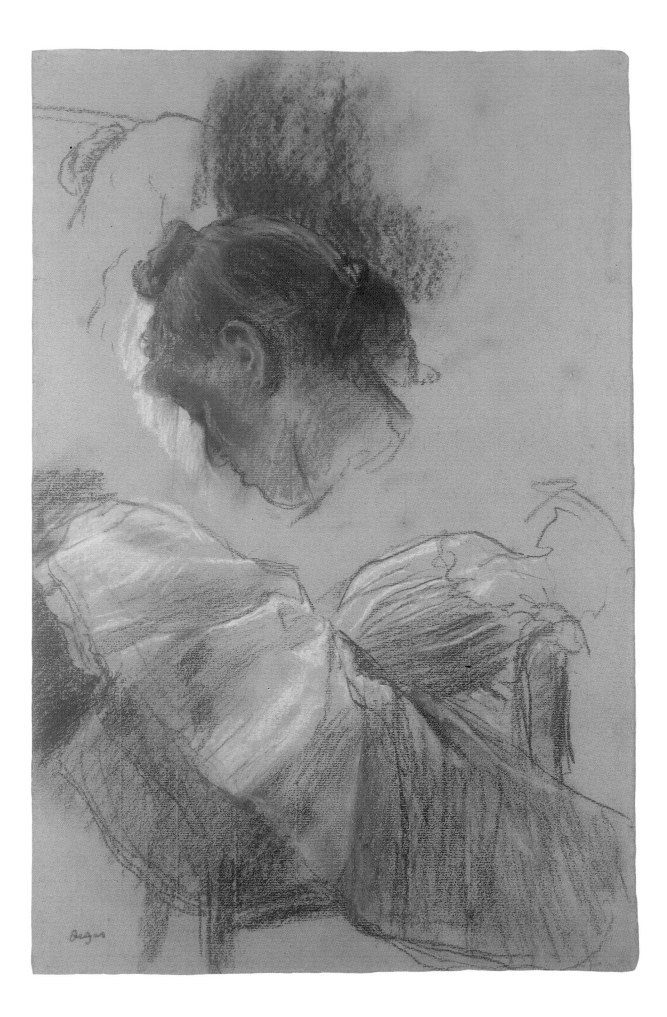

Acknowledgments

THIS EXHIBITION and catalogue are the fruits of several years of research on Degas and his dance compositions undertaken for the Department of the History of Art at Yale University. During the period 1980-1983, I was generously supported as a David E. Finley Fellow of the Center for Advanced Study in the Visual Arts at the National Gallery of Art. I am extremely grateful for this support, which enabled me to travel and live both in the United States and abroad in order to study Degas' works in public and private collections.

To the staffs of those museums, and to the private collectors and dealers who were so generous with their time and advice, I owe an enormous debt of gratitude. Many of them are lenders to this exhibition. I should particularly like to thank, in Europe: David E. Scrase of the Fitzwilliam Museum, Cambridge, and Mrs. Stefanie Maison, London; Mme. Geneviève Monnier, Mlle. Rosaline Bacou, and M. Maurice Sérrullaz of the Cabinet des Dessins of the Louvre; Mr. A.W.F.M. Meij of the Museum Boymans-van Beuningen; and Mrs. Marianne Feilchenfeldt and Dr. Peter Nathan, Zurich.

In the United States, I am indebted to: Suzanne Folds McCullagh and Richard Brettell of the Art Institute of Chicago; Beverly Carter of the Mellon collection; Calvin Brown of the Metropolitan Museum of Art; Joan Buck, Ay-Wang Hsia, and Patricia Tang, New York. William Acquavella, Eugene Thaw, and Paul Weis graciously secured loans for the exhibition.

At the National Gallery of Art, my work has been greatly aided by the members and staff of the Center for Advanced Study in the Visual Arts, particularly Henry A. Millon, Marianna S. Simpson, and Irene Gallas. Ann Bigley, Cameran Greer, and Dodge Thompson have guided me through the administrative side of the exhibition with friendly care. The exhibition has been mounted by Gaillard Ravenel and his talented staff, among whom I should particularly like to thank Mark Leithauser. The massive task of bringing the works to

Washington has been overseen by Mary Suzor of the registrar's office. Valuable assistance and advice have been provided by Shelley Fletcher, Sarah Fisher, Shelley Sturman, Hugh Phibbs, and Charlotte Hale of the conservation department; by Florence E. Coman, Gail Feigenbaum, and Jennifer Saville; and by the staff of the photographic laboratory. I am especially grateful to Frances P. Smyth, Melanie B. Ness, and the staff of the editors office. Amy Pastan, my editor, deserves my heartfelt thanks and a big bouquet.

At the Museum of Fine Arts, Houston, my involvement in this exhibition has been supported by the director, Peter C. Marzio, and by David B. Warren, associate director. Dorwayne Clements cheerfully arranged travel plans for me.

During my apprenticeship in (as it were) the *quadrille d'élèves*, I have been fortunate to receive advice from some of the *étoiles*. Theodore Reff of Columbia University has responded to my requests for help and information with patience and generosity, as have Jean Sutherland Boggs of the National Gallery of Canada and Miss Lillian Browse, London. With Eugenia Parry Janis of Wellesley College (whose work on Degas planted the first seeds of my own study) I have enjoyed many hours of thinking and talking about Degas as an artist and a personality. At various times, with my friends and colleagues Richard Thomson, Carol Armstrong, and Janet Anderson—all of whom are writing dissertations on Degas—I have shared both ideas and many a bottle of wine. May I say to them how much I have enjoyed our *pas de quatre?*

I have been blessed with good friends too numerous to list and with their good advice. I would like to thank Elizabeth Easton and Jean Coyner for their very material help in editing and assembling the catalogue and its checklist. My research and writing have been made easier and happier by: Barbara Adams, Bob Bowen, David Curry, Beatrice Farwell, Ann Coffin Hanson, Mary Tavener Holmes, Franklin Kelly, Leila Kinney, Nancy Olson, Bruce Robertson, Marc Simpson, Fronia Wissman, and Martha Wolff.

Robert L. Herbert of Yale University has been a constant provider of encouragement, enthusiasm, and the best kind of criticism. For all of these, and for his friendship, I am sincerely grateful.

"Ah!" Degas wrote from Louisiana, "what a good thing a family is." My own Louisiana family has been—as Degas' was for him—a source of strength and pride. To my parents, especially, I would like to dedicate this book.

GEORGE T.M. SHACKELFORD
Assistant Curator of European Painting and Sculpture
Museum of Fine Arts, Houston

Introduction

EDGAR DEGAS was born in 1834. He spent almost all of his eighty-three years in the city of Paris, and died there, virtually blind, in the year 1917. The eldest son of a prosperous banker and his New Orleans-born wife, Degas abandoned the study of law in 1855 to begin his training as an artist in the academic system. A misanthropic painter in a household of businessmen, the only one of five children never to marry, Degas was something of a renegade in his family — and yet his sense of honor toward his connections was firm and unalterable throughout his life. He was a reclusive man who spurned publicity of any kind, but nonetheless was known in public as a wit and a brilliant conversationalist. In his private life, the artist was perhaps no more accessible, yet he was at the same time a loyal and faithful friend.

Within his lifetime, as today, Degas was most celebrated as the painter of one subject: the ballet. Above all the subjects that he treated, whether the early history paintings, the scenes of life in the modern city — racecourses and cafés, shopgirls, and laundresses — or the portraits of family and friends that he continued to paint throughout his life, it is the dancer that is now associated with the name of Degas in the popular imagination.

Indeed, almost no other artist has successfully treated the formal ballet since Degas' time. Among his contemporaries, both Manet and Renoir painted ballet pictures, and Forain, following Degas' lead, drew and painted witty scenes of life backstage at the Paris Opera. But Degas' profound interest in and knowledge of the ballet was not shared even by the artists we now link most closely with him — Mary Cassatt and Toulouse-Lautrec. It goes with out saying that Degas' preoccupation with the interiors of the Opera, its dimly lit rehearsal rooms and gaslit stage, was at odds with the interests of many of his colleagues among the impressionists, notably Monet and Pissarro, whose vision responded to sunlight rather than gaslight.

But if Degas was almost alone in making the ballet a subject for

high art, it was not because the ballet was obscure or unknown to his artist-colleagues or to his audience. For the modern viewer, whose attendance at a performance of the ballet or the opera is a relatively rare occurrence, it may be difficult to understand how ubiquitous the ballet and opera were to the upper-class Parisian of the later nineteenth century. Almost every man of any degree of sophistication and urbanity held a subscription, an *abonnement*, to one of the thrice-weekly performances of the Opera; and the subscribers, the *abonnés*, were given free run of the theater, not only the stalls and boxes from which the performance was viewed, but also the wings of the stage, its maze of corridors, the dancers' dressing rooms, and the *foyer de la danse*, the green room where the *abonnés* congregated with the dancers before, during, and after the performance. As one observer recalled, "to see and to discuss acquaintances, and to be seen and discussed by them, and (for men) to go gossiping from box to box, are . . . the main objects with which 'the world' goes to the Opera."[1]

In addition to full-length ballets, shorter ballet sequences were included in almost every Opera performance, and were considered by many *abonnés* virtually to justify the existence of the Opera. Indeed, Richard Wagner's *Thannhäuser* was received with scorn and derision in 1861, in part because it omitted the customary dance sequence, denying the audience a view of the corps de ballet.[2] "It is an accepted principle," wrote one observer, "that society *n'écoute que le ballet.* It is only when the curtain rises on the short skirts that tongues grow still and that eyes turn unanimously to the stage."[3]

The members of Degas' well-to-do family of bankers and business-men are known to have been interested in the arts and, specifically, in music. This appreciation of musicians, whether professional or amateur, is often cited as a likely stimulus for Degas' own interest in the opera and in musical performance of all kinds. Degas portrayed his family's musicales on several occasions. The portrait of the artist's father listening to the singer Pagans, for example, has often been cited as evidence of the seriousness and concentration with which music was welcomed in Degas' household.[4] It seems, too, that the artist's family sometimes took an active role in such musical evenings, as suggested by the unusual double portrait, presumed to be of Degas' sisters Marguerite and Thérèse, entitled *The Rehearsal.*[5] Outside his immediate family, Degas was intimate with professionals from the world of the Paris Opera, such as Ludovic Halévy, the famous librettist and a childhood friend of the painter, and Désiré Dihau, bassoonist in the Opera orchestra. These friends were almost certainly responsible for his entry into the backstage world—into the *coulisses* and the *foyer de la danse.*

Even early in his career, Degas had seen that the ballet could be a subject that would set him apart from the rest of the avant-garde. His

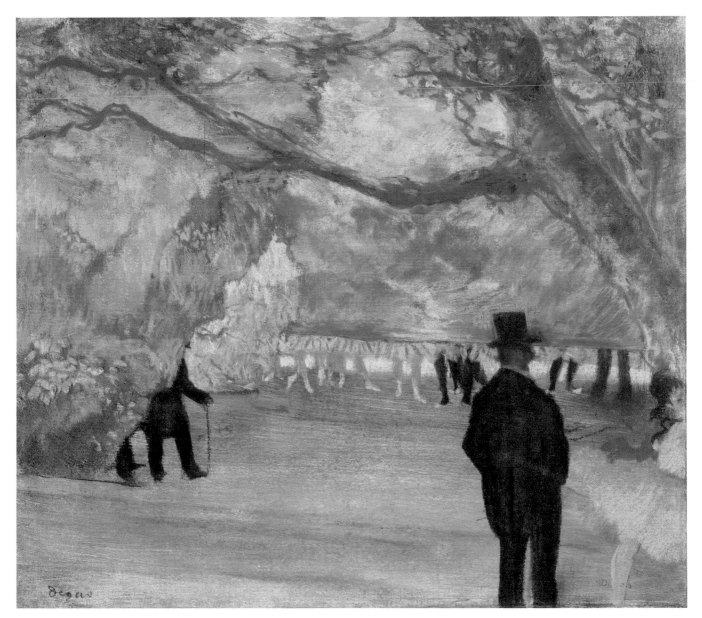

Cat. no. 6. *The Curtain* (*Le rideau*), c. 1880, pastel over monotype. From the Collection of Mr. and Mrs. Paul Mellon, Upperville, Virginia.

plans for an exhibition devoted to the dance theme were apparently shelved in view of the proposed exhibition of independent artists in April 1874—the first exhibition of the artists who were to become known as the impressionists.[6] Moreover, his choice of subject evidenced an abiding concern with figure painting as opposed to landscape, with modern urban life in preference to the charms of the suburbs or countryside. In this predilection for scenes of modernity, painstakingly described, Degas' art bears an affinity with the literary tradition of naturalism as exemplified in the works of Emile Zola and Edmond and Jules de Goncourt, but above all in the literature and criticism of his friend Edmond Duranty.

Once behind the scenes, Degas ardently embraced the subject of the ballet. In fact, at least one half of Degas' mature work was devoted to representations of dance subjects; there are approximately fifteen hundred paintings, pastels, prints, and drawings of dancers in Degas' oeuvre.

This exhibition of only fifty-eight of these works has two goals. The first of these is to survey the range of Degas' treatments of ballet subjects from the late 1860s until the end of his working life sometime after 1900. Thus, dancers will be seen in performance and in rehearsal, in isolation and in groups, accompanied by their mothers and guardians and instructed by ballet masters. Moreover, works in every medium are present, from elaborately finished paintings, pastels, and sculptures to simple pencil drawings.

The second goal of this exhibition and its catalogue is the reevaluation of Degas' working methods. While the iconography of Degas' work has been the subject of much fruitful research in recent years, and individual works have been carefully investigated and catalogued, his art has rarely been reviewed as a whole with the end of establishing the interrelationships between so-called preparatory works and final realizations. When seen from this point of view, Degas' works rarely conform to the expected sequence of preparatory drawing, intermediate study, and finished work. The drawings, for instance, were frequently reused or redrawn many years after they were first incorporated into a composition. The resulting constellations of related works defy traditional schemes of classification. In order to chart some of these constellations, four principal groups of closely related works are discussed in this catalogue. It is hoped that these discussions, while directed toward carefully chosen examples of Degas' dance compositions, will provide models of development that may be applied to the whole of his oeuvre.

In spite of all that has been written about Degas and the dance,[7] we do not fully understand (and perhaps we never will) what led him to accord such prominence to a single subject. Surely, he treated the ballet more successfully than any artist of his time, and, on the

occasions when he chose to sell them, his ballet pictures were popular in the marketplace. A host of explanations can be offered for his interest in dancers and dancing. In the dance Degas found a subject that conflated the natural, unguarded gestures of dancers at rest and the highly artificial movements of the classical ballet. In this respect, dancers were the ideal models for an artist torn between an almost obsessive interest in the idiosyncratic and individual and an equally fine-tuned appreciation for the exquisitely beautiful. And if we argue that his willful misanthropy, and not misogyny, predisposed him to spare his models little, to make them, at times, bestial, awkward, or ugly, this is not to say that he did not feel for them some degree of tenderness. Certainly, he respected the intensity with which they pursued their labors, inasmuch as he refused to romanticize the dancer's life, especially in his early work. And in the end, in his late work, the fantasy of the stage worked its magic: the dancers—or their spirits— became the emblems of light and color, of lyrical beauty. In studying the works reunited here, perhaps we can come closer to understanding not only Degas the craftsman, but also Degas the man.

NOTES

1. Adolphus 1895, 227-228.
2. *Pierre Larousse, Grand dictionnaire universel du XIXe Siècle* (Paris, 1865-1890), 15:1,245.
3. Adolphus 1895, 228.
4. Lemoisne no. 331.
5. Washington, Dumbarton Oaks, Lemoisne no. 331.
6. Reff 1976b, 1:115 (Nb. 22:203-204).
7. The principal study of the dance as a subject in Degas' art is Browse 1949; more recently, insights have been provided by Theodore Reff, "Edgar Degas and the Dance," *Arts Magazine* 53, no. 3 (November 1978), 145-149, and by Muehlig 1979.

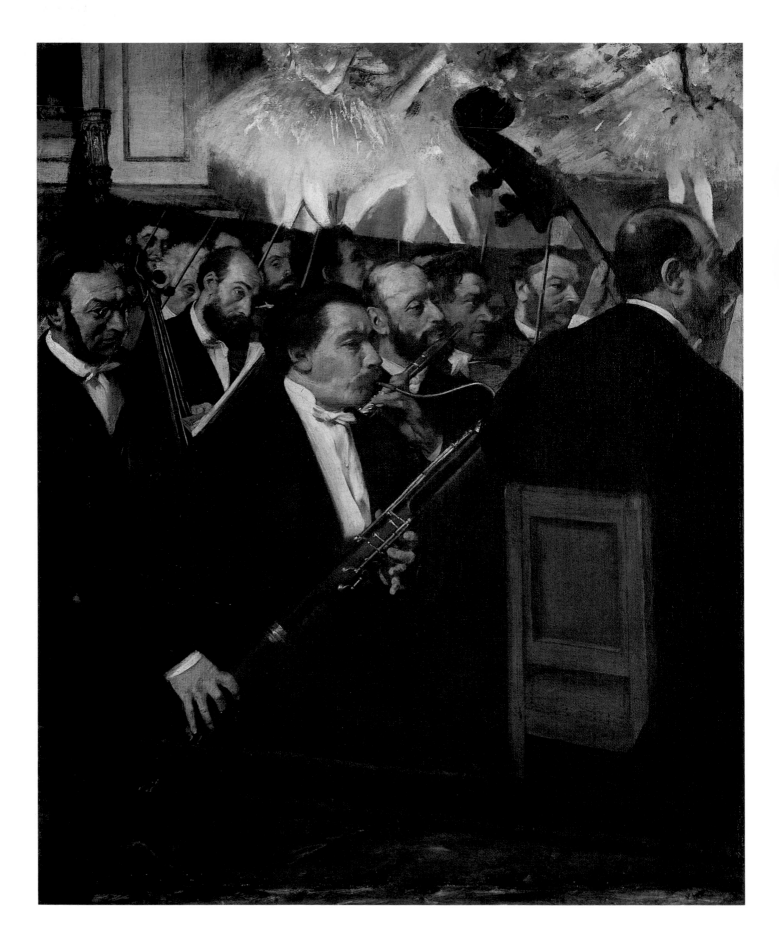

The Opera Ballet

I thought I would sneak into the Opera among the stage mothers. c. 1880

DEGAS' APPROACH to the ballet as a fit subject for his art was gradual, perhaps even circumspect. There is a remarkable change between his earliest images drawn from the world of music and opera—beginning around 1860—and the first of his unequivocally contemporary ballet scenes—from 1868. During this period, the artist turned to opera and ballet subjects with some frequency, more often in drawings in his notebooks than in full-scale paintings, and yet he consistently adapted these subjects to fit already established categories, whether of history painting, portraiture, or scenes of modern life.

Degas' first treatment of a theme from opera was the painting *Semiramis Constructing a City* of 1860-1861 (Musée d'Orsay, fig. 1.1).[1] Inspired by Rossini's *Semiramis*, revived at the Paris Opera in July 1860, the painting represents the Babylonian queen Semiramis surrounded by her attendants, looking out over a landscape while at left, in the distance, a new city rises.[2] It has long been accepted that the picture was based on an operatic source, but in both its subject matter and its formal qualities it is entirely consonant with Degas' other history paintings, such as *The Daughter of Jeptha* of 1859-1860 or *A Scene of War from the Middle Ages* of 1865.[3]

The composition of *Semiramis* is static and friezelike, the figures disposed within the lower right-hand section of the picture space. Like his other history paintings, *Semiramis* was developed according to the academic model, in which the first idea for the picture (the *première pensée*) was elaborated upon in subsequent compositional studies, establishing not only figural groups but also color and value. Detailed drawings of individual figures were then made, the final painting joining all these preliminary studies into a finely finished whole.[4] Whether on account of his still-uncertain handling of the medium of oil paint, or because of his legendary and lifelong dissatisfaction with his own works, Degas did not leave the canvas in a uniformly finished state: while some areas appear finely worked and carefully drawn,

Left: cat. no 1. *The Orchestra of the Opera* (*L'orchestre de l'opéra*), 1868–1869, oil on canvas. Musée d'Orsay (Galerie du Jeu de Paume), Paris.

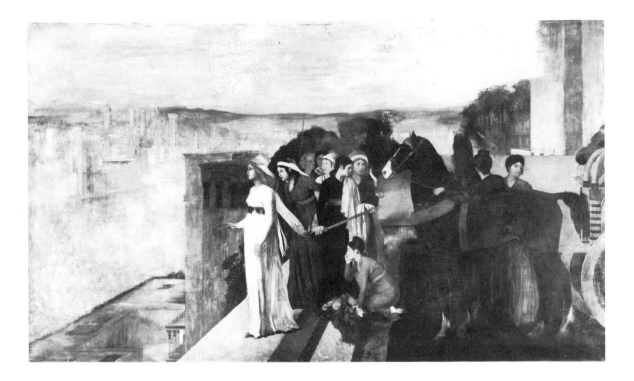

Fig. 1.1. *Semiramis Constructing a City*, 1860–1861, oil on canvas. Musée d'Orsay (Galerie du Jeu de Paume), Paris.

others, notably the landscape background, are either sketchily painted or roughly overpainted.

The manner in which Degas constructed his early history paintings presumably reflects the teaching he received in the studio of the academic painter Louis Lamothe from 1854, and later, for a short time, at the Ecole des Beaux-Arts, where Degas studied under Lamothe's sponsorship, in 1855.[5] But if *Semiramis Constructing a City* was an attempt at a classically conceived history painting in the academic manner, Degas' next ballet picture, *Mlle. Fiocre in the Ballet from La Source* of 1867 (Brooklyn Museum, fig. 1.2), represents a significant step toward the iconography of the contemporary ballet that was to occupy the artist in the succeeding decade.[6] Its title resolutely announces that the subject is a ballerina of the Paris Opera, Mlle. Eugénie Fiocre, depicted in a performance of Saint-Léon's ballet *La Source*, presented first at the Opera in November 1866.[7] The ballerina is seen in the role of Nouredda, wearing a long oriental costume, sitting beside a stream in the company of two attendants and a horse. Still, in spite of the dainty ballet slippers at the horse's feet, it is above all the painting's title that provides a clue to its origins in a recent ballet. Superficially, because of its use of an apparently naturalistic landscape setting and exotic oriental costumes, Degas' painting invites

20

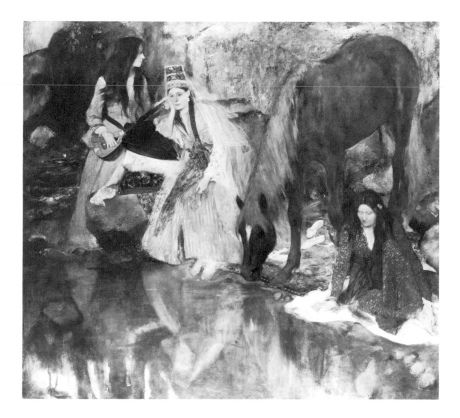

Fig. 1.2. *Mlle. Fiocre in the Ballet from La Source*, 1866–1867, oil on canvas. The Brooklyn Museum, Gift of A. Augustus Healy, James H. Post, and John T. Underwood.

comparison with the orientalist work of Théodore Chassériau, with one of Ingres' odalisques, or with Delacroix's *Women of Algiers*, transported to the out-of-doors. We know, however, that the elaborate decor for the Parisian production of *La Source* consisted of unusually veristic landscape features, including a running waterfall and a pool, and that the costumes for the piece were scrupulously oriental in design.[8] But Degas' painting, by eliminating any direct reference to the modern theater, admits references to older art; although he was inspired by a contemporary ballet, the artist couched his portrait of Mlle. Fiocre in terms of an oriental fantasy—just as the theatrical origins of his *Semiramis* had been obscured by its presentation in the manner of academic history painting.

In the next year, 1868, Degas was to lift the trappings of history from his depiction of theatrical subjects in the painting *The Orchestra of the Opera* (cat. no. 1). Like *Mlle. Fiocre in the Ballet from La Source*, this painting is a portrait, in this case a portrait of the bassoonist Désiré Dihau, who appears as the central figure in the first rank of musicians seated in the orchestra pit of the Paris Opera house. For the first time, ballet dancers appear in one of Degas' works, scampering in a glaring band of pink and blue tulle across the upper register of the picture. Dancers are introduced, it seems, to give us information

21

about the musicians, who, because of the dancers' presence, are understood as being the orchestra of the Opera. Flanking Dihau on the nearest edge of the orchestra pit are, to the left, the cellist Pillet, of whom Degas painted another portrait, and the bass violinist Gouffé; the rest of the orchestra is a mixture of professional and amateur musicians (not all of them actual members of the Opera orchestra), employees, and devotees of the Opera.[9] As in other portraits Degas painted in the late 1860s, it is the sitter's environment that tells us of his occupation and character; and the *Orchestra of the Opera*, in its individualized representations of the various musicians, calls to mind Degas' notes on portraiture: his desire to "make portraits of people in familiar and typical attitudes and especially [to] give the same choice of expression to the face that one gives to the body."[10]

The Orchestra of the Opera is, in fact, among the earliest of Degas' group portraits of friends and family in public settings—that is, in a setting not exclusively or predominantly occupied by the sitter. Through the decade of the 1860s, beginning with his ambitious portrait of his aunt and her family, the *Bellelli Family*, Degas had explored the expressive possibilities of portraiture, both of the isolated figure and of figures in groups.[11] At the end of the decade, however, he began to develop a hybrid category of painting, a blend of genre painting and portraiture, uncompromising in its modernity. Sometimes, as in the case of the *Orchestra of the Opera*, the element of genre painting predominates, making it almost unnecessary to understand the painting as a portrait. Furthermore, in these paintings a narrative situation is frequently suggested, usually because the artist has adopted a specific, definable point of view that places the viewer of the picture within the context of the characters and activity represented. In the *Orchestra of the Opera*, for example, the point of view is that of a person seated in the stalls, or orchestra seats, close by the orchestra pit itself; the viewer is thus pinpointed as a member of the audience, and, more specifically, as a male of the upper classes, because only such men sat in these seats.

This kind of portrait, in which a recognizable figure takes a role in a scene from modern life, preoccupied Degas in the early 1870s. And, like the *Orchestra of the Opera*, the subject matter or narrative of these pictures frequently takes precedence. Such is the case with his famous canvas *Portraits in an Office, New Orleans* of 1872, a depiction of his American relatives' New Orleans workplace, in which there are portraits of his uncle and brothers; or with the *Place de la Concorde*, a street scene in which the painter's friend the viscount Lepic is shown with his daughters *en promenade.*[12] In both cases, the paintings are powerful and convincing portraits; but in both the activity depicted, whether the business of a cotton merchant's office or the chance encounter of a gentleman of leisure, is paramount.

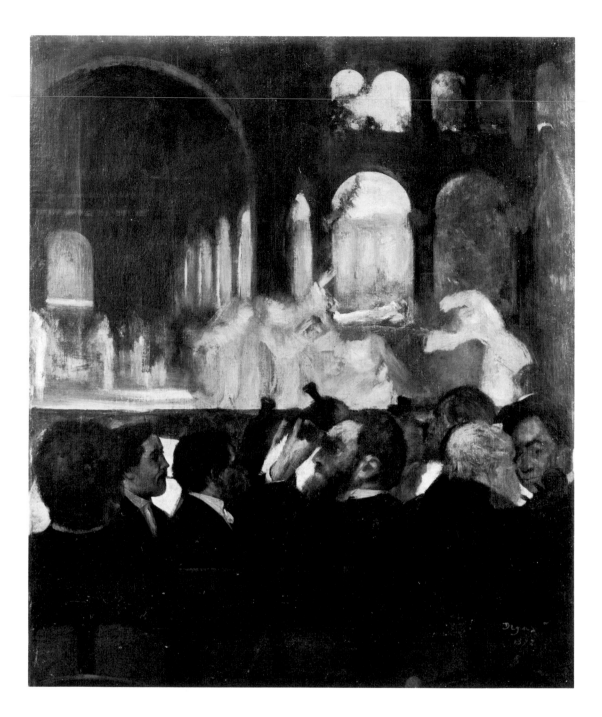

Cat. no. 2. *The Ballet from Robert le Diable* (*Le ballet de Robert le Diable*), 1872, oil on canvas. The Metropolitan Museum of Art, New York, Bequest of Mrs. H. O. Havemeyer, 1929. The H. O. Havemeyer Collection.

The Orchestra of the Opera, then, is one of a class of paintings by Degas that might be called genre portraits. Among these are several other representations of the Opera stage seen from the stalls of the theater, the earliest of which dates from 1872, four years after the completion of the *Orchestra of the Opera*, when Degas began to treat ballet subjects with increasing frequency.[13] One of these is *The Ballet from Robert le Diable* (cat. no. 2). Désiré Dihau is again seen in the orchestra

23

pit, but in this painting spectators have been added to the scene; as if seated behind them, we see one row of members of the audience and the backs of their seats in the foremost plane of the picture. Chief among these spectators is Degas' friend the industrialist Albert Hecht, shown at the center of the composition, gazing through a pair of opera glasses presumably toward the theater boxes outside the picture space to his left.[14] He does not pay any attention to the dance in progress, the macabre ballet of the corpses of nuns which takes place in the third act of Meyerbeer's opera *Robert le Diable*, written in 1831 and revived at the Paris Opera in 1871.[15] The picture space is more evenly divided between stage and stalls than in the *Orchestra of the Opera*, and yet the ballet is only loosely indicated, the nuns looming like indistinct phantoms above the heads of the spectators; the viewer's attention is focused not on the performance, but on the spectators, who turn to look at other unseen members of the audience.

Almost certainly begun in the same year as the *Ballet from Robert le Diable*, the *Musicians of the Orchestra* (Städelsches Kunstinstitut, fig. 1.3) moves the viewer closer to the players, and at the same time expands the view of the stage at the top of the canvas, where a dancer in a brilliant white costume holds the viewer's eye. This expanded area of stage sets and grouped dancers, which distinguishes the *Musicians of the Orchestra* from its precursors, was literally enlarged during the execution of the painting by the addition of a strip of canvas at the top of the image. The canvas was originally about 17 inches high; the added strip measures approximately 7 inches and is seamed to the larger piece at the level of the waistlines of the dancers standing at the upper left. Thus, the *Musicians of the Orchestra*, like the *Orchestra of the Opera*, originally had a band of headless dancers at its upper margin. In fact, the zone of paint between the footlights and the seam in the upper section of the canvas—that is, the area just above the heads of the musicians—exhibits a very uneven paint surface. The paint on the lower legs of the dancers at left and on the lower margin of the principal dancer's skirt is markedly thicker and more opaque than the paint immediately above; it may be that the original composition included a lowering curtain which obscured even more of the dancers' bodies.[16] In any case, the addition of this vividly colored, loosely textured zone marks an important step in the development of Degas' dance pictures, for if the musicians in the orchestra pit were once the focus of the picture, even though they turned their backs to the viewer, now the dancer, glowing pink and white in the footlights, shines over their somber backs. This is, then, among the first unequivocal representations in Degas' oeuvre of the modern ballet dancer in performance.[17]

The most remarkable result of this emendation is the startling division in the painting's focus. Whereas the dancers had served as a

Right: fig. 1.3. *Musicians of the Orchestra*, 1872, oil on canvas. Städelsches Kunstinstitut, Frankfurt.

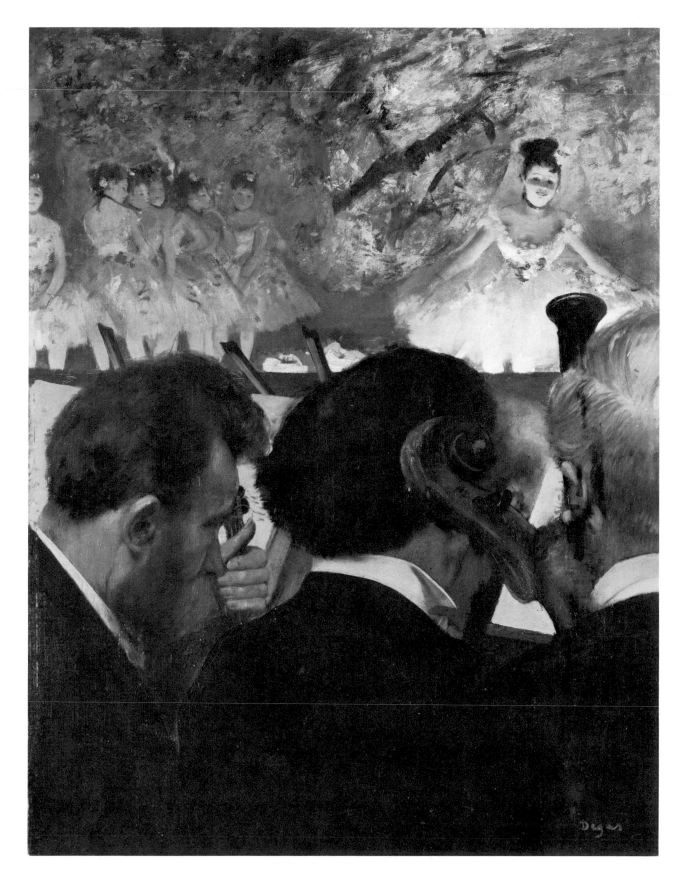

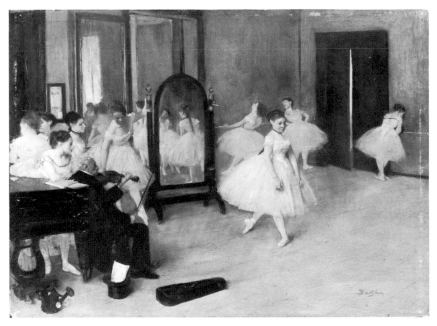

Fig. 1.4. *The Rehearsal Room*, c. 1871, oil on panel. The Metropolitan Museum of Art, New York, Bequest of Mrs. H. O. Havemeyer, 1929. The H. O. Havemeyer Collection.

foil in both *Orchestra of the Opera* and the *Ballet from Robert le Diable*, they had been either so cropped or so blurred as to avoid distracting attention from the musicians or spectators in the foreground. Moreover, in the earlier paintings the viewer is sufficiently removed from the first plane of figures that a wider field of vision is afforded him. As a result, more figures are represented; a more comfortable diminution of figure scale is permitted, from the largest figures in the near foreground to the smallest figures on the stage. In the *Musicians of the Orchestra*, however, there is a radical and unmodulated imbalance of scale between the heads of the three musicians looming large in the foreground and the doll-like dancers on the stage. The viewer is not given intermediary space to explain this dramatic juxtaposition, which curiously reinforces the shift of the viewer's attention from the musicians to the dancers: for the first time in Degas' art, we feel that the somber, bulky figures are in the way, that they obscure our view of the magical stage.

The idea of representing in one picture the orchestra pit or the stalls of the theater and the stage did not originate in Degas' paintings of theatrical subjects. As many scholars have pointed out, there are sources for this motif in art of the previous generation, notably in Daumier's satirical prints and in the work of other artists who drew for the popular press.[18] Nowhere, however, is the effect of spatial and coloristic juxtaposition as brilliantly exploited as in Degas' paintings.

26

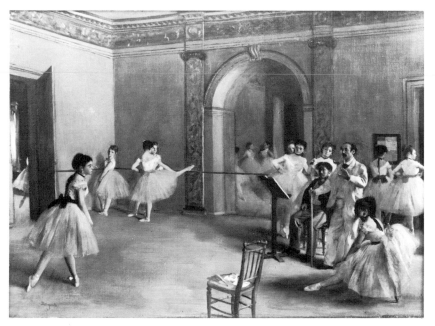

Fig. 1.5. *The Dance Lesson*, 1872, oil on canvas. Musée d'Orsay (Galerie du Jeu de Paume), Paris.

Contemporary with *Musicians of the Orchestra* and the *Ballet from Robert le Diable* is a group of paintings produced around 1872, in which Degas turned to the activity of the opera house during the daytime, when classes and rehearsals filled the practice rooms as well as the stage. These are Degas' first efforts in the subject that was to preoccupy him throughout his life; he approached these early rehearsal pictures from the perspective of the privileged insider, the patron allowed to witness not only the performance, but also the hours of work and training behind the scenes that precede it. This is the view of the friend of the management—the friend of Désiré Dihau and Ludovic Halévy. [19]

In two diminutive paintings, *The Rehearsal Room* (The Metropolitan Museum of Art, fig. 1.4) of c. 1871 and *The Dance Lesson* (Musée d'Orsay, fig. 1.5) of 1872, which are probably the earliest of all Degas' depictions of dance rehearsals, the artist nonetheless refrained from specifying a role for the viewer, as he had done, for instance, in the *Orchestra of the Opera*. [20] We see, in each case, a rehearsal room filled with dancers in working costume, attended by the violinist who accompanied the classes. In the Paris canvas the ballet master, Louis Mérante, dressed in white and carrying a staff, gives direction to a dancer at left. An arch frames a mirror that reflects the rest of the room, just as an arched cheval glass reflects the other dancers in the earlier panel, the *Rehearsal Room*. In both pictures only a corner of

27

the room is represented; the reflections suggest that many other dancers are present, and that practice is under way throughout the larger space of the room. In the *Rehearsal Room*, the principal dancer at center engages our attention, but in the *Dance Lesson* the principal figures regard only each other. It is clear that the point of view is of one permitted to witness the ballet's dancing classes, but a locus of class or precise gender is not firmly insisted upon as it had been in the orchestra pictures: the spectator might as easily be a ballet dancer as an *abonné*.

Degas does not establish a persona or point of view, in part because the two paintings are, in spite of their thoroughly modern subject matter, indebted to prototypes from the eighteenth century and to illustrative images of the romantic generation, by such artists as Eugène Lami, which were also evocative of the *imagerie galante* of the previous century.[21] Striking because of their highly finished, jewel-like facture, meticulous draftsmanship, and precious scale, Degas' first pictures of dancers at work recall the *fêtes galantes* of Watteau, Lancret, and Pater. And in the use of illumination from hidden windows, doors, and mirrors leading to ancillary spaces, we might even see an allusion to the silent light-struck interiors of seventeenth-century Dutch genre paintings.

Essentially conservative pictures, then, the *Rehearsal Room* and the *Dance Lesson*, as Ronald Pickvance states, "announce the theme" upon which Degas was to compose innumerable variations for the rest of his career.[22] Certainly the most enduring among all his subjects is the dance class or rehearsal, in which the dancer is seen at work or in practice. These representations of the ballet behind the scenes far outnumber the depictions of the ballet in performance in Degas' oeuvre (see chapters 2 and 4). However, in the artist's other depictions of ballet subjects, three motifs are of particular importance: the stage seen from the orchestra, the dancer in her dressing room, and dancers seen backstage among the decor of the Opera.

Despite the increasing predominance of ballet rehearsals in his work of the 1870s, the depiction of dancers in performance seen from the orchestra continued to interest Degas. There are several repetitions of the theme among his pastel-covered monotypes of the latter half of the decade, such as the *Ballet at the Paris Opera* of c. 1878 (The Art Institute of Chicago, fig. 1.6), or the *Ballet Dancer* of around 1877 (cat. no. 3).[23] In both of these images the personality of the orchestra is suppressed, the jewellike aura of the dancer heightened. Nonetheless, there is a masculine presence in each picture in the form of the upright, linear silhouette of the bass violin, which is contrasted with the glowing, diaphanous figures of the dancers on stage. In the case of the *Ballet Dancer*, too, an interaction is posited between the performer and the silhouetted form, as if the dancer moves forward, her hands

28

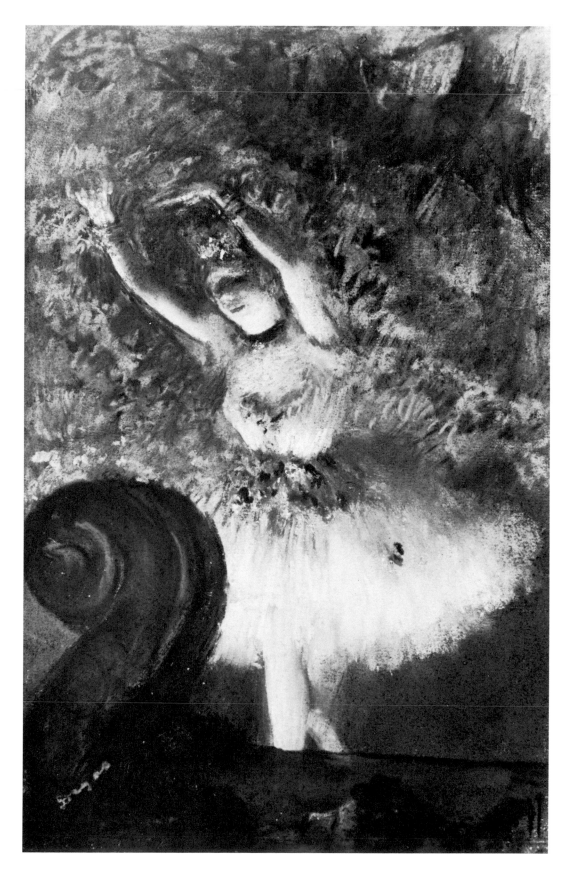

Fig. 1.6. *Ballet at the Paris Opéra*, c. 1878, pastel over monotype. The Art Institute of Chicago, Gift of Mary Block.

elegantly upraised, to meet the rising shape of the double bass. This interaction is, like the pairing of the white-clad dancer and the jet-black cylinder of an oboe in the *Musicians of the Orchestra* (see fig. 1.3), a visual pun occasioned by the point of view the artist has chosen. In neither painting does the dancer actually address the musical instruments of the orchestra; she addresses the audience beyond them. In the *Musicians of the Orchestra* this audience is also represented by the bouquets seen lying on the stage at the dancers' feet. The musicians and their instruments intervene and interrupt the relationship between audience and performer. It should be noted, however, that the coupling of dancer and musical instrument was originally more graphic. The white-haired musician at the right, introduced after the other musicians, now partially obscures the oboe's projecting form. Degas allows the instrument to represent the musician as an iconographic attribute; moreover, the somber instrument recalls, indeed emerges from, the shadows of the orchestra and the stalls, and thus is coloristically associated with the men who support the action of the dance—the musician and the *abonné* alike.

Such confrontation between performer and audience is not peculiar to Degas' ballet pictures. In his *Café-Concert* (Corcoran Gallery of Art, fig. 1.7), for example, he assembles a remarkably similar group of elements: in the foreground plane, the murky orchestra of the outdoor café; on the next level, the brilliantly illuminated and garishly clad singers massed behind the principal performer.[24] Like her dancer counterpart, the singer seems to gesture toward the flat silhouette of a top hat at her feet, the exaggeratedly elongated double bass at right, and at the more graphically displayed neck of the concert master's violin.

Fig. 1.7. *Café-Concert*, c. 1878, pastel over monotype. The Corcoran Gallery of Art, Washington, William A. Clark Collection.

Nor is the essential device of juxtaposing the silhouettes of dark geometric forms, associated iconographically and formally with the male element of the audience, and highly colored, fractured figures of female performers limited, in Degas' dance pictures, to representations of the ballet seen across the orchestra. The pastel *Ballet* (cat. no. 4) shows a black-coated male among the tulle skirts of the dancers, while in *Dancers Backstage* (cat. no. 5), a dancer and a top-hatted *abonné* are seen against the richly worked greens of a stage flat: they are clearly a pair. Madame Cardinal, mother of two dancers and heroine of Ludovic Halévy's *La Famille Cardinal,* makes blatant the meaning of the juxtaposition so subtly presented by Degas: "Just then," recounts Halévy, "Madame Cardinal interrupted her speech and rushed off at a trot toward the stage, only to return a moment later dragging [her daughter] Pauline by the ear. 'Ah! you little creature!' 'But *maman . . .*' 'I tell you Monsieur de Gallerande just kissed you there, behind that stage flat.' 'I say he didn't.' 'I say he did.' . . . 'Ah! monsieur,' said Madame Cardinal [to Halévy], 'two daughters, at the Opera, in the ballet, what a trial for a mother!' " [25]

In *The Curtain* (cat. no. 6), a pastel drawn over a monotype print base, we see the stage set for the rehearsal of a performance, the decor of trees and foliage indicated with free strokes of the pastel crayon. At the back of the picture, a curtain is poised just below the waists of some dancers whose rose-stockinged legs and beribboned skirts (their performance costumes) alone are visible; light falls on their feet, making them stand out on the neutral ground like a row of little petals. Still behind the curtain, to the right, is a group of dancers in black tights and blousy yellow-orange pants—probably female dancers *en travesti;* to the right of these dancers, behind the curtain, are the black trouser-legs, rigid as stovepipes, of a man in evening clothes—probably

31

Cat. no. 4. *Ballet* (*Avant le ballet*), c. 1877, pastel. The Corcoran Gallery of Art, Washington, William A. Clark Collection.

Right page: cat. no. 5. *Dancers Backstage* (*L'entrée en scène*), c. 1875, oil on canvas. National Gallery of Art, Washington, Ailsa Mellon Bruce Collection.

Below: cat. no. 6. *The Curtain* (*Le rideau*), c. 1880, pastel over monotype. From the Collection of Mr. and Mrs. Paul Mellon, Upperville, Virginia. (Illustrated in color on page 15.)

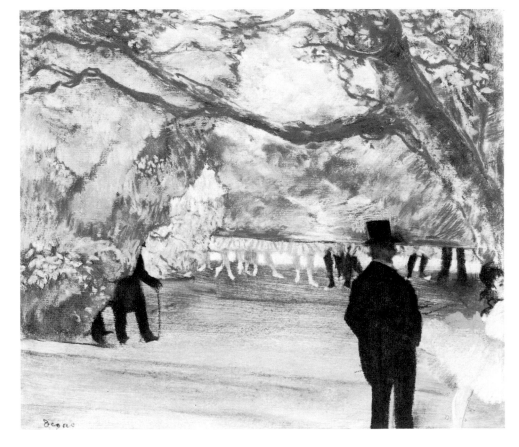

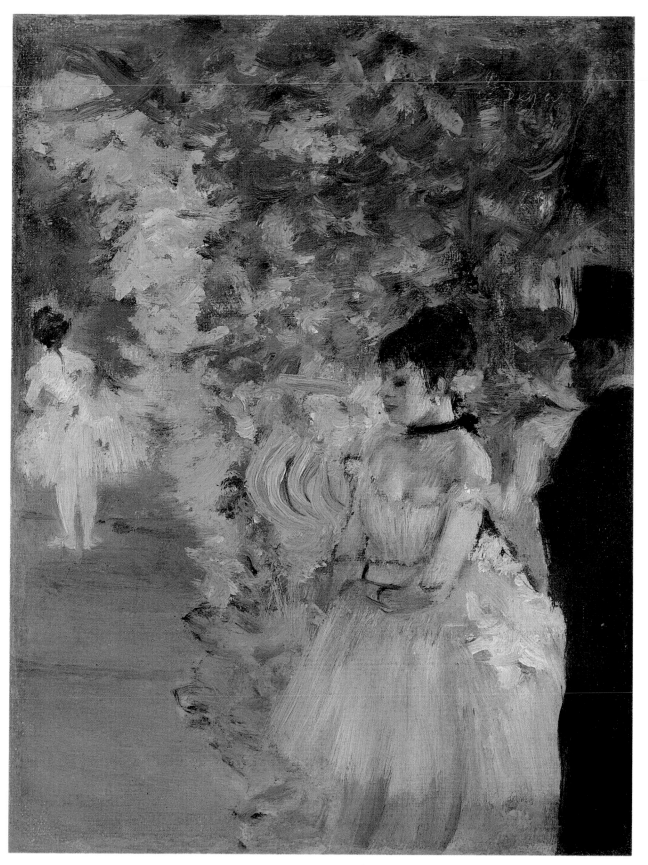

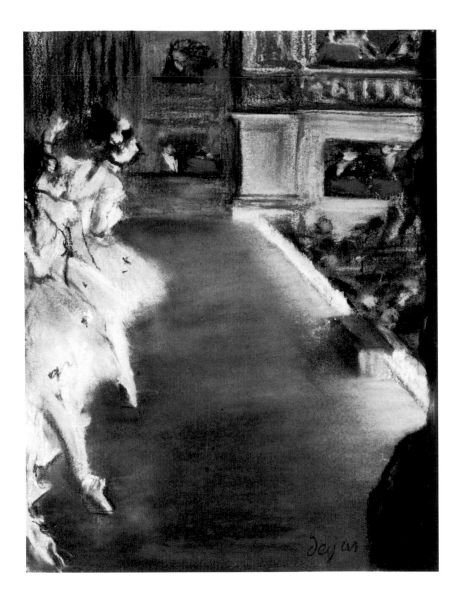

Cat. no. 7. *Dancers at the Old Opera House* (*L'opéra* [*Danseuses à l'ancien Opéra*]), c. 1877, pastel over monotype. National Gallery of Art, Washington, Ailsa Mellon Bruce Collection.

an *abonné*. Other subscribers of the Opera are more legibly presented in the foreground: two stand half hidden by a stage flat at left, and another stands beneath the decor of a branching tree trunk at right. The latter seems to turn his profile, indistinctly indicated, to the right, toward the dancer clad in rehearsal clothes who moves briskly off the stage.

Men in black are sharply contrasted in the *Curtain* with the colorful theatrical decor and costumes. Around the top hat of the man at right, for instance, Degas even further heightened this contrast with a series of parallel hatchings that sharpen its rectilinear contour and make it stand out against the vivid green of the curtain. Still, the placement of these *abonnés*, each cleverly linked with the elements of the decor, reinforces our knowledge of their intimacy with backstage

34

affairs: the silhouettes of the men at left continue and exaggerate the profile of the stage flat that partially obscures them; the legs of the man behind the curtain are placed in apposition to the legs of a female dancer, also black-clad; and the exacting and precise placement of the top-hatted figure, whose hat brim is aligned with, and seems almost to support the curtain far behind him, suggests that he is, in fact, a "pillar of the establishment."

In another monotype covered with pastel, *Dancers at the Old Opera House* (cat. no. 7), Degas almost entirely eliminated direct depiction of the *abonné* in favor of a more sidelong approach; he views the ballet from one of the stage boxes reserved for the direction of the Opera and close associates of the management. From this unusual vantage point, the dancers are seen moving away into the picture space, their torsos and costumes overlapping each other, their legs visually jumbled and difficult to distinguish. Directly opposite the viewer, in another stage box, sits a man in evening clothes whose bulbous profile is caricatured by the artist just as he caricatures the snoutlike profile of the dark-haired dancer at left. In this little picture the juxtaposition of *abonné* and dancer is not principally conveyed in formal terms, but in terms of the point of view—one readily appreciated by a late nineteenth-century audience. Nonetheless, the shadow of the box in which the viewer sits and the amorphous profile of the viewer's neighbor seen in the lower right-hand corner show that the idea of a light/dark opposition, suggestive of a male/female dichotomy, is not entirely abandoned.

Degas went behind the scenes as well, to the dressing rooms of the dancers, to observe the interplay of artist and patron, usually under the guard of the dancer's mother. In his *Dancer in Her Dressing Room* (Oskar Reinhart Foundation, fig. 1.8), he presents what is almost a voyeur's view of this group.[26] From the corridor outside her dressing room, a dancer is seen being fitted into her costume. To the left, an older woman adjusts the waist of her tutu; the dresser might well be the dancer's mother, for these duennas were regularly seen in the wings and the dressing rooms of the theater. The very archetype of these stage mothers, Ludovic Halévy's Madame Cardinal, described her own devotion to her daughter Pauline, a former dancer whose real success was as the mistress of a marquis: "I helped Pauline to undress with my own two hands . . . I once again was in my element. . . . If I hadn't pledged myself, as I had, to the existence of my husband, I'd have been really quite happy to be Pauline's lady's-maid."[27] At the far left of the *Dancer in Her Dressing Room*, indistinct in the shadows, is the dancer's protector, who looks on as she preens in preparation for the ballet.

In each of these images, then, the dark, static, silhouetted forms of the men, whether musicians or *abonnés*, watch; the brightly colored,

35

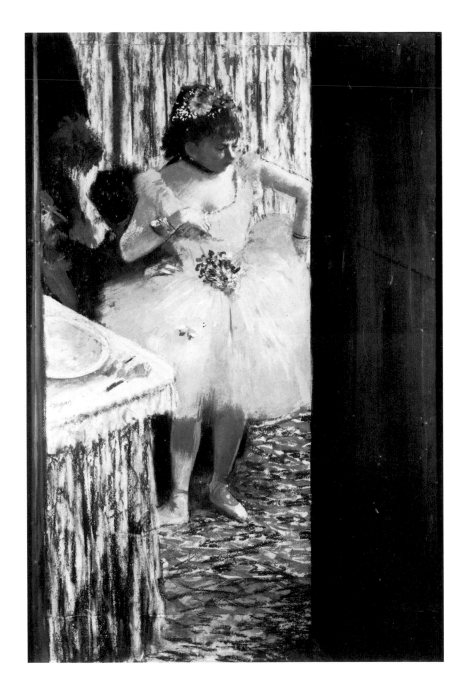

Fig. 1.8. *Dancer in Her Dressing Room*, c. 1880, gouache and pastel on joined paper. The Oskar Reinhart Collection, "am Römerholz," Winterthur.

mobile, impressionistically rendered forms of the dancers pose and perform. This pattern—the man watching and the woman performing—molds much of Degas' imagery, whether of the dance, the café-concert, or the brothel. The watchful but essentially passive male is a presence in many of Degas' early treatments of ballet themes. In some cases, such as in the *Orchestra of the Opera* (see cat. no. 1), where Degas' friend the composer Chabrier is seen peering at the scampering dancers from the stage box,[28] or in *The Rehearsal of a Ballet on Stage*

36

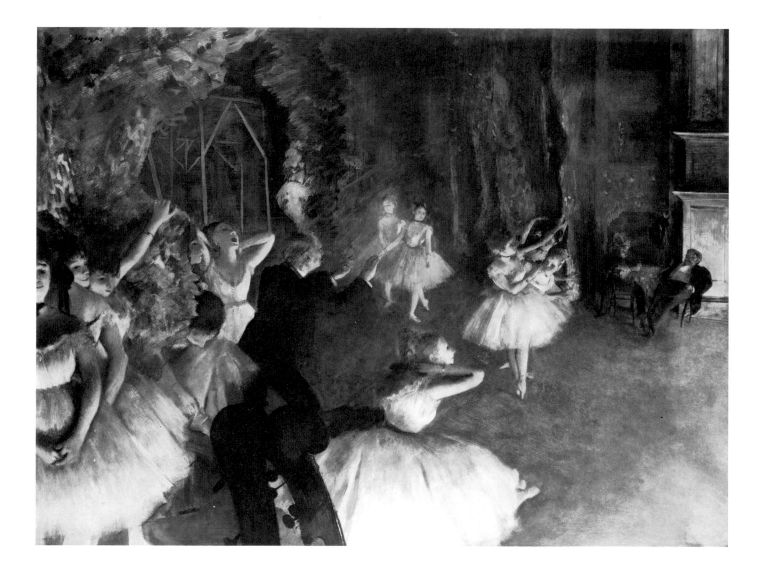

Fig. 1.9. *The Rehearsal of a Ballet on Stage,* c. 1872, pastel over pen and ink drawing. The Metropolitan Museum of Art, New York, Gift of Horace Havemeyer, 1929. The H. O. Havemeyer Collection.

(The Metropolitan Museum of Art, fig. 1.9),[29] where a pair of on-lookers watch the rehearsal, he is plainly depicted; in others, such as the *Dancers at the Old Opera House,* his presence must be inferred from the point of view adopted by the artist.

And yet for all their seeming inactivity, the *abonnés* of the Paris Opera exerted great power and influence not only over the ballet, but in all areas of upper-class Parisian life. As one memoirist wrote of the end of the Second Empire, the ballet

enjoyed at that time at the Opera an importance and popularity much greater than that of today. The male section of the audience thought a great deal of it, and would not permit the management to fail to satisfy their wishes and tastes in this respect. These gentlemen were all-powerful, and their will was final. They had an exclusive, or almost exclusive, right of admission to the green room—rigorously closed to the common crowd—and they were there the masters of the situation. The Jockey Club in particular, of which about fifty members occupied seven side boxes, containing men only, frequented the retiring room of the ballet dancers,—a veritable *salon*—where they reigned absolutely, and furnished most of the fashionable protectors to the young ladies of the corps de ballet. [30]

The emperor Napoleon III is said to have believed "with Balzac, that the extraordinary physical strain upon the lower extremities necessarily interfered with the intellectual development 'at the other end.' 'L'esprit d'une danseuse est dans ses jambes, et je n'aime pas les femmes bêtes,' he remarked [A dancer's spirit is in her legs, and I do not care for stupid women]." [31] The complacency and condescension apparent in the emperor's remark characterize the numerous accounts of dancers' manners and morals written in the Second Empire and Third Republic, although they are generally lighter in tone, or at least wittier. [32] Degas treats many of the same themes as the authors of these accounts; details of physiognomy or costume, of carriage or career often run parallel in the literature and in his art. Yet, although Degas frequently assumes the point of view—in the sense of a physical locus—of the Opera *abonné*, he seems rarely to approach the dancer simply as an object of desire that may be had for a price—to adopt, in other words, the moral stance of the *abonné*. Instead, the artist most often remains rather coolly aloof, letting the understanding of his audience dictate its own conclusions. Or if, as in many of the monotypes, he takes on a more satirical point of view, he caricatures the dancer and the *abonné* alike, accentuating the gaucheries of the one and the gullibilities of the other. [33]

By no means do all of Degas' dance pictures include such spectators, nor does each picture manifest an identifiable vantage point. But in some cases what seems to be a perfectly straightforward representation of dancers in performance must be interpreted as the vision of an insider. For example, the remarkable pastel *Dancers on the Stage* (cat. no. 8), while devoid of any direct reference to the audience or to the *abonné*, conveys the experience of someone who has witnessed the ballet at close quarters. The dramatic cropping of the figures (none of which is seen in its entirety) both by the frame and by each other, makes it clear that the viewer is very near the action represented. Indeed, the forearm jutting into the lower right-hand corner of the image implies that the viewer must be standing just within the wings of the stage.

Ballet Dancers (cat. no. 9) is an early treatment of another theme

Cat. no. 8. *Dancers on the Stage* (*Un coin de scène pendant le ballet*), c. 1885, pastel. Mr. and Mrs. Frank Bartholow and the Dallas Museum of Fine Arts. (Illustrated in color on page 2.)

that was to preoccupy Degas' late career. We see a group of dancers in repose on the stage, arranged so that their silhouettes form decorative patterns against the abstract contours of the stage decor. As in the *Curtain* (see cat. no. 6), the informality of the dancers caught at an off moment indicates that the viewer is privileged to witness the most intimate vignettes of backstage life, and yet there is no discernible mark of position or personality that could be applied to the viewer. In fact, the use of a specific persona for the viewer, or narrator, becomes more and more rare in the later work of Degas. This is true not only in his images of dancers, but also in his other subjects: the bathers of the late 1880s and 1890s do not presuppose the viewer's gender or class; they are observed by an aloof, omniscient narrator.[34]

Cat. no. 9. *Ballet Dancers* (*Danseuses*), c. 1878, gouache and pastel over monotype. National Gallery of Art, Washington, Ailsa Mellon Bruce Collection.

The increasing dissociation of Degas' social role from the experience of his art is rooted in the nature of his development as a working artist. As the decades passed, Degas became more and more interested in the processes of art: in drawing, in materials, in facture itself. This is not to suggest that Degas' later work does not have meaning, or even subject matter. But the irony and wit of the backstage flaneur are seldom seen in Degas' late images of dancers. Instead, the subject became a pretext for commentary of another kind, with a diction and critical vocabulary of its own.

NOTES

1. Lemoisne no. 82.
2. Browse 1949, 50.
3. Smith College Museum of Art, Lemoisne no. 94; Musée d'Orsay, Lemoisne no. 124.
4. For a more complete discussion of the painting's evolution, see Geneviève Monnier, "La genèse d'une oeuvre de Degas: *Semiramis construisant une ville,*" *Revue du Louvre* 28, no. 5/6 (1978), 409-426; for an overview of the academic method of composition, see Boime 1971.

5. Lemoisne, 1:10-15. Although conservative in his working method and in his choice of a quasi-historical subject drawn from a recent literary source, Degas nonetheless may have been influenced by the young painter Gustave Moreau. The artists had known each other in Rome in the years 1857-1858 and *Semiramis* seems to bear some relationship to Moreau's statically disposed historical pastiches.

6. Lemoisne no. 146.

7. Browse 1949, 51, n. 6.

8. Guest 1974, 220.

9. See Lemoisne no. 186 for identification of personalities; see also Boggs 1962, 28-29, Appendix B.

10. Reff 1976b, 1:118 (Nb. 23:46-47); see also Boggs 1962, 23.

11. Musée d'Orsay, Lemoisne no. 79.

12. Musée des Beaux-Arts, Pau, France. Lemoisne no. 320; *La Place de la Concorde,* Lemoisne no. 368, is presumed destroyed.

13. The Opera was closed in September 1870 during the period of the Franco-Prussian War, the fall of the Second Empire, and the Commune, and performances were given only intermittently until October 1871. See Browse 1949, 67-68.

14. For a discussion of this picture and its relation to the second version of the composition in the collection of the Victoria and Albert Museum, see Mayne 1966, 148-156.

15. Mayne 1966, 148; Browse 1949, 52.

16. Compare *The Falling Curtain (Le baisser du rideau),* Lemoisne no. 575.

17. *The Musicians of the Orchestra* followed by only a short time Degas' first treatment of a dance class, *The Rehearsal* of c. 1871 (The Metropolitan Museum of Art, Lemoisne no. 297).

18. Boggs 1962, 29.

19. Halévy's stories parallel Degas' images in many cases; see, above all, his *Famille Cardinal* (Halévy 1883), for which Degas projected a series of illustrations. This project was discussed by Carol Armstrong in "The Illustration Project that Failed: Degas' Monotypes for *La Famille Cardinal*" (Paper delivered at the Annual Meeting of the College Art Association, Toronto, February 1984), unpaginated.

20. Lemoisne nos. 297 and 298.

21. See, for instance, Lami's illustration of the *foyer de la danse,* in Ivor Guest, *The Romantic Ballet in Paris* (Middletown, 1966), fig. 3.

22. Pickvance 1963, 258.

23. Lemoisne nos. 513 and 449.

24. Lemoisne no. 404; like the Chicago *Ballet at the Paris Opera* and the *Ballet Dancer,* the Corcoran *Café-Concert* is a monotype print covered with pastel.

25. Halévy 1883, 32-33. (translation GTMS)

26. Lemoisne no. 529.

27. Halévy 1883, 142-143. (translation GTMS)

28. See Lemoisne no. 186; Boggs 1962, Appendix B.

29. Lemoisne no. 498.

30. Le Comte de Morny, *Souvenirs of the Second Empire, or the Last Days of the Court of Napoleon* (London, n.d.), 184.

31. A.D. Vandam, *An Englishman in Paris* (New York, 1893), 311.

32. Other accounts of the ballet dancer include Adolphus 1895, Abraham Dreyfus, *Scènes de la vie de théatre* (Paris, 1880), and Viel'Abonné 1887. See also extensive bibliography in Guest 1974.

33. See, for instance, Janis 1968, nos. 186, 222, 230.

34. For a conflicting point of view, see Eunice Lipton, "Degas' Bathers: The Case for Realism," *Arts Magazine* 54, no. 9 (May 1980), 94-97.

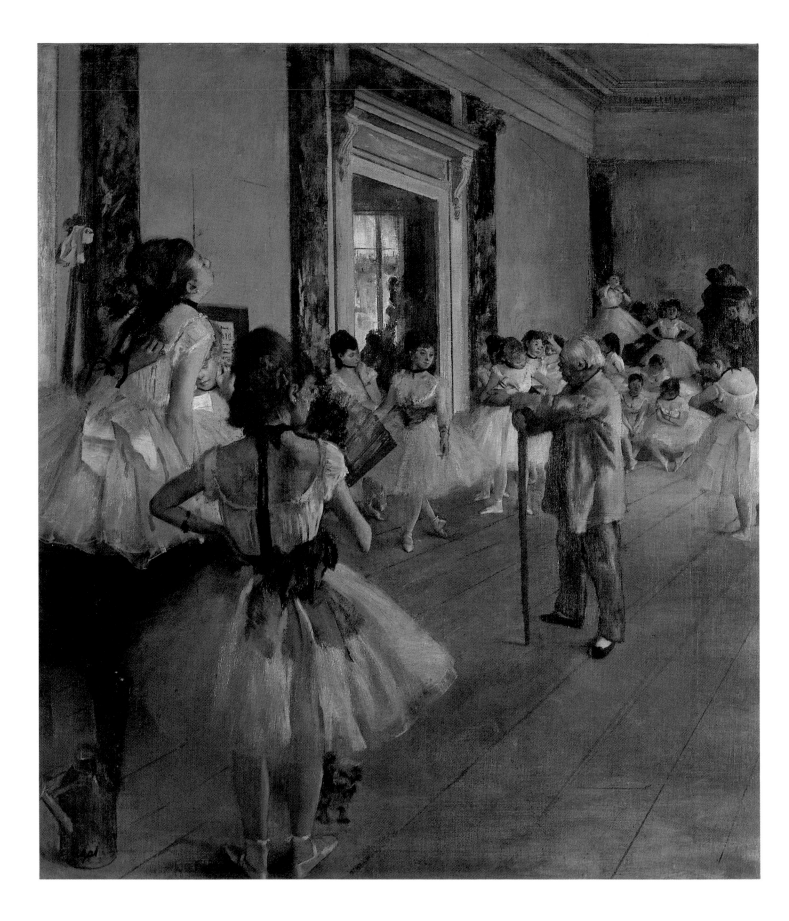

CHAPTER 2

The Master of the Dance

Art does not expand, it distills itself. 1873

THE PAINTINGS OF dance rehearsals that were to become Degas' best-known treatments of ballet subjects had their beginnings in the *Rehearsal Room* and the *Dance Lesson* (see figs. 1.4 and 1.5). Although these two paintings were the first tentative steps toward the fuller exploration of the dance rehearsal theme upon which Degas was to embark in the years 1873–1876,[1] the crucial painting of this period is certainly *The Dance Class* of c. 1874–1876 (cat. no. 10). *The Dance Class* is, in fact, the first and most important milestone in Degas' development as a painter of dancers, for it summarizes the subjects that were to interest him in succeeding decades and exhibits the convoluted and complex process of building a picture that was to become characteristic of the artist's working methods.

In 1873 and 1874, before he began work on the *Dance Class,* Degas painted the *Dancing School* (Corcoran Gallery of Art, fig. 2.1) and *The Rehearsal* (Glasgow, Burrell Collection, fig. 2.2), both of particular importance in understanding the origins of the *Dance Class.*[2] The *Dancing School* is a complex scene of a practice room in which several groups of dancers are disposed, some in rehearsal, others resting or adjusting their working costumes, and still others only just arriving in the rehearsal room by a spiral staircase. As in the *Dance Lesson* (see fig. 1.5), the light is low and cool, its source half hidden by the legs of the descending dancers, and the figures are relatively small in scale, light-struck shapes that emerge from velvety shadows. Degas seems to have concentrated on the atmosphere of a Parisian interior rather than on the more pointed anecdote of the dancers at work. Indeed, he hid the face of practically every dancer depicted. Their heads are either turned away, cast in shadow, or blocked from view; only in the profile of a dancer at right, which is almost completely lost, can a twinge of personality or expression be felt.

Degas was at work on a closely related picture, *The Rehearsal,* when the novelist Edmond de Goncourt paid a visit to his studio in February of 1874:[3]

Left: cat. no. 10. *The Dance Class* (*La classe de danse*), c. 1875, oil on canvas. Musée d'Orsay (Galerie du Jeu de Paume), Paris.

43

Then the dancers come in. . . . It's the *foyer de la danse,* with the fantastic silhouette of the dancer's legs descending a little staircase seen against a lighted window, with the unexpected touch of red from a tartan in the midst of all these ballooning white clouds, with the rascally *repoussoir* of a ridiculous ballet master. And there before you, caught off guard, is the graceful twisting of the movements and gestures of the little ape-girls.

The painter shows you his pictures, adding to his explanation from time to time by miming a *developpement,* by imitating, with the expression of the dancers, one of their arabesques. And it really is very funny to see him, up on point, his arms rounded, mixing the aesthetic of the dance master with the aesthetic of the painter . . .[4]

The painting that Edmond de Goncourt described is the first of Degas' rehearsal pictures to partake of the piquant irony that marks some of his later treatments of the theme. With the *Rehearsal of a Ballet on Stage* (see fig. 1.9), the *Rehearsal* reveals Degas' delight in the gently humorous portrayal of "types"—in this case the solid bulk of the stage mother, modeled on Degas' housekeeper Sabine Neyt, and the white-haired dance master in the far distance, who seems to perch on her shawl-covered shoulder. Goncourt's remarks, while they seem to parody the painter and the painting, make it clear that Degas was not only conscious of this humor but at the same time an informed and sympathetic observer of the ballet dancer at work.[5]

In the Corcoran painting the scale of Degas' rehearsal pictures is expanded, while the idea of a multifigured composition, in which the rendering of elegant effects of light and color is paramount, is maintained. In the Glasgow picture, much simpler in its arrangements of figural groups and pictorial space, a more important function is given to the element of anecdote. These paintings are the immediate precursors

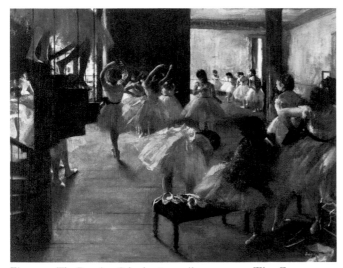

Fig. 2.1. *The Dancing School,* 1873, oil on canvas. The Corcoran Gallery of Art, Washington, William A. Clark Collection.

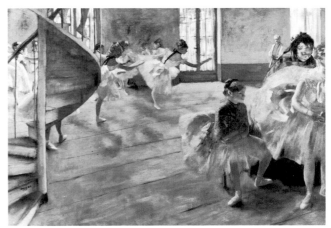

Fig. 2.2. *The Rehearsal,* c. 1874, oil on canvas. Glasgow Art Gallery and Museum, The Burrell Collection.

44

of Degas' *Dance Class* (cat. no. 10), also known as *The Dance Class of Monsieur Perrot.* The painting, executed in oil on canvas, is thought to represent one of the rehearsal rooms of the old opera house on the rue le Pelletier, which had been destroyed by fire in 1873.[6] The space is deep and lofty, ornamented with marbled pilasters, an elaborately framed mirror, and a massive cornice. At the center of the composition, a well-known dance master, Jules Perrot, is giving instruction to a dancer who strikes a position. Around the room are other dancers, all of them at rest, and in the far background, ranged on bleachers, are the omnipresent stage mothers and guardians of the dance students. The immediate foreground of the picture is occupied by a piano, on which is seated a dancer scratching her back; beneath the piano is a watering can used in the classroom to moisten the wooden floors. Another dancer stands facing into the composition, holding a large fan before her, while a little dog, a curiously incongruous detail, is at her feet.

The date of the *Dance Class* has been the subject of some disagreement. Lemoisne states that the painting was completed in 1874, believing that it was included in the first impressionist exhibition held in the spring of that year.[7] Ronald Pickvance, correcting that error, established that the painting in the 1874 exhibition was, in fact, the little panel painting, the *Rehearsal Room* (fig. 1.4), now in the Metropolitan Museum.[8] Pickvance has posited a terminus ante quem of 1876 for the *Dance Class,* since the earliest firm evidence we have of its completion is its inclusion in an April 1876 exhibition in London.[9] It can now be established that the painting went through two distinct stages of development, and that if it was probably begun around 1874, and substantially finished in that year, it was subsequently repainted as much as a year later, leaving the painting we now know. We arrive at this conclusion by trying to work out the evolution of the composition through its various stages, and by way of a careful look at the constellation of paintings, drawings, and prints that can be related to this painting.

Among the most beautiful of these objects is a picture called *Dancers Resting* (fig. 2.3), executed in Degas' favored technique of *peinture à l'essence*—that is, in oil paint from which the oil medium has been blotted, diluted with a solvent like turpentine.[10] It is signed and dated 1874, and it represents the edge of a dance rehearsal room, seen in steep perspective, where two dancers are at rest. One of them adjusts the strap of her slipper; the other, with the awkwardness of gesture often appreciated by Degas, scratches her back. In the upper right corner of the painting, a mirror reflects more of the floor, a window, and the roofs and chimneypots of Paris under a steamy gray sky. Close observation reveals that the picture was painted over another highly colored drawing by Degas, of a mounted jockey;

45

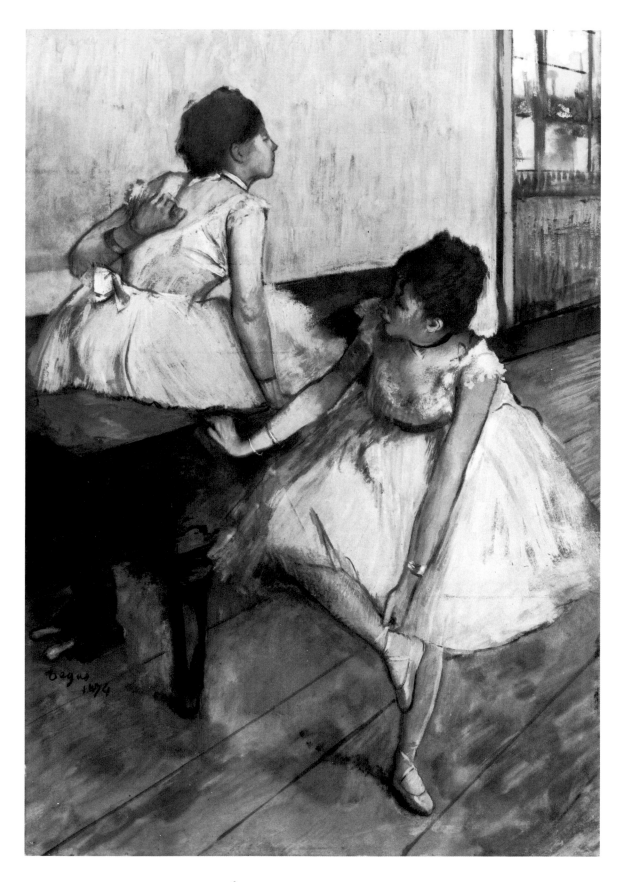

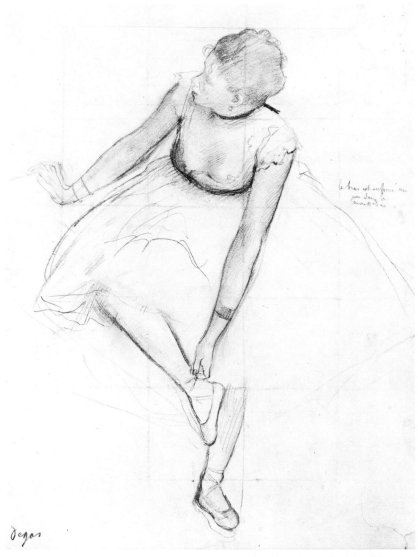

Fig. 2.4. *Dancer Adjusting Her Slipper,* c. 1874, graphite heightened with white chalk on faded pink paper. The Metropolitan Museum of Art, New York, Bequest of Mrs. H. O. Havemeyer, 1929. The H. O. Havemeyer Collection.

Left: fig. 2.3. *Dancers Resting*, 1874, peinture à l'essence on paper mounted on canvas. Private collection.

portions of his cap and racing silks can be discerned underneath the costume of the dancer seated on the piano. The perspective of the room, its decoration, and the piano and seated figure parallel elements found in the *Dance Class.* Accepting the date inscribed on the *Dancers Resting,* a beginning date of sometime in 1874 may be assigned to the Paris canvas.

Several drawings related to the *Dancers Resting* are known, among them a beautiful sheet from the Metropolitan Museum of Art, *Dancer Adjusting Her Slipper* (fig. 2.4), which is a study of the leaning dancer who appears in the foreground of *Dancers Resting*. [11] Executed in pencil

47

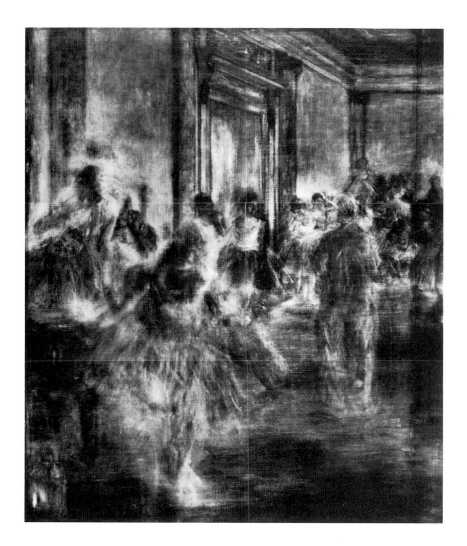

Fig. 2.5. *The Dance Class* (x-radiograph). Laboratoire de Recherche des Musées de France.

on a deep pink paper that has faded over the years to a soft beige, this is among the artist's best-known drawings. The finesse of the pencil line has rightly been compared to that of Degas' idol Ingres, and yet the awkward, imbalanced pose, tenuously held, is typical of Degas' realist conception of the human figure. This sheet, furthermore, is almost a paradigm of the precisely rendered, keenly observed study of the model for which Degas is celebrated; characteristically, he notes a telling detail: "le bras s'enfonce un peu dans le mousseline [the arm sinks into the fabric a little]."

The figure we see in this drawing was once the central character in the *Dance Class*, for she was once visible where we now see a woman holding a fan. In the original canvas the leaning figure is still at least partially visible to the naked eye. The standing figure holding a fan is painted directly over her, without much, if any, scraping, and the

48

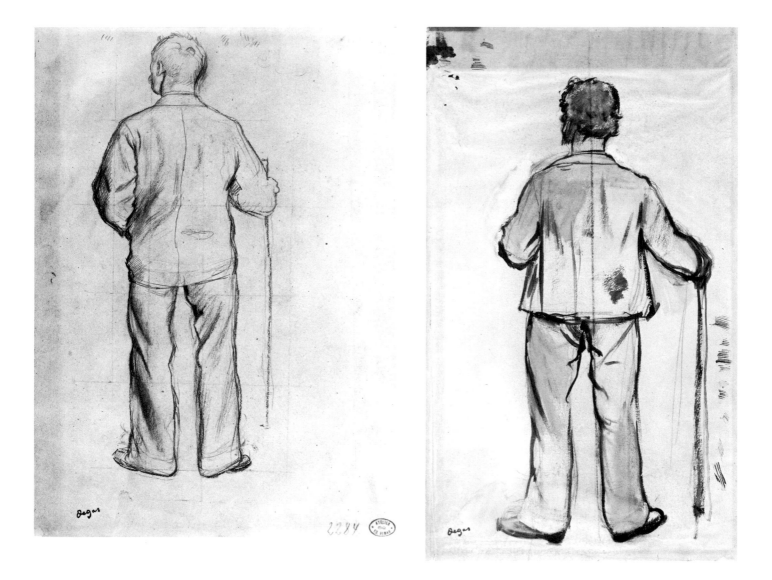

Top left: cat. no. 11. *Dancing Master (Maître de danse)*, c. 1874, graphite and charcoal on tan laid paper. The Art Institute of Chicago, Gift of Robert Sonnenschein II.

Top right: cat. no. 12. *Dancing Master (Maître de danse)*, c. 1874, black ink, watercolor, and oil over graphite on buff laid paper. The Art Institute of Chicago, Gift of Robert Sonnenschein II.

old contours can be seen in raking light. Moreover, even closer inspection reveals that the brown spot on the standing dancer's fan is actually the hair of the former dancer. These observations are confirmed by an x-radiograph of the painting made in 1964 and first published in the *Bulletin du Laboratoire du Musée du Louvre* of 1965 (fig. 2.5).[12] In the lower left-hand corner the leaning dancer's outline can be seen, and over it, the shadow of the superimposed standing dancer.

The change in this foreground figure was occasioned by another important alteration. Further inspection of the x-radiograph of the *Dance Class* reveals that beneath the figure of Jules Perrot lies that of another dance master, who was once represented facing into the background of the composition. This dance master, now obliterated, can be identified from two drawings (cat. nos. 11 and 12) which have not heretofore been linked with the *Dance Class.* The model for these

49

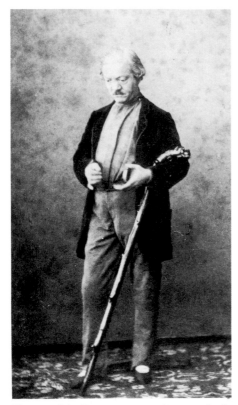

Fig. 2.6. *Jules Perrot*, c. 1861, photographed by C. Bergamasco. Mr. David Daniels, New York.

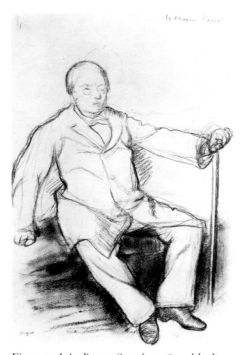

Fig. 2.7. *Jules Perrot, Seated*, c. 1875, black chalk and pastel. Mr. David Daniels, New York.

drawings is thought to have been Louis Mérante, a famous dancer and dance instructor at the Opera, who appears as the teacher in the *Dance Lesson* (see fig. 1.5). The first of these drawings is, like the study of the leaning dancer, executed in pencil on beige-pink paper; it is a meticulously rendered study of the back of a dance master who stands with his feet apart and slightly splayed. The outlines of this figure correspond with the contour of the dance master visible in the x-radiograph. The second drawing is more freely executed than the pencil study. Incorporating washes in watercolor, ink, and *essence*, it is probably a key to the color of the original dance master's costume. This figure, like that of the leaning dancer, was fully developed in the original state of the painting; the dance master Jules Perrot, whose grandfatherly features are easily identified even in his profile position, has been superimposed over the other, anonymous man, who turned his back to the viewer. Degas has shifted our attention from the leaning dancer in the foreground, whose forward-thrusting pose was anchored in place by the backward-facing dance master, to the new figure of dance master Perrot. To reinforce this shift, he has set up a new tension—both pictorial and psychological—between the standing dancer holding a fan, who now becomes a stand-in for the viewer, and Perrot. Whereas the leaning dancer turned away from the action in the background of the picture, the standing dancer who replaced her looks straight into the composition, directing the viewer's attention toward Perrot.

The circumstances of this radical alteration in the composition are still not clear. It is not known exactly how or when Degas met Perrot, but there are several portraits of the dance master by him, indicating that their acquaintance was more than that of artist and model. Jules Perrot had been, in the age of the romantic ballet, one of the greatest dancers at the Paris Opera. He spent many years in Russia as a dancer and choreographer, and returned to France definitively in 1861. A carte-de-viste photograph made before his return shows him in his characteristic work costume, his carved staff in hand (fig. 2.6). Degas' sensitive drawing of Perrot seated, his bandy legs outspread and his hand resting on a cane (David Daniels collection, fig. 2.7), depicts the old dancer in repose, and though his legs might be infirm, his gaze indicates alertness and vigor. Perrot was probably not even teaching in the mid-1870s; in a brief manuscript memoir of his career, not dated, he refers to the final engagement of his working life as occurring in 1864.[13] His name does not appear on rolls of the Opera's staff in the 1870s, but at the end of that decade he was mentioned as a pensioner of the Opera's employees' charity.[14]

A large and very beautiful portrait drawing of Perrot, directly related to the *Dance Class*, is signed by Degas and dated 1875 (cat. no. 13). Such an inscription on a drawing by Degas is not conclusive

50

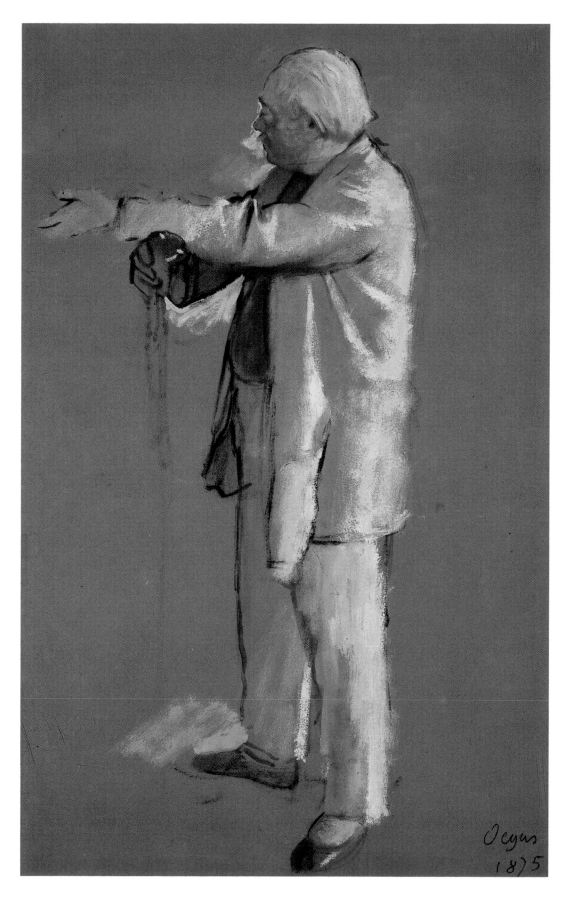

Cat. no. 13.
The Dancer Jules Perrot
(*Le maître de ballet*), 1875,
peinture à l'essence on tan
paper. Henry P. McIlhenny,
Philadelphia.

51

evidence of its date, for Degas is known to have inadvertently mis-dated drawings on occasion.[15] Nonetheless it seems safe to assume, from other paintings and drawings and from the appearance of Perrot's name in a notebook Degas used in the first half of the decade, that the artist met Perrot around the time he was completing the first version of the *Dance Class*—that is, toward the end of 1874.[16] The character of Perrot, the acclaimed dancer and choreographer, partner of the ballerina Marie Taglioni, indeed himself one of the great legends of the nineteenth-century ballet, must have been particularly striking to Degas—so much so that he decided to reshape an existing canvas in homage to the great man.

Thus the picture had as its original subject a dancer in the midst of a class, taking a brief moment to adjust the strap of her slipper while supporting herself on a piano. As in the earlier painting, *Dancers Resting*, she leaned forward toward the viewer, her neck and shoulders bare, her gaze turned away. The rest of the action of the picture (the dancer under examination, her teacher, the other dancers at rest, the watch-ful mothers at the edge of the room) explained her circumstance: that of the young dancer, rigorously disciplined, who must repeat and repeat an exercise in order to perfect it, and who must snatch moments of repose whenever she can. This is the nature of the dancer's life, and of her work: "[Her] work, it's the lesson, the class; the rehearsals, in the foyer or on the stage, of steps, of groups, and of the ensemble. It all begins at nine o'clock in the morning and is over at four in the afternoon. . . . And do not imagine that [the hard work of the dancing lesson] will be finished after a short time. It must go on forever and renew itself without a break. Only under this condition will the dancer keep her suppleness and lightness. A week of rest will cost her two months of work—double-time and with no loafing."[17] And "a dancer in class is not at all seductive or poetic. She has a complexion that is marbled, blue-violet, or blotched, depending on her constitution; her eyes are without sparkle or attention, her lips without a smile. She is breathless, worn out, fatigued; . . . sweat dampens her bodice and stands out in droplets on her forehead and on her arms."[18]

Before the introduction of Perrot, then, the protagonist of the picture was the dancer; when Degas inserted the figure of Jules Perrot, he charged the painting with an element of portraiture not unlike that found in the *Orchestra of the Opera* (see cat. no. 1). *The Dance Class* became a genre portrait, and, with this transformation, the leaning dancer disturbed the balance of the new composition, both by distracting the viewer's attention from Perrot and by almost falling out of the picture space. It may be that Degas regretted this change and was therefore prompted to reassert the importance of a forward-facing dancer in a reprise of the painting now in a private

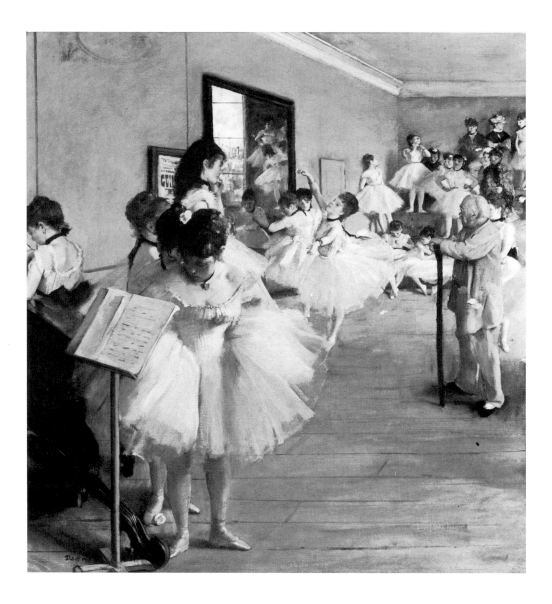

Fig. 2.8. *Dance Class*, c. 1876, oil on canvas. Private collection, New York.

collection in New York (fig. 2.8).[19] Although Degas may have been at work on the two paintings simultaneously, the New York canvas is almost certainly a later variant of the Paris version of the painting because it exhibits almost no pentimenti, whereas in the Paris version many of the figures have been moved or overpainted. The difference in final effect between the two paintings is marked: where the dramatic spatial recession of the Paris picture is held in check by the planar organization of the composition and the firmly planted solidity of the figures, the New York version is disturbingly unbalanced. The tunnellike upper right-hand quadrant of the painting seems to pull most of the figures into it, the ceiling is strangely close to the heads of the dancers and their guardians, and the dancer in an arabesque at the center of the canvas appears to be caught in a futile struggle to escape.

53

Cat. no. 14. *A Ballet Dancer in Position Facing Three-Quarters Front (Danseuse vue de face)*, c. 1872, graphite and crayon heightened with white chalk on pink wove paper. The Fogg Art Museum, Harvard University, Cambridge, Bequest of Meta and Paul J. Sachs.

The drawings that we can associate with the *Dance Class* are disparate in size, in medium, and in degree of finish; some appear to have been working drawings, surrounded by notes and inscriptions and squared for transfer to the canvas, while others stand on their own, perhaps conceived as separate works in themselves. Not all of the drawings that relate to the *Dance Class* were prepared specifically as studies for this particular painting. The figure of the dancer under examination, for example, is painted from the drawing *A Dancer in Position, Facing Three-Quarters Front* now in the Fogg Art Museum

54

Fig. 2.9. *Dancer Adjusting Her Costume*, c. 1873, graphite heightened with white on pink paper. The Detroit Institute of Arts, Bequest of John S. Newberry.

(cat. no. 14). This drawing, like the study of the leaning dancer in the Metropolitan Museum of Art (see fig. 2.4), is executed in graphite pencil heightened with white chalk on pink paper (in this case a salmon rather than rose-pink) and is squared for transfer with a friable crayon or charcoal. In both works the handling of line is precise and sure, contrasting the firm contours and exquisite shading of the dancer's bust and torso with the nervous calligraphy that describes the hem of her tutu. Beside these similarities of materials and draftsmanship, such details of costume as the deeply décolleté bodice, the ruffled camisole beneath it, the paired bracelets and wide ribbon at the neck, as well as the curling lock of hair that falls on her forehead, suggest that the same model may have been used for both drawings. The dancer, depicted in fourth position, also appears in the three versions of the *Rehearsal of a Ballet on Stage* (see fig. 1.9), which have been shown by Ronald Pickvance to date from as early as 1873.[20] Jean Sutherland Boggs has suggested that the Fogg sheet was redrawn, in preparation for the *Dance Class*, from another, earlier study, but it is much more likely that Degas simply returned to a drawing at hand when assembling the figures in the middle ground of the 1874 painting.[21]

It should also be noted that the dancer adjusting her costume who appears immediately to the right of this figure in the *Dance Class* also appears in the Louvre version of the *Rehearsal of a Ballet on Stage*, and indeed can be recognized in a drawing in the collection of the Detroit Institute of Arts (fig. 2.9).[22] Again, because of coincidences of facture and costume, it can be established that she is the same model depicted in the Metropolitan and Fogg sheets. In fact, all three of these drawings must have been made at the same sitting, sometime before 1873, when Degas began working on the *Rehearsal of a Ballet on Stage*. In putting together the *Dance Class*, the artist turned to drawings made a year or two earlier rather than making "fresh" studies of every figure to be inserted in the composition.

In some instances, however, Degas seems to have made careful preparatory drawings for specific figures in the painting. The beautiful study *Dancer in Profile Facing Right* (cat. no. 15) was almost certainly made to perfect the pose and features of the scratching dancer found in *Dancers Resting* (see fig. 2.3). In this drawing Degas exhibits not the crisp linearity he inherited from Ingres, but more sensuous, almost *sfumato* tonalities that signal his growing interest in rich effects of chalk and pastel. On a rosy beige paper, the charcoal and black pastel which subtly define the shadows on her back and her hair are like soft powdered pewter and coal. The figure of the dancer appears to stretch to fill the page: Degas used the top of her head and her jutting chin as the matrix for his squaring, which extends downward and to the left across the sheet. The exact purpose of this squaring is not

55

clear, for it seems unlikely that Degas would have needed such a device to reduce the scale of this figure from the drawing to the canvas; it may have served as a grid upon which to establish the figure's proportions, used during the execution of the drawing itself.

Drawings were also made of the dance master Jules Perrot, among them the *essence* portrait in the McIlhenny collection (see cat. no. 13). In the Fitzwilliam Museum, there is a chalk drawing of the dance master, clearly working with the problem of placing the figure in the context of the *Dance Class* (cat. no. 16). The outline of the dancer

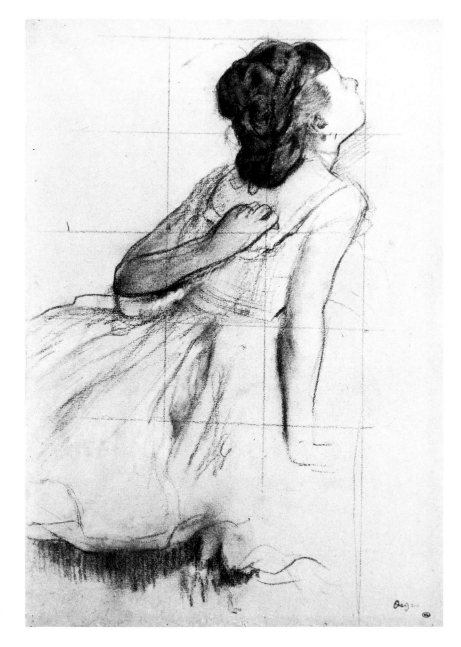

Cat. no. 15. *Dancer in Profile Facing Right* (*Danseuse vue de profil vers la droite*), c. 1874, charcoal and black chalk heightened with white chalk on beige-pink laid paper. Cabinet des Dessins, Musée du Louvre, Paris.

Cat. no. 16. *The Dancer Jules Perrot* (*Le danseur Perrot, debout*), c. 1875, charcoal and black chalk heightened with white chalk on pinkish laid paper. The Syndics of the Fitzwilliam Museum, Cambridge, England.

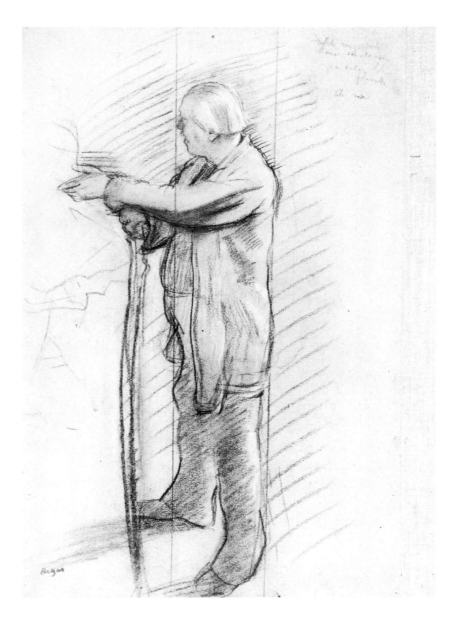

under examination, derived from the Fogg sheet, can be made out to the left of Perrot in the Fitzwilliam drawing, though their relative positions are different in the final version. The Fitzwilliam drawing was probably made from life; Degas' scribbled notes on the colors of the figure lend weight to this assumption. However, the McIlhenny drawing is almost certainly a studio perfection of the Fitzwilliam idea, infused with greater character, literally with more color and more life, even though it was made from the artist's imagination, without a live model. But though the later drawing shaped the *Dance*

57

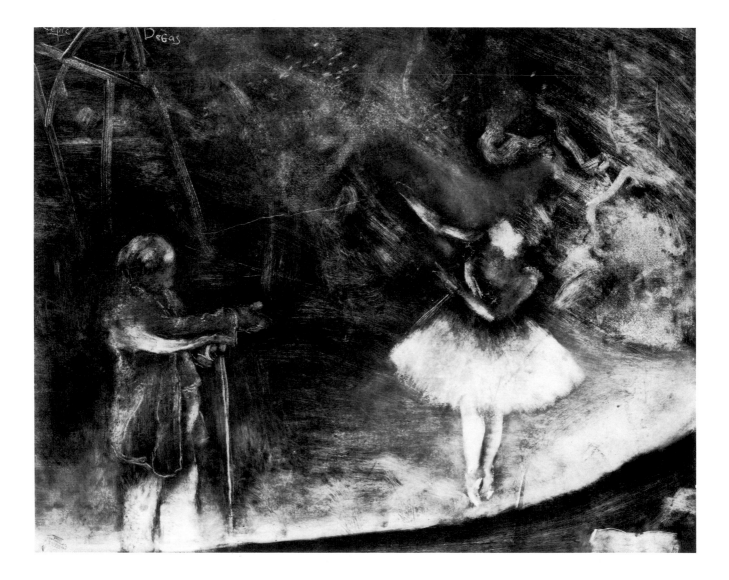

Cat. no. 17. *The Ballet Master* (*Le maître de ballet*), c. 1874, monotype heightened and corrected with white chalk or wash. National Gallery of Art, Washington, Rosenwald Collection.

Class, and might in that sense be called a study for the painting, it nonetheless has a wholeness and self-assuredness that make it an independent portrait of the dance master at work, in which habitual gesture and carriage, heightened, perhaps even caricatured by the artist, convey the character of the subject.

Degas' first monotype print, *The Ballet Master* (cat. no. 17), shows the dance master Jules Perrot on the stage, directing a rehearsal of a ballet. The pose derived from the two drawings of Perrot, but because Degas drew the figure onto the printing plate exactly as it appeared in the drawings, facing to the left, the image was reversed when the plate was printed. A second impression of this print was completely overpainted in gouache and pastel. In this work, *The Ballet Rehearsal* (Nelson-Atkins Museum, fig. 2.10), new figures were added

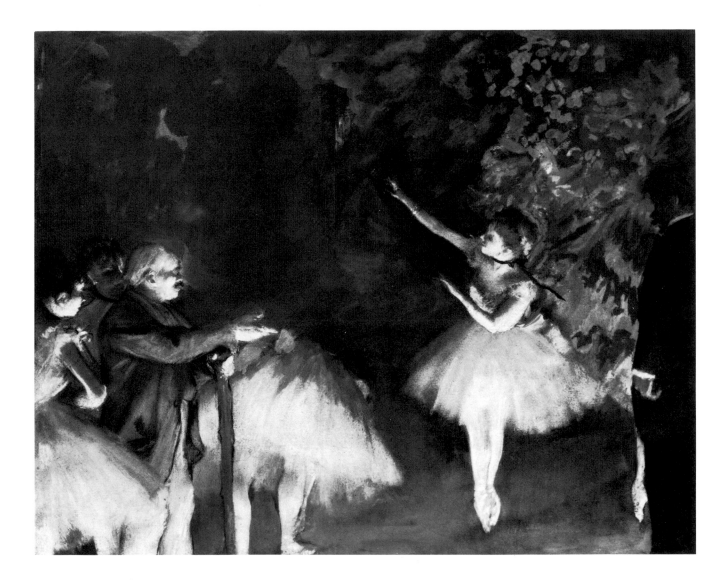

Fig. 2.10. *The Ballet Rehearsal*, c. 1875, gouache and pastel over monotype. The Nelson-Atkins Museum of Art, Kansas City, Missouri (Acquired through the Kenneth A. and Helen F. Spencer Foundation Acquisition Fund).

to the compsosition: a man facing into the picture at the right, and dancers bending down behind Perrot at left. Degas used the McIlhenny drawing of Perrot as the basis for the retouching of the monotype; and since the *Ballet Rehearsal* was bought by the American collector Louisine Havemeyer in 1875, it is certain that the *essence* drawing of Perrot must have been made by that time. 23

By looking more closely at the development of the *Dance Class*, one necessarily forms a new idea of the painting's meaning, because what the painting was at one stage informs the understanding of its final stage. Moreover, a knowledge of the physical processes underlying the finished painting should affect the interpretation of the nature of its narrative. The inclusion of an identifiable figure—Jules Perrot— puts the painting in the context of contemporary history. Since it is

59

known that Perrot taught ballet classes, it has been assumed that the painting might portray a real event.[24] But the evidence of the works reconfirms that it was constructed by the artist from his imagination, on the foundation of observations—drawings—made either in a ballet class or from models in his studio.

A further proof of the artificiality of Degas' compositions lies in the continuing reappearance of a single figure or a group of figures. For instance, Degas returned to the pose of the leaning dancer (from the

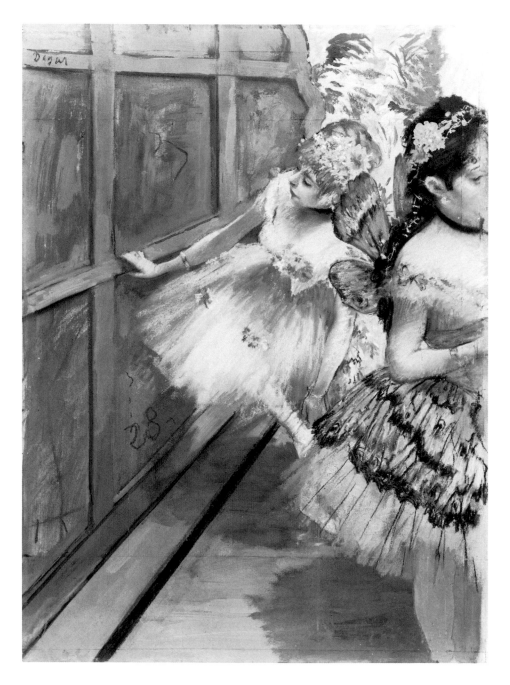

Fig. 2.11. *Dancers in the Wings*, c. 1878, gouache and pastel on joined paper. The Norton Simon Art Foundation, Pasadena.

60

Metropolitan drawing, see fig. 2.4) in at least two other works of a slightly later date. One of these is the monotype, almost completely covered with pastel, entitled *Ballet Dancers,* in the collection of the National Gallery of Art (see cat. no. 9). Traces of the monotype are visible in the angle of the tree at the top and on the rocklike stage flat at front that partially obscures the figure in question. The other is a pastel-painting in the collection of the Norton Simon Foundation, *Dancers in the Wings* (fig. 2.11), in which the figure again appears in the center of the composition, grasping the support of another stage flat. [25]

Two technical observations give an even clearer sense of the variety of ways in which Degas might have approached reusing a figure. In the National Gallery monotype, *Ballet Dancer,* the figure, like all the others in the composition, was almost certainly added to the sheet after the printing of the monotype image. So Degas used a few figures from a stockpile of images in his possession to fill what might have been a less-peopled pictorial space.

A different technical problem is presented in the Norton Simon pastel. In this case the work almost certainly began as a second drawing of the leaning figure, perhaps a copy of the Metropolitan sheet, which was subsequently enlarged to accommodate an auxiliary figure and a backstage setting. [26] The edges of the original sheet are clearly visible, as are the subsequent additions on all sides. The most remarkable of these, perhaps, is the strip of paper, less than an inch wide, added at the right-hand side of the image to admit the inclusion of a dancer's eye. The practice of turning a drawing into a more elaborate work, which was to become the rule later in Degas' career, was still rare around 1878, the approximate date of the Norton Simon pastel. In the first example, then, Degas "fills in" a compositional idea with a stock pose; in the second, he elaborates the pose into a finished work.

Degas' method of working on these compositions can best be understood if we imagine him compiling a repertoire of figures and poses, a repertoire that not only helped him formulate ideas for pictures, but also served as a stockpile of images from which to draw — a corpus of drawings such as Watteau had built up in much the same ways in the eighteenth century. In a reversal of the academic practice he had used in *Semiramis Constructing a City* (see fig. 1.1) fifteen years before, Degas amassed many of the details *before* envisioning what to do with them. Of course, he may have made new studies as a painting progressed—for example, the Perrot study at the Fitzwilliam or the *Dancer in Profile;* but Degas' habitual reuse of favorite drawings from his repertoire invalidates the notion of a specific, preconceived, and finite role for each drawing he made. It was a challenge for the artist to work with a limited range of poses, to vary their uses, and

61

to achieve markedly different ends with similar means.

In order to appreciate fully the artist's working methods, we should envision him in the studio, surrounded by hundreds of drawings. Unable to relinquish his control over his work, he hoarded not only drawings, but paintings and pastels, so that several thousand works were found in his studio at the time of his death.[27] In the studio he imagined from his repertoire all the scenes of the ballet, the racecourse, and city life, which some have accepted as direct transcriptions of reality, as if the mind only relayed the message of the eyes to the hand. If the visible evidence of our eyes were not enough to convince us of the falseness of this idea, we could turn to Degas' own words:

It's all very well to copy what one sees. But it's much better to draw what one can see only in memory. It's a transformation during which the imagination collaborates with the memory. You only reproduce that which has struck you, that is, the necessary. There, your recollections and your fantasies are liberated from the tyranny which nature imposes. And that is why paintings made in this way by a man with a cultivated memory, who knows his masters, and has mastered his métier, are almost always remarkable works—look at Delacroix.[28]

Degas' works are almost always the result of such collaborations between the imagination and the memory. And yet they are constructed on the basis of nature, keenly observed and recorded in drawings. Drawing is the foundation of Degas' art, for it was the act of drawing that shaped his vision. "Drawing is," Degas said, ". . . a way of seeing form."[29]

NOTES

1. The most important article on this subject is Pickvance 1963.

2. Lemoisne nos. 398 and 430.

3. See Keith Roberts, "The Date of Degas's 'The Rehearsal' in Glasgow," *Burlington Magazine* 105 (June 1963), 280–281.

4. Edmond and Jules de Goncourt, *Journal: Mémoires de la vie littéraire* (Paris, 1956), 2:968. (translation GTMS)

5. See Muehlig 1979, 6–16.

6. Browse 1949, 53.

7. See Lemoisne's entry for the painting, no. 341.

8. Pickvance 1963, 257.

9. Pickvance 1963, 265.

10. Lemoisne no. 343.

11. See Boggs 1967, 114–116, no. 71.

12. Andrée Jouan, "A propos de quelques radiographies effectuées en 1964," *Bulletin du Laboratoire du Musée du Louvre* (1965), 70–71.

13. Jules Perrot, "Notice autographe" (n.d., after 1864), Bibliothèque et Musée de l'Opéra, Paris.

14. Association Philanthropique des Artistes de l'Opéra, *Exercises* (Paris, 1879–1880), 11.

15. Theodore Reff, "New Light on Degas' Copies," *Burlington Magazine* 106 (June 1964), 250–259.

16. Reff 1976b, 1:115 (Nb. 22:210). Reff dates the notebook 1867–1874.

17. Viel' Abonné 1887, 24–25. (translation GTMS)

18. Albéric Second, *Les petits mystères de l'Opéra* (Paris, 1844), 181. (translation GTMS)

19. Lemoisne no. 397.

20. Pickvance 1963, 260.

21. Boggs 1967, no. 70.

22. *The John S. Newberry Collection* [exh. cat., The Detroit Institute of Arts] (Detroit, 1965), no. 28.

23. Pickvance 1963, 264, n. 71.

24. See, for instance, Browse 1949, 54.

25. Lemoisne no. 585.

26. Multiple copies of drawings by Degas are not rare: there exists another copy of the Detroit sheet (fig. 2.9; for the copy, see Boggs 1967, no. 74); yet another copy of this drawing may be the base of *Dancer in Her Dressing Room* (Oskar Reinhart Foundation, fig. 1.8).

27. See the catalogues of the four sales of the contents of his studio, cited hereafter as *Vente.*

28. Georges Jeanniot, "Souvenirs sur Degas," *La revue universelle* (Paris, October 1933), 158. (translation GTMS)

29. Paul Valéry, "Degas, Dance, Drawing," in *The Collected Works, Volume XII: Degas Manet Morisot* (New York, 1960), 82.

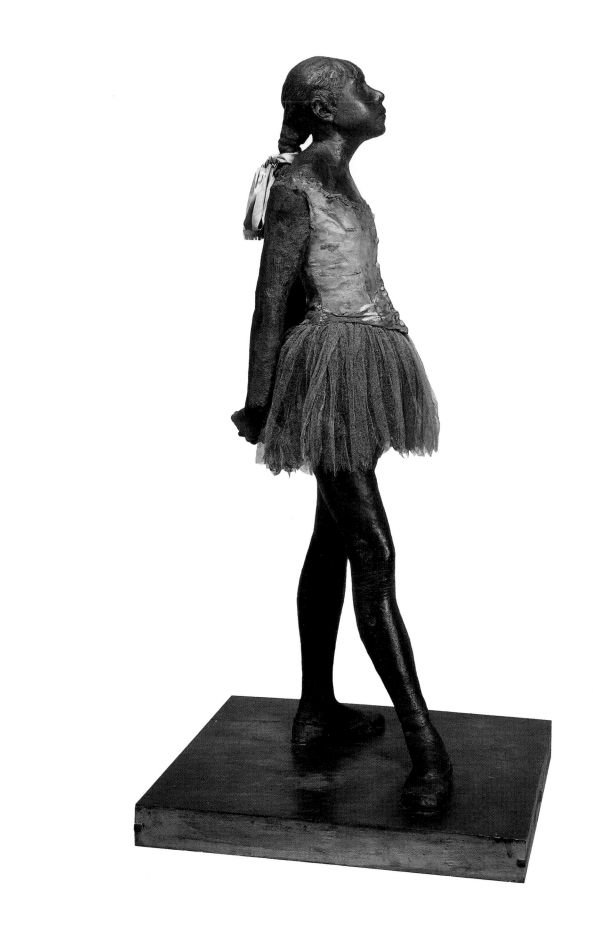

A Way of Seeing Form

*Study from every perspective a figure
or an object, no matter what.* c. 1878

THE MISTAKEN NOTION that Degas' drawings are always studies for specific finished works has led to a profound misunderstanding of the origins and development of his most famous sculpture, *The Little Fourteen-Year-Old Dancer* (cat. no. 18). The drawings related to this sculpture have always been seen as preparatory studies made expressly as research tools to aid Degas in modeling the statuette. In fact, their history and function is much more complex. Close study of the sculpture and the drawings in the context of Degas' working method indicates that the drawings not only served as models in the creation of the sculpture, but were also the genesis of the sculptural idea. They are, moreover, the most exemplary realization in his oeuvre of Degas' naturalist aesthetic.

The *Little Dancer* is the largest and best-known of any of Degas' sculpture, and the only piece that he exhibited during his lifetime. It is thought that Degas began making sculpture in the 1860s, continuing to model in wax and clay until very late in his life. His works, however, were reserved for his own study, with the exception of the *Little Dancer.* In all, he made an estimated 150 pieces, approximately seventy of which were reproduced in bronze after his death. The original works were modeled in sculptor's wax or artificial modeling clay, over armatures made of wire, wood, or of any material Degas might have had on hand in the studio while he was working. Although a bronze replica of the *Little Dancer* is being displayed in the exhibition, it is the original wax, modeled by Degas' hand, that will be discussed here.

Perhaps the sculpture's remarkable realism, startling even to the modern-day viewer, is in part responsible for its enforced isolation from the rest of Degas' work in sculpture, and even more from his two-dimensional work. The *Little Dancer* was executed by Degas in sculptor's modeling wax over an armature, probably made of wire.[1] The figure stands approximately 39 inches high (about two-thirds life size) and is dressed in clothing made of real fabrics. The bodice of

Left: cat. no. 18. *The Little Fourteen-Year-Old Dancer* (*La petite danseuse de quatorze ans*), c. 1881,
From the Collection of Mr. and Mrs. Paul Mellon, Upperville, Virginia.

the dancer's costume is made of a cream-colored grosgrain silk faille, with tiny buttons, also covered in silk, down the front. The dancer's skirt is made of tulle and gauze in several layers of varying weave and density. A wig, probably of horsehair, sits on the dancer's head; Degas covered most of the wig with wax, incorporating it within the facture of the modeling of the young dancer's face. Bits of hair still protrude, however, at the end of the pigtail, which is tied with a real satin ribbon. Like the dancer's hair and bodice, the fabric slippers she wears have been covered with a thin layer of wax to further integrate them with the sculpture.

The figure is strangely moving. Although time and dust have darkened the wax, always deep-toned, to the color of mahogany, one can still sense the fleshlike quality and texture that must have characterized the wax's surface when the statuette was new. Above all, it is the translucency of the wax, so unlike the opaque, lacquer-colored waxes Degas used in his other statues, that one remembers: light penetrates the outermost surface of the form, and is reflected back from within. Even in its darkened state, the figure's translucency gives it an extraordinary appearance of liveliness and vitality that is almost completely lost in the bronze replicas now familiar to the museum-going public.[2]

Surely this resilient quality of light and liveliness was part of the reason the sculpture was seen as so radical—too true to life—when it was exhibited at the sixth impressionist exhibition in April 1881. Critics were almost universally struck by the figure's ugliness, by the uncompromising objectivity with which Degas had rendered his image of a little student (a "rat," as they were called) of the Paris Opera. Some of the critics were affronted: "Wishing to present us with a statuette of a dancer, he has chosen among the most odiously ugly; he makes of it a *type* of horror and bestiality. Oh certainly, at the very bottom of the barrel of the dance school, there are some poor girls who look like this young monster . . . but what good are they in terms of statuary? Put them in a museum of zoology, of anthropology, of physiology, all right; but in an art museum, really!"[3] Others reacted with greater tolerance and understanding to the work's "strangely attractive, troubling, singular naturalism . . . which recalls, with a modern note both very Parisian and very piquant, the realism of Spanish polychrome sculpture."[4] The most attentive of all the critics was the novelist Joris-Karl Huysmans, who wrote about the sculpture at length:

[Degas exhibits] a statue of wax entitled *The Little Fourteen-Year-Old Dancer*, before which an astonished public flies, as if embarrassed. The terrible realism of this statuette makes the public distinctly uneasy: all its ideas about sculpture, about cold, lifeless whiteness, about those memorable formulas copied again and again for centuries, are demolished. The fact is

66

that on the first blow, M. Degas has knocked over the traditions of sculpture, just as he has for a long time been shaking up the conventions of painting. . . . At once refined and barbaric with her busy costume and her colored flesh, palpitating, lined with the work of its muscles, this statuette is the only truly modern attempt I know in sculpture.[5]

Huysmans predicted that the work would "not obtain even the slightest success [with the public of Degas' time]; no more than [Degas'] . . . painting, whose exquisiteness is unintelligible to the public, his sculpture—so original, so audacious—will not even be noticed."[6] But since Degas' death in 1917, and the posthumous casting in bronze of some seventy-three of his sculptural works, the *Little Dancer* has eclipsed all the other sculptures in celebrity. The sculpture's fame, too, has caused us to see the *Little Dancer* as an idiosyncratic work, somehow divorced from the rest of Degas' sculpture.

John Rewald, in his catalogue raisonné of Degas' sculpture, sets the *Little Dancer* apart from the rest of Degas' work: "Since he probably considered his attempt as an experience that had to be approached and not as a vein to be worked, Degas was now to devote himself to other problems . . . [The *Little Dancer*] was not only to remain alone among Degas' sculptures, but was also to find no imitators. In the history of modern sculpture, it occupies a place by itself . . ."[7]

More recently, Theodore Reff has placed the work in the context of two other sculptures made by Degas just after the *Little Dancer*, the *Apple Pickers* and the *Little Schoolgirl*, pointing out parallels of subject matter and method of development among the three works.[8] Furthermore, Charles Millard has demonstrated that the *Little Dancer* is central to the development of Degas' sculptural colorism, and is therefore intimately related to his *Tub* and *Woman Washing Her Left Leg*, both of which combine foreign elements with the sculptor's wax that forms the figure. Millard sees these as part of a classical tradition of polychromy that underwent a revival of scholarship and practice in the later nineteenth century.[9] Nonetheless, these writers have not addressed the degree to which the *Little Dancer* was an integral product of Degas' artistic concerns, both iconographic and formal, at the end of the 1870s.

The *Little Dancer* is the archetype of the young ballet student, poised between being one of the little girls, the "rats" of the Opera, and a young woman, a member of one of the *quadrilles*. These young dancers were of particular interest to Degas between 1875 and 1885. He especially admired and recorded the dedication with which the young students approached the mastery of their difficult craft and their awkward first efforts toward the perfection of movement. Around 1880 he made a series of drawings of one very young dancer, not more than ten years old, in which he stressed the inelegant but patient gestures of the student at the bar, practicing a series of exercises, each

67

Cat. no. 19. *Four Studies of a Dancer* (*Quatre études d'une danseuse*), 1878–1879, charcoal corrected with white chalk on rose-beige wove paper. Cabinet des Dessins, Musée du Louvre, Paris.

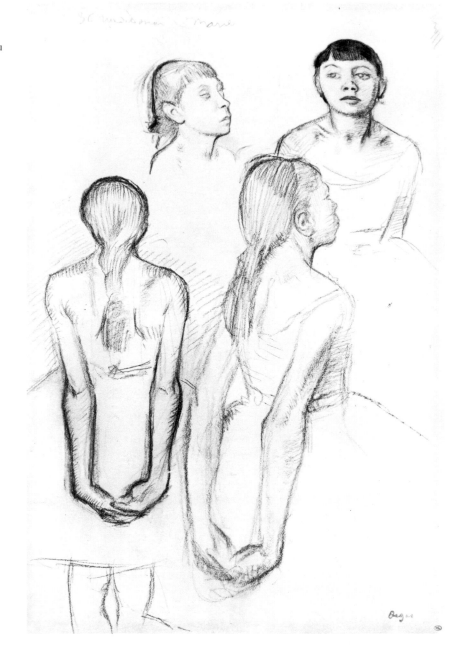

identified by the artist in marginal notes.[10] The famous *Mante Family* portrait of c. 1884 shows two of the girls, Blanche and Suzanne Mante, one in street costume and the other being dressed by her mother for a performance or rehearsal.[11] Another group of drawings, dating from the end of 1878, was made from a fifteen-year-old dancer named Melina Darde. Lillian Browse identifies her as the model for several studies that Degas was to place in paintings in the last years of the 1870s. In one sheet, inscribed with her name, she is shown seated on

68

the floor, crablike, her hands grasping her ankles, her head bent down exposing her scrawny shoulders and the back of her neck.[12]

It is thought that Degas made the first of his many drawings of the dancer Marie van Goethem, the model for the *Little Fourteen-Year-Old Dancer,* in 1878.[13] Marie, of Belgian origin, was a ballet student at the Opera, as were her two sisters Antoinette and Louise-Josephine. That she was the model from whom Degas' sculpture derived is established by the inscription on a sheet of studies of her face and torso in the Cabinet des Dessins of the Louvre: *36 rue de Douai Marie* (cat. no. 19). Perhaps noted at the first session with this model, so that Degas might remember her name to draw her again, the address is also found, with the girl's patronymic, in an address book that Theodore Reff convincingly dates to 1880–1884.[14] Marie, in later years, achieved a certain notoriety as an artist's model. Writing in 1887, the pseudonymous Viel' Abonné refers to Marie as "a model— for the painters . . . she willingly frequents the Brasserie des Martyrs, the Café de la Nouvelle-Athènes, and the popular café *Le Rat Mort.*"[15] He quotes a journalist, Panserose, who had written, "Her mother . . . but no, I don't want to talk about it . . . I'd say things that would make you blush or cry!"[16] Madame van Goethem, according to Millard, was a laundress, her husband a tailor. Degas chose as a model, then, a girl who was not only a recognizable physical type, but who rose from the background commonly associated with dancers of the Paris Opera: "Most dancers," wrote the Viel' Abonné, "are daughters of *petits gens:* low-level employees of workshops, department stores, or offices, long-suffering insignificant artists, concierges whose wives have done the housework for a large number of tenants—and lots more for them besides."[17]

The suggestion that dancers originated from, and were destined for, a life of doubtful virtue is frequently found in the literature of the late nineteenth century. And at least one critic of the *Little Dancer* attributed, if half-satirically, a moralistic motive to the sculpture's creator: "Why is she so ugly? Why is her forehead, half-hidden by her bangs, already marked, like her lips, by such a profoundly vicious character? M. Degas is doubtless a moralist: perhaps he knows something about the future of dancers that we do not. He has picked from the hothouse of the theater a flower, precociously depraved, and he shows it to us, withered before its time."[18]

In fact, a gentler tone, far from moralizing, pervades Degas' sonnet on a young dancer, which has so often been associated with the *Little Fourteen-Year-Old Dancer.*

> Danse, gamin ailé, sur les gazons de bois.
> Ton bras maigre, placé sur la ligne suivie
> Equilibre, balance et ton vol et ton poids.
> Je te veux, moi qui sais, une célèbre vie.

69

Nymphes, Grâces, venez des cimes d'autrefois;
Taglioni, venez, princesse d'Arcadie,
Ennoblir et former, souriant de mon choix
Ce petit être neuf, à la mine hardie.

Si Montmartre a donné l'esprit et les aïeux
Roxelane le nez et la Chine les yeux,
A ton tour, Ariel, donne à cette recrue

Tes pas légers de jour, tes pas légers de nuit . . .
Mais, pour mon goût connu! qu'elle sente son fruit
Et garde aux palais d'or la race de sa rue.

In the sonnet's first four lines, the poet-painter addresses the dancer, wishing her, from his position of superior wisdom, a famous life. He then invokes the nymphs and graces of the past, the spirit of the famous dancer Marie Taglioni, "Princess of Arcady," calling on them to look favorably upon this little new, bold-faced one. Yet in the concluding lines, he seasons his pleas for grace, balance, and noble beauty with a piquant caveat: "But for my well-known taste—keep her firm on her feet/To hold fast in the palace the race of her street."[19]

Degas' sonnet alludes to the affection he evidently felt for the young dancer, an affection that is clear in his portrayal of the student-dancers throughout his oeuvre; but the sonnet also illuminates the essential dichotomy of ideal beauty and naturalist objectivity that the statuette embodies. In the closing lines of the sonnet, Degas suggests that above Ariel's light steps of day and light steps of night he prizes, as an artist whose tastes are well-known, the frank expression of the girl's race, her roots, and social status. Like Degas' other representations of the awkward, inexperienced student, the *Little Dancer* is—as some hostile critics accused it of being—a specimen, the result of a scientific inquiry. The drawings associated with the wax of the *Little Fourteen-Year-Old Dancer*, seen in relation to the sculpture, as well as in the broader context of Degas' other drawings, his working method, and his theories of draftsmanship, elucidate the quasi-scientific qualities of this work, and Degas' naturalist aesthetic.

Degas made a remarkable suite of drawings of Marie van Goethem in costume, standing with her feet in the fourth position, the right extended before her and turned sharply outward, the left held back, supporting her weight, and less exaggeratedly out-turned. In some of the drawings (as in a sheet from the Metropolitan Museum of Art, fig. 3.1), she adjusts the strap of her bodice with her right hand, her left arm crossed loosely in front. In others, such as the sheet of three studies from the Art Institute of Chicago (cat. no. 20), a similar drawing in a private collection (fig. 3.2), and the two back views on a sheet from the collection of Lord Rayne (cat. no. 21), she clasps

Fig. 3.1. *Two Dancers*, c. 1880, charcoal and pastel on green paper. The Metropolitan Museum of Art, New York, Bequest of Mrs. H. O. Havemeyer, 1929. The H. O. Havemeyer Collection.

70

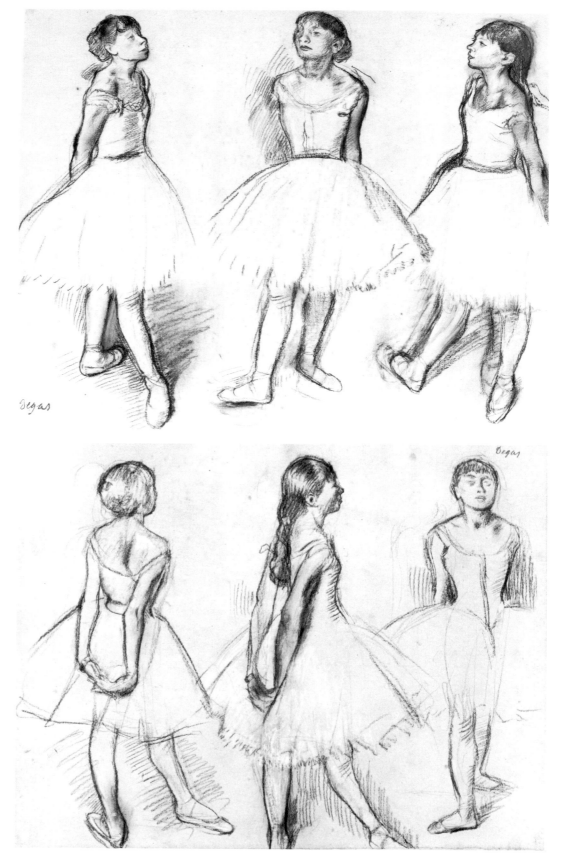

Cat. no. 20. *Three Studies of a Dancer (Trois danseuses)*, 1878–1879, black chalk and pastel over graphite heightened with white chalk on buff laid paper. The Art Institute of Chicago, Bequest of Adele R. Levy.

Fig. 3.2. *Three Studies of a Dancer*, c. 1878, black chalk heightened with white on pink paper. Private collection.

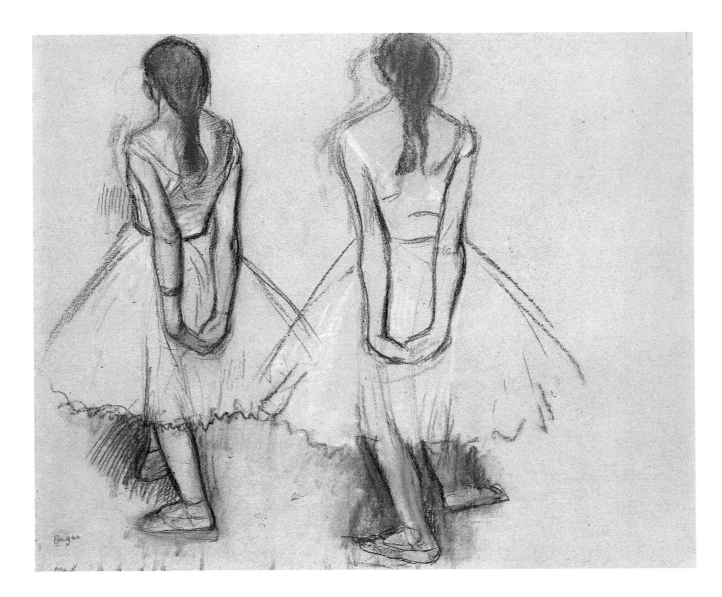

Cat. no. 21. *Two Studies of a Dancer* (*Deux danseuses*), 1878–1879, black and brown chalk and pastel, worked with a brush, on gray laid paper. The Lord Rayne, London.

her hands behind her back as in the wax statue of the *Little Dancer.* There is one sheet, known from the catalogues of the Degas estate sales, showing five studies of a dancer's legs in the fourth position, that seems to have been drawn from Marie van Goethem.[20] There are also studies of Marie van Goethem nude, such as the sheet from Oslo (cat. no. 22) or one from a British private collection (cat. no. 23). Similar nude studies exist, furthermore, in the position represented by the Metropolitan drawing.

In all the drawings there is an extraordinary consistency of medium, support, and size. The drawings are uniformly executed in charcoal and black fabricated chalk or pastel, sometimes heightened with white or colored pastel, on softly tinted papers. The drawings of multiple figures measure between 18½ and 19 inches in height, about 24

72

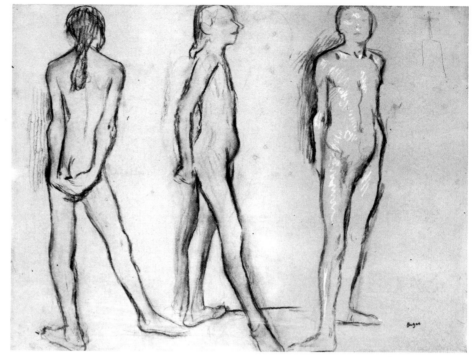

Cat. no. 23. *Three Studies of a Nude Dancer* (*Etudes de femmes nues*), c. 1879, charcoal heightened with white chalk on gray wove paper. Private collection, London.

Below: cat. no. 22. *Study of a Nude Dancer* (*Etude de nue*), 1878–1879, black chalk and charcoal on mauve-pink laid paper, slightly faded. Nasjonalgalleriet, Oslo.

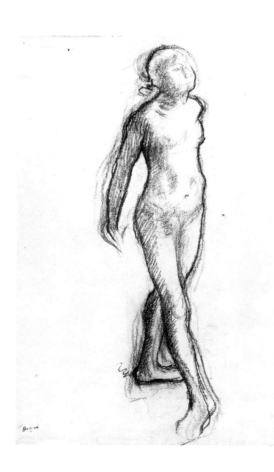

inches in width (the Metropolitan sheet, of the same dimensions, is vertical). The Olso drawing of the single figure, the Louvre sheet of head and torso studies, and the unlocated study of five pairs of legs are half the size of the larger sheets, roughly 19 x 12 inches each. This unformity suggests that the drawings may have been made within a relatively short period of time: there are, for instance, no small studies in pencil, or notebook sketches, of the pose of the wax statuette.

But beyond this shared range of technical and stylistic qualities, there is no firm evidence of the drawings' sequence or of their role in the creation of the statuette. Heretofore, historians have unanimously presumed that the drawings were made with the eventual sculpture in mind. However, writers have differed as to the role of individual drawings in the process, and as to the rightful place of certain drawings in the sculpture's development. Thus, Lillian Browse, referring to the drawing in the Metropolitan (see fig. 3.1), comments that "it would seem as if Degas were contemplating doing the sculpture with this different angle of the head and placing of the arms."[21] Moreover, she characterizes the nude studies in this crossed-arm position as studies for the drawings of the dressed figure. Theodore Reff does not number these other drawings of Marie van Goethem among the studies for the *Little Dancer* at all, citing only six studies of the dancer holding the pose later seen in the sculpture itself.[22] John Rewald reproduces eight drawings of Marie van Goethem, and refers to a ninth, the Louvre sheet.[23] Charles Millard, the most recent

73

author on Degas' sculpture, does not discuss the drawings of this model at any length, referring only to the Louvre sheet as a piece of evidence for the dating of the *Little Dancer*.[24]

In addressing the question of the sequence of the drawings, there is again disagreement among historians. Ronald Pickvance proposes an order of drawings and sculpture that places the drawings from the nude model first, followed by the small, unclothed statuette of the dancer (cat. no. 24).[25] He argues that the drawings of the dancer clothed follow this first sculpture, adopting the pose established in it, and precede the final, dressed, wax figurine. Rewald affirms that the drawings of the figure with uplifted arms predate all the others, acknowledging that Degas might have begun the series of drawings before thinking of making a statuette. The other studies, nude and dressed, follow, according to Rewald, "and are the only known case of Degas' making drawings for one of his modellings."[26] Reff suggests that all the drawings were made before the modeling of the two statuettes began.[27]

It seems almost certain that the drawings of Marie van Goethem, whether nude or clothed, precede the making of the sculpture. Their likeness to other drawings by Degas supports this assumption. But what is the character of the different drawings when seen as a group? In the Louvre sheet of head and torso studies (see cat. no. 19), Marie's head is somewhat flatter, with the simian contours of the mouth and lower jaw more apparent than in either of the two drawings in which her face is clearly shown (see cat. no. 20 and fig. 3.2). In the three drawings of the clothed figure, comprising in all eight full-length studies of the dancer, there is a marked pictorial, even painterly, quality that transcends the simple study of volumes. The Chicago sheet, for instance, has the central figure placed more or less frontally; her skirt is shown in its full outline. On either side, obliquely positioned figures complete a kind of arc in the picture space, denying the separation between the three studies of one dancer on the sheet, and implying a unity of space and time shared among three different dancers. This quality is even stronger in the other sheet of three studies (fig. 3.2), in which the angles of vision are more widely varied; because of this, there is a greater differentiation among the three representations of the one dancer, which further heightens the pictorial effect. Moreover, all three sheets are embellished with beautiful touches of pastel color, raising them above the rank of simple preparatory drawings. These effects of color are particularly vivid in the sheet from Lord Rayne's collection (see cat. no. 21), on which Degas applied strokes of blue-violet pastel to define the shadows on the dancer's arms and richly worked and washed passages of coral-pink pastel on her stockings and slippers.

It seems equally likely that the nude studies of Marie van Goethem

74

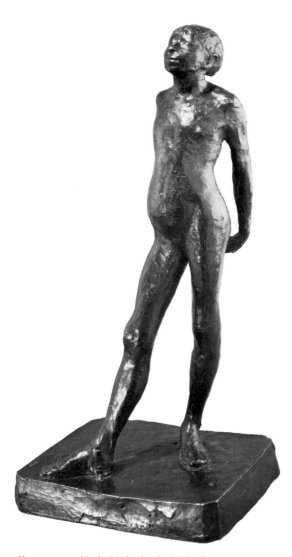

Cat. no. 24. *Nude Study for the Little Fourteen-Year-Old Dancer* (*La petite danseuse de quatorze ans*), c. 1881, bronze cast of wax original. From the Collection of Mr. and Mrs. Paul Mellon, Upperville, Virginia.

were also made before the project for the sculpture had fully taken shape: the fact that a nude study of the dancer with upraised arms exists, probably without the intent of making a model, supports this hypothesis. Notwithstanding, the nude studies are more expressly sculptural, less pictorial, than the studies of the clothed figure, and seem to have been made rather quickly, with less attention to details of physiognomy or expression of character. It may be that their purpose was to establish the configuration of the dancer's limbs and the relationship between volumes, though whether this was in preparation for a sculptural work is uncertain.

This suite of drawings is, in fact, not merely a preparation for the *Little Fourteen-Year-Old Dancer,* nor even principally that. On the contrary, the drawings began with an essentially pictorial end in view: that of rendering on a flat surface a series of multiple points of view of the same model, expressive of three-dimensional form. This goal was expressed by Degas in the description of a project recorded in one of his notebooks in the late 1870s: "do some simple operations, like drawing a profile that would not move, moving oneself, up or down, the same for a whole figure, a piece of furniture, a whole room. Do a suite of movements of arms in dance, or of legs which would not move, turning oneself around—etc. In fact, study from every perspective a figure or an object, no matter what. One can use a mirror to do this—one would not move from one's place. Only the mirror would tilt back and forth, one would turn [it] around."[28] The substance of the exercise is that a stationary, unchanging model would be drawn from many points of view, either by the artist himself moving around the figure, or by means of a mirror, from which the artist would draw the figure's reflection, being moved about behind the figure.

In the Louvre drawing we can see the application of Degas' idea to do a stationary profile; in the unlocated sheet of studies of a pair of legs, there is a full circle around a stationary figure, and in the three horizontal sheets of studies of the clothed dancer, another complete revolution is traced. If we take as a starting point the Art Institute of Chicago's sheet, we see the figure drawn in three positions; she seems to turn before us in a clockwise direction, indicating that the artist moved around her counterclockwise. In the left-hand figure of Lord Rayne's drawing, the right-hand figure of the Chicago sheet has been turned further clockwise, so that the back of the figure is visible, oblique to the picture surface. The right-hand figure on this sheet is turned further, her back squarely parallel to the picture plane. In the remaining drawing of the clothed dancer (see fig. 3.2), this revolution continues, returning to a pose more frontal than that of the first dancer of the Chicago sheet.

In spite of the neatness of this progression, it is unlikely that Degas

75

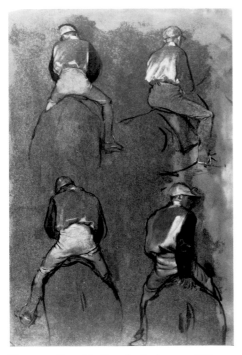

Fig. 3.3. *Four Studies of a Jockey*, c. 1866, peinture à l'essence on oil-glazed paper. The Art Institute of Chicago, Mr. and Mrs. Lewis L. Coburn Memorial Collection.

actually followed so methodical a procedure in completing the drawings. In each sheet the figure at the center of the composition overlaps the other two, suggesting that Degas drew it first on the paper, adding the flanking figures afterward. Moreover, each sheet has its internal logic of *mise-en-page* and of spatial construction. Each exists independently of the other two.

If the studies' origins consist of an idea that is fundamentally pictorial, the transition from drawing into sculpture must be explained. It seems probable that Degas was struck with the possibility of translating the form rendered in two dimensions into a three-dimensional object. The nude maquette was made as an intermediate step, based on the drawings of Marie van Goethem nude. And so the finished version, dressed in real clothing, was modeled after the drawings of Marie in ballet costume. The drawings served Degas as *aides-mémoire* in the process of finishing the statuette, though neither the smaller nude version nor the dressed version replicates exactly the pose or the costume recorded in the original drawings. The sculpture, then, is dependent on the drawings, both in terms of its form and because the drawings predicted the idea of the sculpture itself. And though the drawings prepared Degas to model the sculpture, they did not have that single purpose at their origin.

The drawings are a realization of a project recorded by Degas, probably around 1878, that was essentially draftsmanlike in its ends. But this kind of drawing, in which a single figure is seen from multiple points of view, is not simply the result of a brainstorm, nor is it without precedent either in the practice of other artists or in Degas' oeuvre. Van Dyck's famous portrait of Charles I, in which the monarch is seen in profile, full-face, and three-quarters perspectives, or even Daumier's three-faced caricature of Louis-Philippe, could be cited as precedents for Degas' method.[29] In the generation before Degas' experiments with this procedure, the sculptor François Willème had patented a process by which a series of silhouettes, taken by a camera at regular intervals from a rotating object (usually a human being, of course) and subsequently mounted on sections of wood, could be bound together to reconstitute the three-dimensional form.[30] Degas' project, however, is more likely his own variation on the schools' methods of teaching drawing, though his aims were radically different from those of even the most advanced teachers of his day.

The practice of grouping many studies on one sheet is common in Degas' work before 1880. Sketches of details of works of art or of models are often found together in his early drawings and in his early notebooks.[31] One of his best-known drawings, *Four Studies of a Jockey* (Art Institute of Chicago, fig. 3.3), which has often been compared to Watteau in its *mise-en-page*, was made over a decade before Degas began the drawings of Marie van Goethem. The four sketches on this

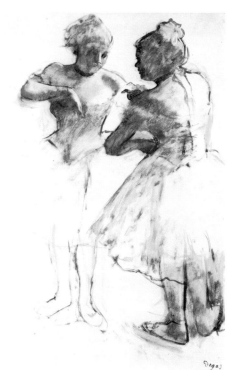

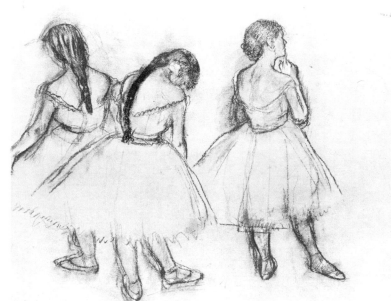

Fig. 3.5. *Three Dancers*, c. 1878–1880, black chalk heightened with white and pastel. Present location unknown; as reproduced in Rivière 1922–1923, pl. 95.

Fig. 3.4. *Two Dancers*, c. 1880, peinture à l'essence on pink glazed paper. The Metropolitan Museum of Art, New York, Bequest of Mrs. H. O. Havemeyer, 1929. The H. O. Havemeyer Collection.

page were probably also made from a single model, his pose changing slightly, altering the play of light over the folds in the back of his racing silks. In preparation for the *Ballet from Robert le Diable* (see cat. no. 2), Degas had made numerous brush drawings in which two or three dancing nuns are disposed on single sheets.[32] Another drawing, slightly earlier than the drawings of Marie, shows two dancers in conversation (The Metropolitan Museum of Art, fig. 3.4): it is as if one dancer had been turned around to face herself, and the drawing may have been made in just this way, from a single model.

In *Three Dancers* (present location unknown, fig. 3.5) the model has been thought to be Marie herself, though the almost-lost profile of the right-hand dancer does not recall the cruder features of the young Belgian ballet student.[33] But the use, in the two left-hand figures, of a rotating pose, varied in the third figure by the erect torso and the upraised arm, is remarkably like aspects of the sheets related to the *Little Dancer.* Moreover, the notation in the upper right-hand corner of the sheet—*vue de dessus* (seen from above)—makes us think yet again of the artist's avowed interest in varying his point of view in a series of "simple operations."

There are in Degas' oeuvre, beside the drawings of Marie van Goethem, other drawings that may be related to the project recorded in his notebook. An example is the sheet of studies of a dancer's head (Cabinet des Dessins, Musée du Louvre, fig. 3.6), seen at three different angles from slightly above the figure. Recalling vividly the

77

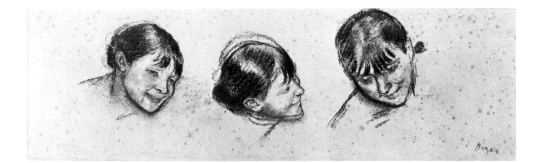

Fig. 3.6. *Three Heads of a Dancer*, c. 1880, pastel. Cabinet des Dessins, Musée du Louvre, Paris.

note to "draw a profile that would not move, moving oneself, up or down," the pastel study served Degas as a model for the heads of dancers in several representations of performing or bowing dancers that date from the 1880s.[34] Another application of this technique is seen in the beautiful study of a café-concert singer (fig. 3.7), again an example of the single figure drawn twice on a sheet. Neither of these drawings, in spite of its suggestion of three-dimensional forms, is related to a work by Degas in sculpture.

Both of these drawings, like the drawings related to the *Little Dancer*, were made as studies of forms that remained still as the artist moved around them to observe the changing relationship of features and volumes. The method of the artist is analytical. In order to understand the form in three dimensions, he draws it — *sees* it — from more than one point of view. On the basis of these multiple perspectives, the whole form may be reconstituted, like the photo-sculpture previously mentioned. But it is clear that the individual views are highly valued for the degree to which they offer different kinds of information about the form under analysis. So Degas may have varied his draftsmanship, his "way of seeing form," as he moved through the stages of the analysis. Even within their limited range of media, the drawings may thus appear rather different from one another. One drawing may be aloof, almost cruel, in its uncompromising attention to the details of expression and carriage of body; such is the case with the studies of Marie van Goethem's face and back on the Louvre sheet (see cat. no. 19), which is moreover rendered with a brittle, nervous line, unsoftened by highlighting or color. Another drawing, like the nude study in Oslo (see cat. no. 22), may reveal a sinuous line, varied in weight, which defines contours and shadows with equal fluidity. And yet another may savor the discovery of a smaller, more subtle relationship between forms and colors; in *Two Studies of a Dancer* (see cat. no. 21) the shift in balance and line is occasioned by a rotation of less than forty-five degrees. Also here are the exquisite contrasts of tints, violet shadows on flesh and glowing apricot highlights on stockings and silk slippers, all against a neutral gray background.

78

There is an instructive kinship between these drawings of Marie van Goethem from the late 1870s and another sheet from approximately the same date, the *Portraits in a Frieze, Project for Decoration in an Apartment* (fig. 3.8).[35] This drawing, extensively worked in pastel, is one of a number of studies of women in street costume that are generally dated around 1880. Here Degas employed the format of the three-figure drawings of Marie but abandoned the self-imposed discipline of using a single model. In the earlier drawings of the young dancer, Degas had sought to record all possible details of a single young woman. In this case, and in other drawings from the group, the object was to study many aspects of a single *kind* of woman, urban, dressed to be out-of-doors in the city. Although the model does not remain consistent, the generic type that she represents is the same.[36] Degas did not want so much to fix an indelible image of only one *Parisienne*, as he had in the drawings of the dance student, for example. Instead, he wanted to research the physical attitudes of a whole class of *Parisiennes.* In the one case, his procedure was more exacting and methodical, a careful physical description of an individual specimen; in the other, he essayed a broader experiment, to define a larger type by recording in drawings well-chosen examples of its behavior. In both cases, his profound interest in breed, family, and origins, what he called in his sonnet "the race of her street," is betrayed.[37]

These interests were shared by Degas with his friend the novelist and critic Edmond Duranty, one of the writers associated with the naturalist movement in French letters in the second half of the nineteenth century, a movement which characterized itself as scien-

Fig. 3.7. *Two Studies of a Café-Concert Singer,* c. 1880, black chalk and pastel. Present location unknown; as reproduced in Rivière 1922–1923, pl. 90.

79

tific, descriptive, and analytical, much as we have characterized Degas' drawings. It was Duranty, writing about the impressionist exhibition of 1876, who proposed something quite like Degas' project for drawing "a figure, a piece of furniture, or a whole room . . . from every perspective":[38]

The visual aspects of things and of people have a thousand ways of being unforeseen, in reality. Our point of view is not always in the center of a room with two side walls leading to the back of the space: . . .[there is not always] mathematical regularity and symmetry; [our point of view] is sometimes very high, sometimes very low, seizing objects from beneath, cutting furniture off unexpectedly . . . [A person] is not always at equal distance from two parallel objects, in a straight line; he is pushed more to one side than another . . . never in the center. . . . He does not always show himself whole, but as easily in three-quarters or half-length, or cut vertically down the middle.[39]

So Duranty, in an extended discussion of Degas' contribution to the "New Painting," had characterized the nature of vision, and so had praised the independent artists whose works accorded with that vision. But aligned with his belief that the unexpected point of view more accurately replicated human perception was another idea, a conviction (shared by Degas) that chance gestures and subtle details of physiognomy were expressive of the most profound truths of character. "With a back," he wrote, "we want to reveal a man's temperament, his age, his social status; with a pair of hands, we must express a magistrate or a shopkeeper; . . . by a gesture, a whole series of feelings. Physiognomy will tell us that one man is dry, organized, and meticulous, another careless and disordered."[40]

Duranty and Degas had shared these ideas for some time before the beginning of the artist's series of drawings related to the *Little Dancer.* As Theodore Reff notes, both the critic and the painter had formulated a response to theories of expression and character in the 1860s, including the treatises of the eighteenth-century writers J.C. Lavater and François Delsarte, both of whom had written on the human countenance and the ways in which it expressed emotion. Degas had, for instance, proposed to "make of the *tête d'expression* (in the style of the academy) [at the academy of Degas' time, this was a bust-length portrait, expressive of a single emotion] a study of modern feelings. It's Lavater, but a more relative Lavater, somehow, sometimes with accessory symbols."[41]

Reff points out, in his discussion of Degas' musings on physiognomy, that the artist's portraits are marked by his attention to both the individual's gesture and physiognomy and to his individualized emotions. These preoccupations seem to have become particularly powerful around the time of the development of the *Little Dancer,* and the exhibition of 1881, in which it was first shown, is almost a manifesto of Degas' views on the subject. When we recall the works

Fig. 3.8. *Portraits in a Frieze, Project for Decoration in an Apartment*, c. 1879–1880, black chalk and pastel on gray paper. Private collection.

that Degas sent to the sixth impressionist exhibition, we can affirm even more strongly a context of naturalist iconography and working method. In fact, these works seem to form a coherent, carefully planned group. Degas showed, along with his wax sculpture, four portraits, two *physionomies* of criminals, a laundress, and, *hors catalogue*, the *Portraits in a Frieze*.[42] Exactly which laundress or which portraits were shown remains unclear, but with the possible exception of the laundress the works in this group must all be concerned with portraiture, physiognomy, and expressive gesture. In particular the drawings of criminals and the *Portraits in a Frieze* should be linked with the *Little Dancer*. The physiognomic drawings of the bestial faces of these criminals express the same unrelenting curiosity that motivated the Louvre sheet of Marie van Goethem's head—studies which in turn shaped the "bestial impudence, the visage, or more accurately the muzzle" of the wax statuette.[43]

In his emphasis on the precise rendering of individual gestures and expressions, Degas went against classical academic practice. His naturalism, which valued accident, asymmetry, and the unpolished,

81

can effectively be contrasted with the advice of the theoretician Quatremère de Quincy, who had established the standards of drawing from the model in such works as his *Considerations sur les arts du dessin en France* of 1791. Curiously, certain of Quatremère's procedures, notably the close study of a large number of models, are like the ones followed by Degas, but Degas' goals were diametrically opposed to those of the neoclassical aesthetician. Quatremère's object was the reform of the Academy's drawing practice, and to this end he recommended extensive study from a variety of models in order to achieve perfection of form. Believing that "nature is the species, [and that] the model is but one individual of that species," he reasoned that "the study of nature is therefore nothing other than the study of the species." Quatremère argued that this study should concentrate on the perfect details of the individual, so that a composite of these details might yield a perfect image of the species, that is, of nature. "If this is true," he wrote, "the study which is limited to the copying of a single individual"—and here we might think of Degas' drawings of Marie van Goethem—"is nothing but the study of imperfection."[44]

Another important theorist of academic reforms, Horace Lecoq de Boisbaudran, placed greater value on the observation of fugitive or chance effects from nature that might accent an otherwise idealized composition. In his work *L'Education de la mémoire pittoresque,* he advocated the training of the visual memory and mnemonic drawing. Degas, who was an intimate of several of Lecoq's students (notably Fantin-Latour and Alphonse Legros) seems to have shared some of Lecoq's ideas about the value of drawing from memory. In the notebook in which we find his project for multiperspective drawings, he also wrote: "For a portrait, pose [the model] on the ground floor and work on the first floor, to get used to retaining forms and expressions and never drawing or painting *immediately*."[45] But in Degas' case, it is what might be called "the study of imperfection," the retention of the idiosyncratic so that it may be carefully transcribed, that is the goal, rather than the retention of ideal or perfect forms.

In Degas' drawings for the *Little Dancer,* as in the sculpture, we see the conflict of methodical, analytical practice—which in the hands of an academician would yield a studied, perfect form—and impudent objectivity, studied accident. For Degas believed that the surest way to master a form or an idea was to attack it repeatedly. "One must repeat the same subject ten times, a hundred times," he wrote, "nothing in art must seem an accident, not even movement."[46]

NOTES

1. The clasped hands and arms of the figure are, however, modeled over an armature of hemp rope.
2. The history of the casting of Degas' sculpture is set forth in Millard 1976, 30–39.

3. Henry Trianon, "*Sixième Exposition de peinture par une groupe d'artistes,*" *Le Constitutionel* (24 April 1881), 2, quoted in Millard 1976, 123. (translation GTMS)

4. Jules Claretie, *La Vie à Paris* (Paris, n.d.), 150–151, quoted in Millard 1976, 119. (translation GTMS)

5. Huysmans 1908, 250–255, quoted in Millard 1976, 124. (translation GTMS)

6. Huysmans 1908, quoted in Millard 1976, 126.

7. Rewald 1944, 8.

8. Reff 1976a, 239–269.

9. Millard 1976, 61–63.

10. Reproduced in Browse 1949, pls. 76–78.

11. Lemoisne no. 971. Boggs 1962, 66.

12. Browse 1949, pl. 68; *Vente* 2:230a. See also Browse 1949, pls. 66–69.

13. See Millard 1976, 8, for biographical information on Marie van Goethem.

14. Reff 1976b, 1: 141 (Nb. 34:4).

15. Viel' Abonné 1887, 265. (translation GTMS)

16. Viel' Abonné 1887, 265–266. See also Millard 1976, 8, n. 26.

17. Viel' Abonné 1887, 15.

18. Mantz 1881, 3, quoted in Millard 1976, 121. (translation GTMS)

19. Lemoisne, 1: 208.

20. *Vente* 3:149a.

21. Browse 1949, 369.

22. Reff 1976a, 245; 333, n. 17.

23. Rewald 1944, 21–22.

24. Millard 1976, 8.

25. Pickvance 1979, 64.

26. Rewald 1944, 6.

27. Reff 1976, 245.

28. Reff 1976b, 1:134 (Nb. 30:65).

29. To these might be compared Degas' portrait of Mlle. Salle (Lemoisne no. 868), which also shows profile, full-face, and three-quarters views.

30. Peter Fusco and H.W. Janson, eds., *The Romantics to Rodin* [exh. cat., Los Angeles County Museum of Art and participating museums] (Los Angeles, 1980), 360–361.

31. For example, Reff 1976b, 2: not paginated (Nb. 7:2 and 4v).

32. For example, *Vente* 3:364, Victoria and Albert Museum.

33. Lemoisne no. 579.

34. For example, Lemoisne nos. 572, 577, and 828.

35. Lemoisne no. 532.

36. As Theodore Reff notes, the right-hand figure on the sheet, drawn from the actress Ellen André, was used as the basis of an etching, which in turn bears a strong resemblance to another of Degas' statuettes of young women, *The Schoolgirl.* This sculpture was probably begun in the summer of 1881, the year in which Degas exhibited the *Little Dancer;* see Reff 1976a, 257–262.

37. See note 19 above.

38. See note 28 above.

39. Duranty 1876, 28. (translation GTMS)

40. Duranty 1876, 24.

41. Reff 1976b, 1:26 and 117 (Nb. 23:44). See also Reff 1976a, 216–221.

42. Lionello Venturi, *Les archives de l'impressionnisme* (Paris and New York, 1939), 2:265–266. Ronald Pickvance argues against the assumption that the pastel *Portraits in a Frieze* was exhibited as early as 1879 (as *Essai de décoration*) on the basis that that work was executed in *détrempe;* instead, he asserts that the pastel *Portraits* was exhibited in 1881. See Pickvance 1979, 60.

43. Mantz 1881, quoted in Millard 1976, 122.

44. Quatremère de Quincy, *Considerations sur les arts du dessin en France* (Paris, 1791; Geneva, 1970), 124–125.

45. Reff 1976b, 1:134 (Nb. 30:210).

46. Guérin 1945, 119. (translation GTMS)

83

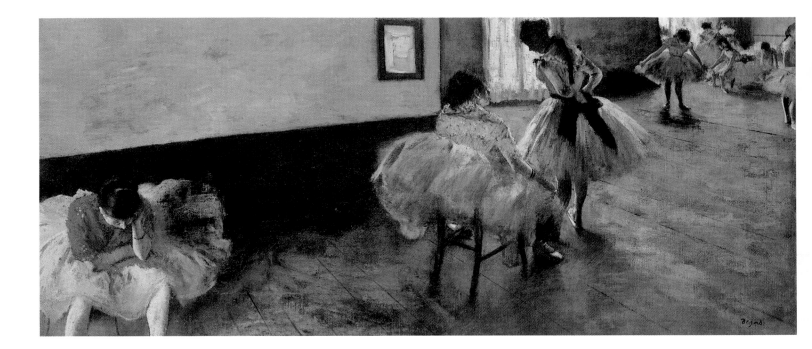

CHAPTER 4

Theme and Variations

It is necessary to do a subject ten times, a hundred times. Nothing in art must seem an accident . . . 1886

Extending his practice of using and re-using a single figure (discussed in chapter 2), Degas began in the very late 1870s to use and reuse an imaginary space, painting a series of pictures of dance rehearsals, all of which employ a distinctive horizontal format that has often been likened to a frieze. There are approximately forty paintings and pastels of this type, each measuring about 17 x 35 inches. The space portrayed is usually divided into two distinct zones. In the foregound, situated either at the right or the left of the picture space, there is a group of dancers, sometimes surrounded by musical instruments. They are usually grouped against a wall that seems to end, turning sharply back into space about halfway across the canvas. In the background, greatly diminished in scale, other dancers perform exercises or rest, massed in a wedge-shaped space. The floor of the rehearsal room is tilted up toward the viewer; the whole of the pictorial space is curiously flattened, although the great disparity between the scale of the figures represented implies a deep, broad room. The paintings' unusual shape raises the question of their intended function. Is it possible that they are literally a frieze, a composition intended to serve a decorative purpose?

Here it should be noted that the word *decorative* has two distinct meanings. One of these is contained in the idea of decoration, that which serves to decorate, as a painting in an interior. Under this heading might specifically be classed works painted to harmonize with or to fill a space in an architectural setting, in other words, those that serve a decorative function. There is, too, in the word *decorative* the implication of essentially formal concerns that reside in every work of art: the relationships between colors, lines, and shapes, what might be classified under the heading *design*. It is the decorative component of any work of art that is concerned with what the theoretician Charles Blanc called "optical beauty, that which responds to the pleasure of the eyes" as distinguished from "poetic beauty, that which touches the feelings."[1]

Left: cat. no. 25. *The Dance Lesson (La leçon de danse)*, c. 1879, oil on canvas. From the Collection of Mr. and Mrs. Paul Mellon, Upperville, Virginia.

85

Fig. 4.1. *Compositional sketch*, c. 1878, graphite. Cabinet des Estampes, Bibliothèque Nationale, Paris, Notebook 31:70.

Little is known about Degas' projects for decoration, although one of them, the *Portraits in a Frieze, Project for Decoration in an Apartment* (see fig. 3.8), has often been cited in the literature. But even in the case of the *Portraits in a Frieze* there is no indication as to how the figures studied in the several surviving related sheets would be incorporated into a scheme of mural decoration. It can be established, however, that from as early as 1860 Degas was concerned with the possibility of creating decorative paintings and that this concern lasted for at least twenty years. Furthermore, it can be shown that one feature of Degas' interest in the decorative was his continuing determination to reconcile purely formal investigations with the expression of "modern feelings" conditioned by the aesthetics of naturalism.[2]

The earliest of the frieze format pictures is probably *The Dance Lesson* from the collection of Mr. and Mrs. Paul Mellon (cat. no. 25). It can be dated to 1878–1879 on the basis of a tiny sketch of the composition in one of Degas' notebooks, datable to the beginning of 1879 (fig. 4.1).[3] This sketch has been called a preparatory study, but it has all the characteristics of a thumbnail copy of the composition, made perhaps to give a colleague, a collector, or a dealer a brief idea of a work in progress. The sketch, moreover, records elements that have been suppressed in the final version of the painting. On the floor behind the seated dancer in the center of the composition there was once an open violin case, now obliterated by overpainting; whether there was ever a circular niche supported by a bracket in the Mellon painting is not known. The expanse of wall, unmodulated except for a notice board or mirror just before the corner, is a powerful compositional element, leading the eye along the dramatically receding perspective toward the back corner of the room. This recession is punctuated by the floorboards of the room and by the craftily placed dancers. These dancers, none of whom engages the viewer's attention, are varied in attitude, but four of them in the right half of the composition are almost mirror images of each other: on a

86

Cat. no. 26. *A Seated Dancer and a Head of a Girl* (*Tête de femme—Etude de danseuse*), c. 1878, black chalk and pastel on pink laid paper, slightly faded, laid down. Private collection, on loan to the Museum Boymans-van Beuningen, Rotterdam. (Illustrated in color on page 10.)

direct line between two seated dancers, their hands on their knees, two more figures stand looking at the floor; one faces into the picture space, the other out. This delicately manipulated counterpoint of pose recalls the drawings related to the *Little Dancer*, which are contemporary with the Mellon painting.

The figures in this painting can be recognized in a number of drawings which, again, probably date from around 1878. The head of the central standing figure, for instance, is derived from a masterful study in a Dutch private collection (cat. no. 26), executed in chalk and

87

Fig. 4.2. *Two Seated Women*, c. 1878, pastel on gray paper. The Museum of Art, Rhode Island School of Design, Providence, Gift of the Museum Committee in appreciation of John Maxon's directorship.

pastel on pink paper. This is surely among Degas' most remarkable works, both for the artist's powerful observation of physiognomy and for its color (the head is worked up in rich bordeaux and olive-colored pastels, the light behind the head is the color of seafoam) and for its extraordinary *mise-en-page*. The disjunction between the two halves of this drawing, the strange tension which results from having the smaller figure placed illogically "in front of" the larger head, contributes greatly to its appeal. The seated figure at the center of the painting is a composite of the skirted figure on this sheet and the head and shoulders from a sheet in the Museum of Art of the Rhode Island School of Design (fig. 4.2),[4] on which we also find a study of the dancer seated on a bass violin in the lower left-hand corner of the Mellon picture.

The standing dancer arranging her skirts in the background and the seated dancer behind her derived from drawings from the Staatliche Kunsthalle Karlsruhe and from a New York private collection (cat. nos. 27 and 28). These drawings were probably made from the same model, an English dancer named Nelly Franklin, whose name is inscribed on a sheet, known from the estate sales catalogues,[5] which established the pose of the central seated figure; another drawing of Nelly Franklin shows that she posed for the central standing figure as well.[6]

Another figure, known from a drawing in the National Gallery of Art (cat. no. 29), was added to those in the Mellon painting in a version of the composition from the Metropolitan Museum of Art titled *Dancers in the Rehearsal Room with a Double Bass* (cat. no. 30). Even more dramatic in its spatial recession than the Mellon painting, the Metropolitan canvas places all the figures in the right half of the

Cat. no. 27. *Standing Dancer* (*Danseuse*), c. 1878, black and white chalk on gray laid paper. Staatliche Kunsthalle Karlsruhe, Federal Republic of Germany.

Cat. no. 28. *A Seated Dancer* (*Danseuse assise*), c. 1878, black chalk heightened with white chalk on blue laid paper, squared. Private collection, New York.

picture space. Again, four of them are set along a straight line, but in this case they are contrasted with each other rather than paired, the billowing bulk of the dancer bending to tie her shoe dominating the foreground of the composition. Although Lemoisne dates the painting 1887, it is much more likely that it was at least begun around the same time as the Mellon picture, though it may have been retouched at a later date. Indeed, George Moore, the critic and sometime friend of Degas, said as much when he wrote a review of the painting in 1891: "[The painting] is in Degas' early and Watteau manner, but it

89

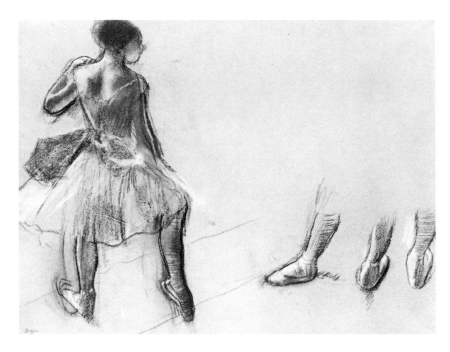

Cat. no. 29. *Dancer Seen from Behind and Studies of Feet* (*Danseuse vue de dos et trois études de pieds*), c. 1878, black chalk and pastel on blue-gray laid paper. National Gallery of Art, Washington, Gift of Myron Hofer.

Below: cat. no. 30. *Dancers in the Rehearsal Room with a Double Bass* (*Danseuses au foyer*), c. 1885, oil on canvas. The Metropolitan Museum of Art, New York, Bequest of Mrs. H. O. Havemeyer, 1929. The H. O. Havemeyer Collection.

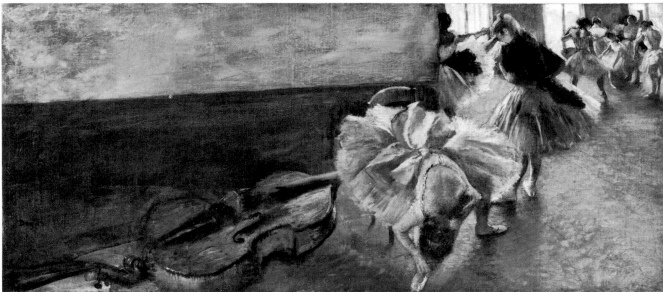

bears traces of Degas in his later and rougher manner. It is certainly an old picture that he has retouched within the last five years."[7] It probably was not much more than five or six years old when it was retouched, but slight inconsistencies in surface texture and paint application on the foreground dancer's back, the bass violin, and the floor in the background give credence to Moore's observations. Furthermore, the existence of two oil variants of almost identical composition suggests that Degas may have been occupied with this painting over a protracted period of time.[8] As is evident in some of his other

pictures within this group, however, Degas' practice of retouching or even wholly repainting a composition was by no means unusual.

In the Yale University Art Gallery's *Ballet Rehearsal* (cat. no. 31), the format of the Mellon and Metropolitan pictures is reversed, the foreground figures and the near wall being on the right-hand side of the canvas. The Yale picture is slightly later in date than *The Dancing Lesson* from the Sterling and Francine Clark Art Institute (cat. no. 32), although in both cases Lemoisne's dates, 1885 for the *Dancing Lesson* and 1891 for the *Ballet Rehearsal*, seem to be too late.[9] The similarity of facture between the Clark and Mellon pictures indicates closer dates for the two, dates not too many years after the completion of the *Dance Class* of 1876 (see cat. no. 10); the Yale frieze may be as much as five to seven years later than the other two.

Drawings incorporated by Degas into the Yale picture reveal the sure, linear hand of Degas' draftsmanship in the early 1880s. Frequently executed in black fabricated chalk or pastel, and heightened with white or colored pastels, these drawings are characterized by a firm thick-and-thin line and loosely hatched tonal areas. On some drawings, for instance one of the dancer pulling on her stocking (private collection, cat. no. 33), color harmonies were established while the position of the limbs and the precise gestures of face and hands were set. Another drawing of this figure (Fitzwilliam Museum, cat. no. 34), probably slightly earlier, may have been squared for transfer to the Yale canvas or to another cognate picture, the National Gallery of Art's *Before the Ballet* (cat. no. 35).

The dancer standing at the end of the bench in *Ballet Rehearsal*, her hands supporting her head, was the subject of an extended series of drawings, rivaling in number and in range the artist's studies of Marie van Goethem. The pose seems to have interested Degas particularly for its awkwardness, or perhaps for the challenge it set for him in rendering it convincingly. Two of the most beautiful studies of the dancer are in the Narodni Muzej in Belgrade (cat. nos. 36 and 37). On one of these, showing the figure half-length, Degas included a number of remarkable observations. He notes that the ear is transparent, that the blond hair is bordered with pale gold, that the shadows are green in hue. On the second drawing, showing the figure full-length, he indicates her flushed complexion, and two curious details: the protrusion of her left shoulder blade above the line of the back and the crossed elbows on her knee. Both of these drawings are richly colored and rendered even more complex by their *mise-en-page*. In each the central motif is surrounded by repetitions of important details, so that it appears to be emerging from a complex background. Another drawing of this figure, coupled with a variant of the seated dancer at the far right of the Yale canvas, is in the collection of the High Museum of Art (cat. no. 38). This sheet, much more freely

91

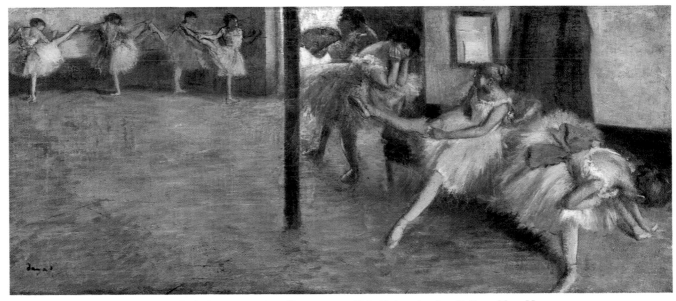

Cat. no. 31. *Ballet Rehearsal* (*La salle de danse*), c. 1885, oil on canvas. Yale University Art Gallery, New Haven, Gift of Duncan Phillips, B.A. 1908.

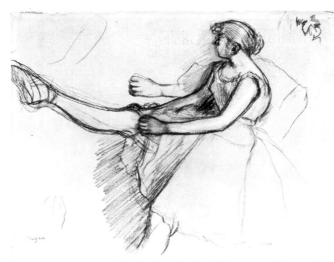

Cat. no. 33. *Dancer Adjusting Her Stocking* (*Danseuse assise*), c. 1880, black chalk and pastel on cream-colored laid paper. Frau Sabine Helms, Munich.

Cat. no. 34. *Dancer Adjusting Her Stocking* (*Danseuse rajustant son maillot*), c. 1880, black chalk, squared for transfer with charcoal and touched with white chalk. The Syndics of the Fitzwilliam Museum, Cambridge, England.

rendered than the Belgrade drawings, might possibly be the first of the many drawings of this figure. Perhaps the most unexpected of these drawings is the study of the figure unclothed (Cabinet des Dessins, Musée du Louvre, fig. 4.3), which has previously been associated with the artist's pastels of bathers.[10] The persistent curiosity that motivated Degas to study the position in the greatest detail (as he had studied the young dancer Marie van Goethem both clothed and nude) lies behind his often-quoted advice to his friend the

92

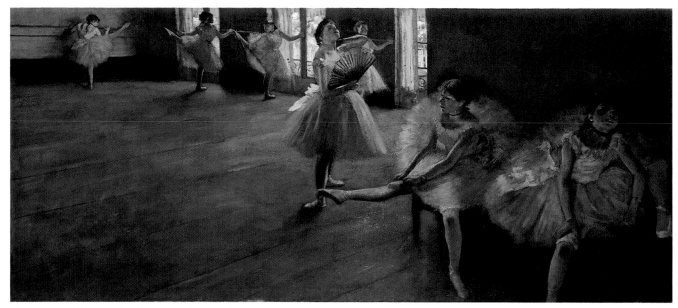

Cat. no. 32. *The Dancing Lesson* (*La leçon de danse*), c. 1880, oil on canvas. Sterling and Francine Clark Art Institute, Williamstown, Massachusetts.

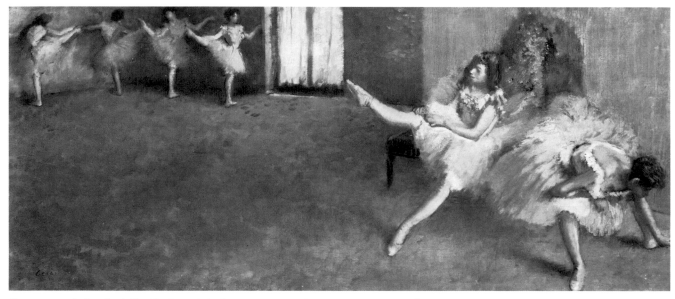

Cat. no. 35. *Before the Ballet* (*Le foyer de la danse*), c. 1885, oil on canvas. National Gallery of Art, Washington, Widener Collection.

sculptor Bartholomé that it was necessary to do a subject again and again.[11]

Rarely can the repetition and variation of a single motif be better demonstrated than in the pose of the seated dancer leaning forward to adjust her slipper, a subject Degas treated frequently in the 1880s. The dancer in the foreground of the Metropolitan picture, for instance, is closely related to a freely worked pastel, in which the dancer's head is placed slightly to the left of her arms (cat. no. 39), the

93

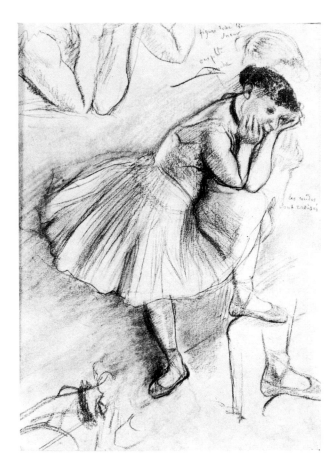

Left: cat. no. 36. *Bust-Length Study of a Dancer* (*Femme accoudée, vue à mi-corps*), c. 1880, black chalk and pastel on beige laid paper. Narodni Muzej, Belgrade. (Illustrated in color on page 128.)

Right: cat. no. 37. *Study of a Dancer Leaning on Elbows* (*Femme accoudée*), c. 1880, black and red chalk and pastel on beige laid paper. Narodni Muzej, Belgrade.

angular mass of her torso in relief against her billowing skirts. A more finished pastel of this motif (Dixon Gallery and Gardens, cat. no. 40) completes the swing of the torso from left to right begun in the other two images. Although they were not conceived in sequence, and were almost certainly made from different models, this group illustrates again the subtly varied points of view from which Degas approached a form.

There are almost as many replicas of the Yale *Ballet Rehearsal* as there are drawings related to it. The same figures, on the same scale, are present in both the Yale painting and the National Gallery's *Before the Ballet* (see cat. no. 35). Where there are now only two figures on the bench in the Washington painting, there were once four. X-radiographs of the National Gallery picture (fig. 4.4) reveal the presence of the dancer supporting her chin on her palms (see cat. nos. 36–38), which has been painted out of the composition entirely, as has the dancer holding a fan just behind her. And as in the Yale canvas, there was once a notice board over the head of the seated dancer pulling up her stocking. *Before the Ballet* is more loosely painted than the *Ballet Rehearsal* and although both canvases, because of inconsistencies of

94

Fig. 4.3. *Standing Nude (Femme nue debout)*, c. 1883, black and colored pastels on blue paper. Cabinet des Dessins, Musée du Louvre, Paris.

Cat. no. 38. *Two Dancers (Ballerinas) (Danseuses)*, c. 1880, charcoal and black chalk heightened with white chalk on faded pink laid paper. The High Museum of Art, Atlanta.

brushstroke and paint texture, appear to have been worked on over an extended period of time, it seems probable that the final layer of brushstrokes on the National Gallery picture is somewhat later than the Yale painting.

A related composition (fig. 4.5), in a private collection in Switzerland, is painted in broad patches of scumbled pigment, but with a greater range of hues, including some touches of violet and pink. While it is certain that the visible paint layer was applied by the artist very late in his career (probably after 1900), it can be demonstrated that the painting was actually begun as much as two decades earlier, around the time of the Clark canvas. X-radiographs, again, show that the present surface of the picture conceals a much more tightly painted group of figures, basically in the same poses, which should be compared with the figure types of the early 1880s. Each of the poses in the painting can be linked with drawings datable to the period 1878–1885.[12] Moreover, details such as a bracelet on the dancer at the center of the composition, visible only in the x-radiograph, point to an early date for the first state of the picture, since such details were invariably suppressed after about 1890, when Degas' handling of paint (perhaps due to his failing vision) became increasingly broad.

Another case of Degas' return to a long-finished canvas is seen in a

95

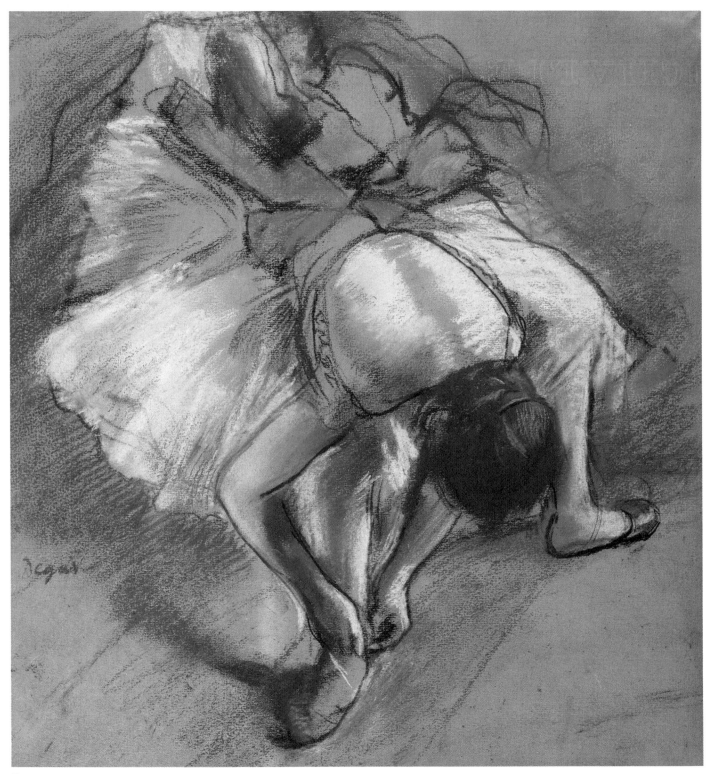

Cat. no. 39. *Dancer Adjusting Her Slipper* (*Danseuse attachant son chausson*), c. 1880–1885, pastel. Private collection, Paris.

96

Top: cat. no. 40. *Dancer Adjusting Her Shoe* (*Danseuse ajustant son soulier*), c. 1880, pastel on gray paper. The Dixon Gallery and Gardens, Memphis.

Middle: fig. 4.4. *Before the Ballet* (x-radiograph), National Gallery of Art, Washington.

Bottom: fig. 4.5. *The Dancers*, c. 1900, oil on canvas. Private collection, Switzerland.

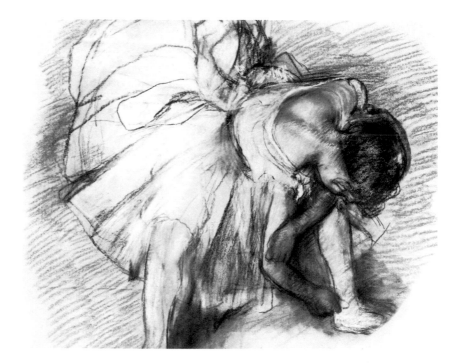

Above: cat. no. 41. *The Rehearsal Room (Foyer de la danse; Danseuses au foyer)*, c. 1889 and c. 1905, oil on canvas. Foundation E. G. Bührle Collection, Zurich. (Illustrated in color on page 140.)

Below: fig 4.6. *The Rehearsal Room*, c. 1889, lithograph after painting by Degas, Cabinet des Estampes, Bibliothèque Nationale, Paris.

painting from the Bührle Foundation in Zurich, the *Rehearsal Room* (cat. no. 41), probably executed between 1900 and 1905. Lemoisne dates the canvas 1889, though on stylistic grounds the paint layer now visible cannot be reconciled with other paintings known to date from that time. But it is certain that the painting was begun before 1889, because a lithographic reproduction of the picture (fig. 4.6) entered the Bibliothèque Nationale in Paris in that year.[13] The lithograph shows a painting related in composition to the Mellon collection's *Dance Lesson* and the Metropolitan Museum's *Dancers in the Rehearsal Room*, in which the near wall is placed on the left-hand half of the picture space, with figures grouped at the center of the composition, extending back to the upper right-hand corner. In repainting the canvas, Degas added another figure, a dancer fluffing out her skirts, perhaps drawing on a study he had made of the figure isolated on a sheet (cat. no. 42). But there are several full-scale variants directly related to this canvas, notably the charcoal and pastel drawing from

the Toledo Museum of Art, *Dancers at the Bar* (cat. no. 43), and the finished pastel from the Wallraf-Richartz Museum in Cologne, *Dancers* (cat. no. 44). The forceful, heavy lines describing the contours of the figures in these two works are typical of the artist's hand at the very end of his career. Since we now know that the oil painting was completed at least a decade before the two works on paper, they can no longer be considered studies made in preparation for the painting's composition. Instead, they were probably traced from the oil at some stage of its repainting. The pastel, for instance, was drawn on a support of tracing paper, mounted onto a heavier wove paper, in turn (and probably much later) attached to a canvas. The works on paper were made in order to perfect the composition, but the oil painting is not necessarily the conclusion of the exercise or the work the artist considered most important in the group. On the contrary, there seems to have been a less linear development of the suite of works, in which each kind of research informed the other.

This process is most clearly seen in a comparison of the composition and the facture of the oil painting from the Bührle Foundation and the Wallraf-Richartz Museum's pastel (see cat. nos. 41 and 44). The works are almost exactly the same width ($36\frac{1}{4}$ to $36\frac{5}{8}$ inches), but the pastel is slightly greater in height, allowing for a larger area of wall space above the figures' heads. But Degas seems to have been indecisive in making this change, for the uppermost band of the pastel is slightly different in handling from the area beneath it roughly corresponding to the oil painting's dimensions. To this extent, the painting seems to dictate the form of the pastel. But the paint surface is applied in such a way that it replicates effects found in the pastel, notably the tension between complementary colors and between broadly applied pigment and tight contours.

A detailed examination of a single portion of the two works, such as the skirt of the dancer bending forward at the center of the composition, shows that the paint has been applied to the canvas in the manner of pastel pigment. In the scumbled application of paint, layers are allowed to show through, as they do in pastel; there is very little liquid blending of paints. Finally, the charcoal drawing that underlies the pastel is suggested in the canvas by the heavy outlines painted over the roughly brushed color. Lemoisne refers to the oil painting as a sketch—an *esquisse*—presumably in order to explain its unfinished, even brutal surface quality. But, in fact, the final effect of both color and design in the painting is remarkably close to that of the pastel's surface precisely because Degas had deliberately mimicked his own manner in another medium. Thus while the pastel is, strictly speaking, a replica of the oil painting (in that it derived compositionally from the oil), its formal characteristics dictate those of the final version of the canvas.

99

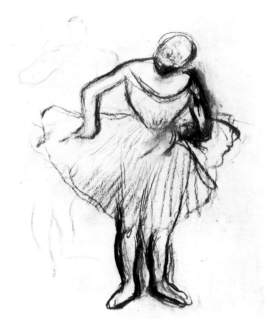

Cat. no. 42. *Standing Dancer* (*Danseuse*), c. 1900, charcoal on tracing paper mounted on wove paper. The Syndics of the Fitzwilliam Museum, Cambridge, England.

Right top: cat. no. 43. *Dancers at the Bar* (*Exercises de danse*), c. 1905, charcoal and pastel on tracing paper mounted on wove paper. The Toledo Museum of Art, Gift of Mrs. C. Lockhart McKelvy.

Right bottom: cat. no. 44. *Dancers* (*Danseuses*), c. 1905, pastel over charcoal on tracing paper laid down on wove paper mounted on canvas. Wallraf-Richartz Museum, Cologne.

The series of friezelike paintings, then, extends over more than two decades of the artist's career, from the late 1870s until after the turn of the century. Not only was it a fruitful motif for the artist, one that seemed to offer enormous possibilities for more or less exact repetition of a compositional idea; it also contained the seeds of many other works or groups of works which do not employ the friezelike format. These works can be shown to branch off from the underlying root of the frieze series, though these connections have seldom been pointed out.

For instance, in another work from the Mellon collection, the *Three Dancers* (cat. no. 45), Degas took a fragment of the composition found in the Yale *Ballet Rehearsal* and enlarged it, so that the figures occupy the entire picture space instead of being surrounded by a larger room.[14] The figures are compressed by the edges of the sheet, further charging the picture's emotional character. In the Mellon pastel the weariness of the dancers is accentuated because of our closeness to them and the consequent elimination of supplementary figures. The variation of scale and space, rather than an alteration of the pose, costume, or expression, changes the meaning of the image.

Although the Yale canvas was probably the closest source for the grouping of the dancers in the Mellon pastel, Degas seems to have returned to drawings for the specific figures represented in the composition. For instance, the right-hand dancer is probably derived from a sheet in the Musée Bonnat (cat. no. 46), or from the seated dancer at the right of the High Museum's charcoal drawing (see cat.

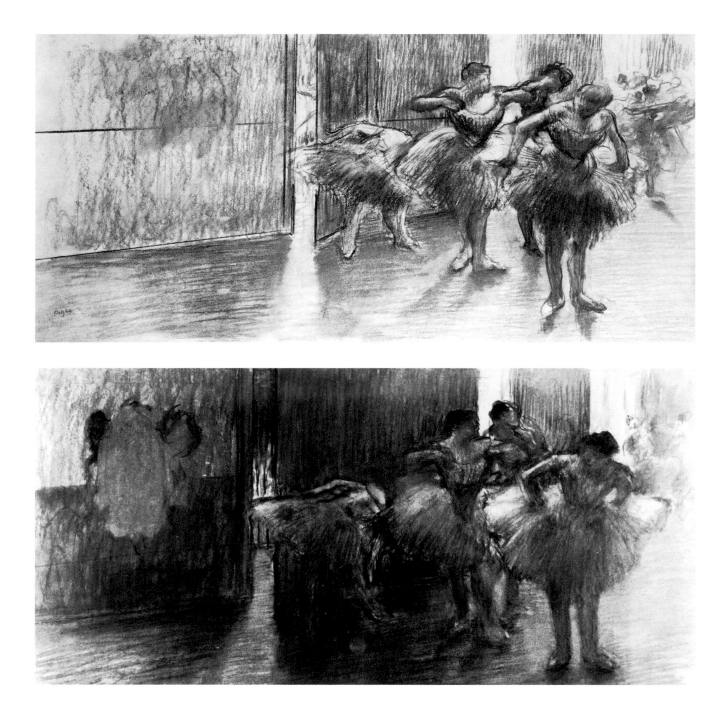

no. 38). In both these variations, then, Degas extracted an idea from a more complicated composition, the Mellon or the Yale painting, and elaborated on it, reforming both the spatial relationships between the figures and their individual appearance.

Another important group of pictures that has its origins in the friezelike compositions consists of images of two dancers seated together on a bench against a wall. In these works, such as the *Two Dancers* from a private collection (fig. 4.7),[15] a pair of figures from one

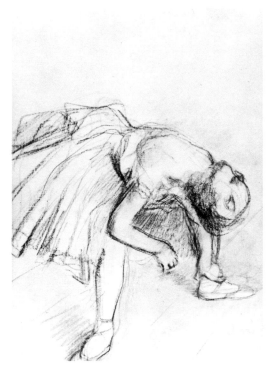

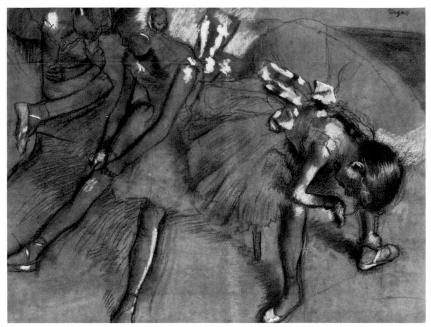

Cat. no. 45. *Three Dancers* (*Trois danseuses*), c. 1880, black chalk and pastel on tan paper. From the Collection of Mr. and Mrs. Paul Mellon, Upperville, Virginia.

Cat. no. 46. *Dancer Adjusting Her Slipper* (*Danseuse ajustant son chausson*), 1880–1885, black chalk heightened with pastel on ivory-white laid paper. Musée Bonnat, Bayonne, Collection Personnaz.

of the frieze pictures is isolated and expanded, much as in the pastel from the Mellon collection. As another means of cultivating the motif, the locale of the picture might have been changed from the rehearsal room to the stage, as in the case of the well-known pastel from the St. Louis Art Museum, *Ballet Dancers in the Wings* (fig. 4.8).[16] Here the figures are disposed as they are in the Swiss oil (see fig. 4.5), which is roughly contemporary in date: the principal difference is the omission of the dancer tying her shoe and the addition of a dancer leaning against a flat at the far left. The St. Louis pastel is, in turn, one of several related works, all of which descend from the Clark collection *Dancing Lesson*.

The frieze format was also used for a series of pictures of racehorses, later in date than the first of the horizontal paintings of dance rehearsals. Like the ballet pictures, these scenes of jockeys and racehorses in a landscape setting are frequently organized with a principal group at one side of the picture surface extending obliquely into the background space. An oil from the John Hay Whitney collection (fig. 4.9),[17] one of over a dozen pictures of this type, exhibits many parallels with the Swiss ballet composition (see fig. 4.5): in each picture, the group at the far right sets up a movement into the deep space of the picture, punctuated by variations in pose (whether of

102

dancer or racehorse) and by geometric elements (details of architecture or a screen of trees). This movement is, in each composition, checked by a stable vertical element that bisects the surface of the canvas.

An even more developed use of the exaggeratedly horizontal format is seen in the monumental canvas from the Cleveland Museum of Art, *Frieze of Dancers* (fig. 4.10).[18] Measuring over six feet in width, the canvas shows four views of the same dancer bending to tie her shoe, a pose very close to that in the drawing from a private collection (see cat. no. 39). This painting is certainly the most dramatic realization of the project for studying a figure from multiple perspectives associated with the drawings related to the *Little Dancer*, though it probably dates from at least a decade after those drawings. The painting is based on a series of studies of the dancer, in every case showing only one figure on a sheet, which dates from the mid- to late 1880s. The individual studies are regrouped in the painting to suggest not only a wide space, in which a group of dancers are seated preparing themselves for exercises or performance, but also one dancer seen across time, as had been the case in the studies of Marie van Goethem.

The scale of the Cleveland painting suggests that it may have been

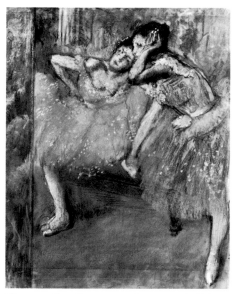

Fig. 4.7. *Two Dancers*, c. 1895, pastel. Private collection.

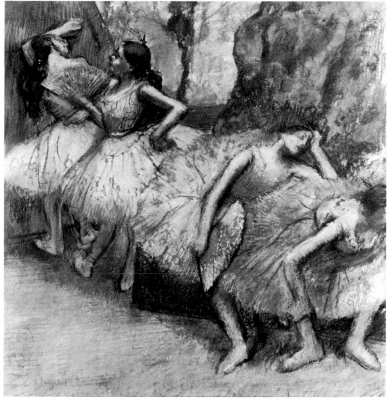

Fig. 4.8. *Ballet Dancers in the Wings*, c. 1895, pastel. St. Louis Art Museum.

103

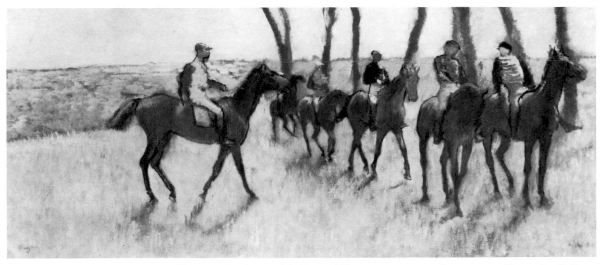

Fig. 4.9. *Landscape with Mounted Horsemen,* c. 1895, oil on canvas. From the Collection of Mrs. John Hay Whitney.

conceived for a particular function, perhaps in relation to an architectural setting. If this is the case, what can be learned, by inference, about the decorative qualities of the other frieze-format pictures, whether of ballet rehearsals or of racehorse scenes?

The earliest record we have of Degas' desire to exploit the potential of decorative paintings is a series of notes for a pair of portraits recorded in a notebook used between 1859 and 1864. In these notebooks drawings of figures in contemporary dress are interspersed with compositional studies for some of the artist's early history paintings and copies after the Old Masters. In the notes in question, Degas proposes to make a "portrait of a family in a frieze . . . the proportions of the figures at least one meter. There could be two compositions, one of the family in town, the other in the country . . . on either side of a door [there would be] subjects in the spirit of the house, in the manner of attributes."[19] This quotation immediately brings to mind Degas' portraits of families in domestic interiors, especially the painting of the *Bellelli Family*, dating from 1858–1860.[20] The projected painting, presumably never executed, has a parallel in such works as the *Portrait of the Epps Family* of 1870–1871 (a friezelike folding screen comprising a group portrait of no less than twenty figures), by Laurens and Laura Alma-Tadema, whom Degas knew and had encouraged to exhibit with the impressionists as early as 1875.[21] Moreover, the project envisioned a pair of paintings, which were typically associated with decorative works but rarely encountered in the work of independent artists of Degas' circle. (An exception, perhaps, is Renoir's pair of pictures, the *Dance in the City* and the

104

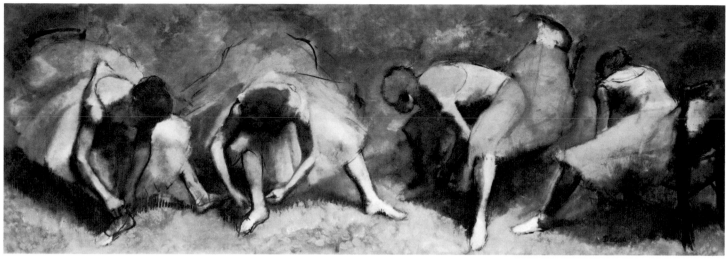

Fig. 4.10. *Frieze of Dancers*, c. 1895, oil on canvas. The Cleveland Museum of Art, Gift of the Hanna Fund.

Dance in the Country, of twenty years later.) Indeed, only Whistler among Degas' contemporaries had embraced the idea of unifying paintings and interiors: his *Six Projects* of 1867, conceived, like Degas' proposed portraits, for the decoration of a dining room, were his first scheme to incorporate large-scale figures.[22]

Degas' notes for the project suggest, furthermore, a union between the interior and the portrait, in which elements, or attributes, of the family's daily environment would be used in a painting that would, in turn, be placed in that environment. This concept is integral to the naturalist aesthetic (discussed in chapter 3). (It is useful to recall in this connection, too, Degas' later note to "make portraits of people in familiar and typical attitudes."[23]) It may be that the project sketched out around 1860 was still in Degas' mind around 1880 when he set about planning the *Portraits in a Frieze* (see fig. 3.8), which would seem, from the little information remaining to us, to have been an exercise in decoration of a specifically naturalist kind.

Between 1860, when he projected the family portraits in a frieze format, and the project of c. 1880, Degas continued to investigate the relationship of decoration and modern subject matter. In the notebook of c. 1870, containing Degas' often-quoted observations on portraiture and physiognomy, the artist recorded several ideas which have never received sufficient attention. These are relevant to the concept of naturalist decoration, and demonstrate the degree to which he interwove form and content in his art. "Ornament," he wrote, "is the interval between one thing and another. One fills in this interval with a relationship between the two things, and *there* is the

105

source of ornament."[24] This essentially theoretical concept attempts to define the ornamental or decorative quality in any arrangement of two or more things. In Degas' own work, of course, this arrangement is usually a painting or a drawing. Furthermore, this sentence might serve as an explanation of the decorative or ornamental character of *Portraits in a Frieze*, the Cleveland *Frieze of Dancers* (fig. 4.10), or of the drawings of Marie van Goethem (see cat. nos. 20 and 21), which is expressed principally in the rapport between the individual figures, the interval filled in between one thing and another. It is not necessary, in the logic of Degas' argument, to fill the supposed interval with a physical object or design: the mind bridges the gap between the figures, thus understanding the ornamental unity of the composition.

There is nothing in this idea that is specifically related to naturalist theory or aesthetics; in fact, its tone is more or less academic. But the sentence that follows shows us to what use that notion of ornament might be put: "Think," he wrote, "of a treatise of ornament for women or by women, after their way of observing, of combining, of feeling their costume [*toilette*] and everything else. Every day, more than men, they compare, one with another, a thousand visible things."[25] Clearly, he did not divorce the possibility of the ornamental from the expression of modern life, of fashion, or of modern feelings, as he had written on an earlier page of the same notebook.[26] And as we have seen, he was to continue to associate these ideas over the course of two decades: the project for a family portrait in a frieze dates from around 1860; his observations on ornament, and on a treatise of ornament by women, probably date from c. 1870; and the *Portraits in a Frieze*, a project which seems a logical conclusion of all these ideas, can be dated to sometime around 1880.

The frieze-format pictures of ballet rehearsals have a place in the development of these concepts, for although they are not projects for decoration, or conceived with a particular ornamental end in view, their exaggeratedly horizontal shape invites comparison with mural painting or with ornamental Japanese screens.[27] Because they are so numerous, and because they are almost all of the same dimensions, it is also tempting to try to reconstruct a continuous frieze by laying the pictures end-to-end. Of course, they do not form such a frieze, but their discontinuity does not contradict an implied extension of the composition laterally, beyond the boundaries of the picture frame.

In addition to their resemblance to other decorative paintings or sculptural friezes, the frieze-format paintings are imbued with the decorative or ornamental character that Degas had defined in his writings. Their principal formal concern is the establishment of relationships between forms, the incessant and obsessive regrouping of forms, and the alteration of the intervals between those forms. In the earliest of the frieze pictures, Degas was concerned with representing

not only forms and the intervals between them, but also with investing those forms with specific meaning. Works such as the Mellon collection *Dance Lesson* or the Yale *Ballet Rehearsal* are about the cycles of work and rest inherent in a dancer's daily routine, and about the weariness caused by that work and its repetitive character. In the later pictures, however, particularly those painted after 1895, there is little suggestion of such precise significance in Degas' figures. Instead, the subject of his work became the intervals between forms and figures, and on a larger scale, the intervals between the works themselves, as Degas proceeded toward abstraction.

NOTES

1. Charles Blanc, *Grammaire des arts du dessin* (Paris, 1867), 496.
2. See chapter 3, n. 41.
3. Reff 1976b, 1:137 (Nb. 31:70).
4. Lemoisne no. 626.
5. *Vente* 1:354. Her name and address, "Nelly Franklin 75 rue de Provence," appear in a notebook used between 1877 and 1883. Reff 1976b, 1:133 (Nb. 30:A).
6. *Vente* 2:351. Browse 1949, pl. 121.
7. George Moore, *The Speaker* (2 January 1892), quoted in Pickvance 1979, 24.
8. Lemoisne nos. 900 and 902.
9. See also Reff 1976b, 1:137, 151 (Nb. 31:70).
10. Lemoisne no. 615.
11. Guérin 1945, 119; compare chapter 3, n. 46.
12. The dancer adjusting her slipper at the left side of the bench is altered in the final painting. Her original pose is known from a drawing in an English private collection. Boggs 1967, no. 115.
13. Degas oeuvre albums (Dc327d oeuvre); Cabinet des Estampes, Bibliothèque Nationale Paris; it is possible that Lemoisne, as chief curator of the Cabinet, knew this lithograph and based the painting's date on the date of the print. However, he does not refer to the print in his catalogue raisonné of the artist's work.
14. A similar process is seen in the relationship of the Mellon *Dance Lesson* (cat. no. 25) and a pastel at the Museum of Fine Arts, Boston (Lemoisne no. 661).
15. Lemoisne no. 1397; compare nos. 1329–1332.
16. Lemoisne no. 1066.
17. Lemoisne no. 764.
18. Lemoisne no. 1144.
19. Reff 1976b, 1:100 (Nb. 18:204).
20. Musée d'Orsay (Galerie du Jeu de Paume); Lemoisne no. 79.
21. Theodore Reff, "Some Unpublished Letters of Degas," *The Art Bulletin* 50, no. 1 (March 1968), 89.
22. See David Park Curry, *James McNeill Whistler at the Freer Gallery of Art* [exh. cat., Freer Gallery of Art] (Washington, 1984), nos. 7–12.
23. Reff 1976b, 1:118 (Nb. 23:46).
24. Reff 1976b, 1:117 (Nb. 23:45–46). The French text has been accidentally mistranscribed in the Notebooks catalogue. The text should read: "l'ornement est l'intervalle/entre [une chose et une autre/on comble cet intervalle/par un rapport entre] les/deux choses et c'est là/la source de l'ornement." (Brackets indicate text omitted in catalogue.)
25. Reff 1976b, 1:117–118 (Nb. 23:46).
26. See chapter 3, n. 41.
27. For a discussion of Degas' awareness of Japanese art and prints in an exaggerated horizontal format, see Reff 1976a, 104–105.

107

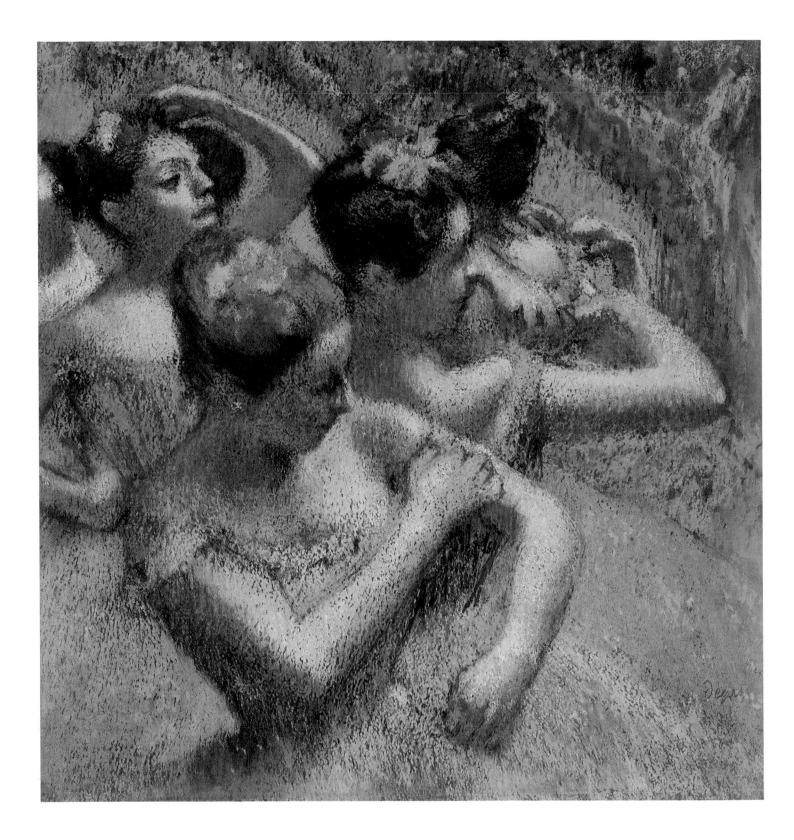

CHAPTER 5

The Last Dancers

*I am still here working. Here I am
come back to drawing, to pastel.*
C. 1907

D<small>EGAS' PROCESS</small> toward abstraction in the last decade
of his career is integrally linked with the changes taking place in his
working method at that time. In fact, it is in the continued repetition
of a handful of compositions at the end of his life that this develop-
ment is most graphically illustrated. If this method of working was, at
the beginning of his career, a way of using a pose or composition to its
fullest potential, as a means of storing the artist's energies, later in his
career it became habitual, almost obsessive—in fact, the distinguish-
ing characteristic of his art after 1890.

Degas customarily turned not to the outside world but to his own
art for inspiration, for new sources of motifs and their arrangement.
This led him to take figural groups and transform them by varying
the relationship of the figure to ground and frame. The resulting
composition might be radically different in spatial effect, as the pastel
Three Dancers (cat. no. 45) is different from the Clark collection's
Dancing Lesson (cat. no. 32); or the two pictures might be different
iconographically, as are the pastel *Ballet Dancers in the Wings* (St. Louis
Art Museum, fig. 4.8), representing a break in mid-performance, and
the Yale *Ballet Rehearsal* (cat. no. 31). Thus it is often difficult to
recognize in Degas' late pictures the traces of his earlier works, but
they are almost always identifiable upon close study. Only rarely after
1890 did he invent a wholly new group of figures or a new compositional
idea.

Instead of treating new subjects in his art, he attempted to find new
ways of treating very old ones. This attempt led him to develop
unusual technical approaches to the work of art; technical prowess,
the mastery of *métier* and *matière*, became his goal. His experiments
ultimately led him to concentrate on the abstract relationships of
lines and forms and light and color to the exclusion of anecdote or
narrative content. Yet his subjects do not exist entirely outside a
social context: the ballet is still the ballet of the Paris Opera, the
racecourse still Chantilly or Longchamps, the bather still readies

Left: cat. no. 51. *Dancers (Danseuses)*, c. 1898,
pastel. M. Charles Durand-Ruel, Paris.

109

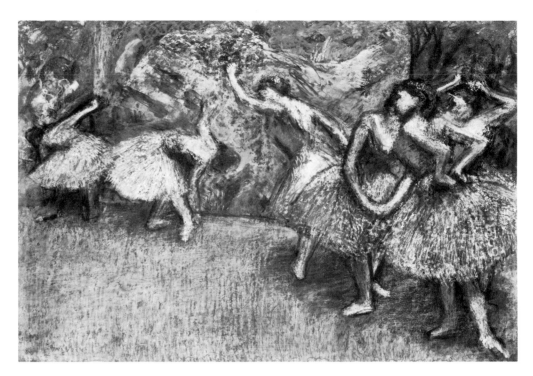

Cat. no. 47. *Ballet Scene* (*Scène de ballet*), c. 1900, pastel. National Gallery of Art, Washington, Chester Dale Collection. (Illustrated in color on page 6.)

herself for the preparation of a Parisian toilette. But gesture, which had once for Degas been expressive of character, personality, and class, becomes expressive of form, shape, line, and balance. Thus the gesture of a ballet dancer standing on one leg, balancing her body by grasping a bar with her left hand in order to examine the sole of her foot, which was frequently repeated in the late sculpture,[1] might serve just as well to represent a bather stepping out from a tub, supporting her weight on a nearby chair.[2] Gesture in the late work of Degas is no longer tied to occupation or personality. These elements are suppressed for the greater emphasis of formal concerns.

Degas' tendency to create what might be called suites of works by repeating single compositions became increasingly pronounced in the 1890s. One theme seems to have interested him, particularly as the decade progressed: dancers seen on the stage in moments between practice and performance, grouped in front of stage sets. Like the *Ballet Dancers in the Wings* (see fig. 4.8), *Ballet Scene* (cat. no. 47) and the *Three Dancers* (cat. no. 48) are derived loosely from the frieze-format compositions of the later 1880s, transposed to a performance locale, and rendered less specific by the broad treatment given to the pastel medium.

The most important of these late groups has as its focus the National Gallery of Art's *Four Dancers* (cat. no. 49), the most monumental of Degas' late canvases, which probably dates from between 1895 and 1900.[3] This composition is ultimately derived from a group

Cat. no. 48. *Three Dancers (Trois danseuses)*, c. 1900, pastel. The Ordrupgaard Collection, Copenhagen.

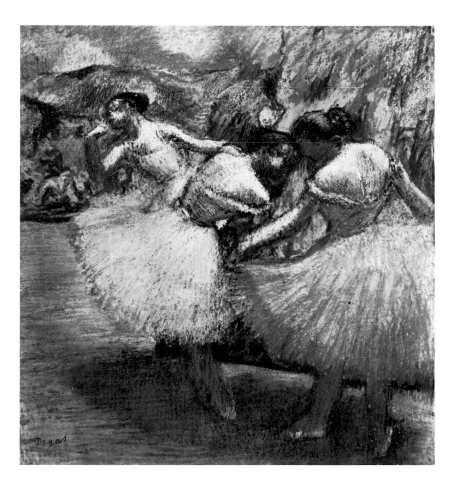

of paintings that can be dated to the mid-1870s, among which is the *Dancers Preparing for the Ballet* from the Art Institute of Chicago (fig. 5.1).[4] In the Chicago picture, as in the National Gallery canvas, a group of dancers adjusting their costumes is arranged before a stage flat. They are evidently hidden from the view of the audience, which must be located behind the viewer outside the picture space. The irregular contour of the flat indicates that it was part of a typical stage decor, in which several such flats were placed in a staggered sequence down the side of the stage to suggest a forest or woodland scene. In each painting, a landscape backdrop provides the ground for the picture, but in the earlier canvas a wealth of anecdotal detail is presented against, and even behind, this ground. A comic element is introduced by the feet of three dancers protruding under the curtain at left. And the three dancers in the foreground seem to be portraits, so individualized are their faces and gestures. They are fully round, standing out from the ground of the stage flat and distinguished from each other. In the National Gallery painting, however, the figures are flattened, merged with each other in a decorative arabesque, and denied individuality.

111

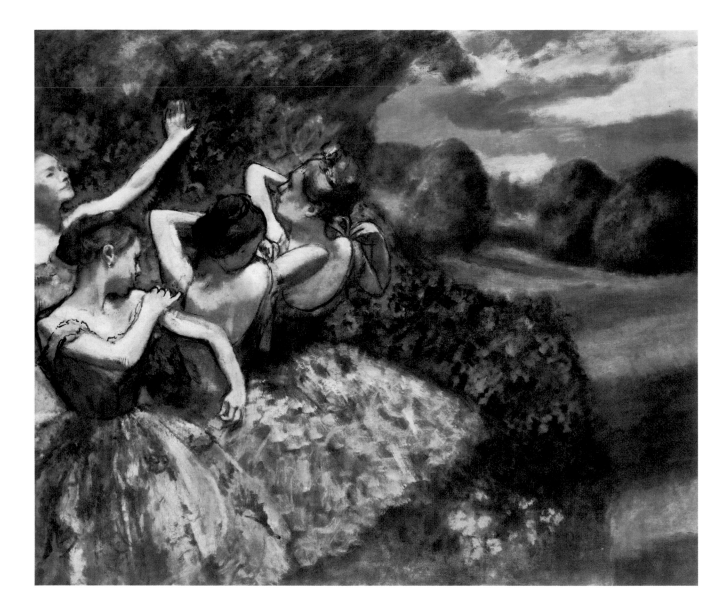

Cat. no. 49. *Four Dancers* (*En attendant l'entrée en scène*), 1895–1900, oil on canvas. National Gallery of Art, Washington, Chester Dale Collection.

Although the Chicago picture and others like it provide a precedent for this kind of multifigured composition in Degas' art, there is another more immediate source for the figures in the painting. In the Bibliothèque Nationale there is a group of photographic negatives of uncertain authorship, but unmistakably connected with the *Four Dancers*. The dancer (or the model costumed as a dancer) represented in these photographs (figs. 5.2–5.4)[5] is seen in a variety of poses: in one image she grasps a screen with an upraised hand; in another she is shown in profile, her arms raised to adjust her shoulder strap; in a third, she is seen from behind, again touching the straps of her bodice with upraised hands. It has always been assumed that Degas himself was the author of these negatives. Unfortunately, it cannot be proved

that Degas actually made the photographs or even that he directed their composition. The sole basis for our assumption of Degas' authorship is the evident relationship between the photographs and his paintings, pastels, and drawings. He undoubtedly used these poses (and presumably, therefore, the photographs) in the suite of works around the *Four Dancers*. It is certain, for instance, that the photograph of a dancer grasping a screen served as a model for the Fitzwilliam Museum's *Half-Length Nude Girl* (cat. no. 50), which studies a pose found in many pastels and drawings of this period, a pose which later was the basis for the figure at the far left of the *Four Dancers* (though the direction of the head has been altered in this case).[6] And the dancer at the far right of the National Gallery canvas is also clearly based on one of the photographs, the image of the dancer in profile (see fig. 5.3).

Contemporary with the National Gallery picture, and closely related to it, are scores of works on paper, ranging from simple charcoal

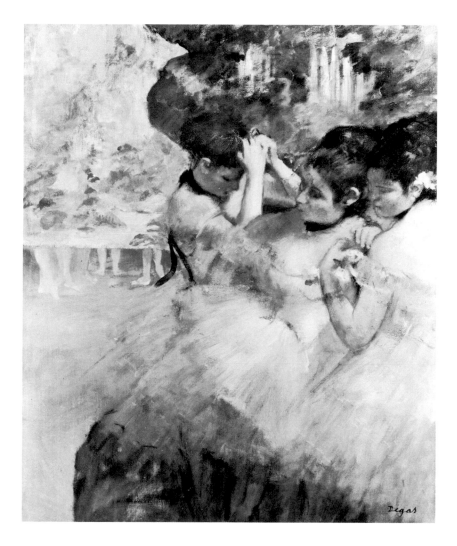

Fig. 5.1. *Dancers Preparing for the Ballet*, c. 1875, oil on canvas. The Art Institute of Chicago, Gift of Mr. and Mrs. Gordon Palmer, Mrs. Bertha P. Thorne, Mr. and Mrs. Arthur M. Wood, and Mrs. Rose M. Palmer.

Left: fig. 5.2. *Dancer,* c. 1895, photograph.
Cabinet des Estampes, Bibliothèque
Nationale, Paris.

Middle: fig. 5.3. *Dancer,* c. 1895, photograph.
Cabinet des Estampes, Bibliothèque
Nationale, Paris.

Right: fig. 5.4. *Dancer,* c. 1895, photograph.
Cabinet des Estampes, Bibliothèque
Nationale, Paris.

studies of isolated figures in the composition to varied groupings of such figures rendered in charcoal and pastel. Many of these pictures show two or more half-length dancers arranged in an overlapping group against an ambiguously rendered stage set. Some of these works on paper incorporate figures from the photographs, but by no means do all of the poses come from this source. Because they are so numerous and so different from one another in visual aspect, these works almost defy classification into categories of "studies" and "finished works." They might be arranged in groups ranging from the plainest to the most elaborate, but this simplistic evolutionary model does not, certainly, reflect the way the works were created.

The *Four Dancers* is much larger in scale than any of the related works on paper. It measures roughly 60 x 70 inches, and the figures represented are only slightly smaller than life size. They are seen at the left of the composition, before a flat that covers approximately half the picture surface; behind this flat is a landscape decor representing a meadow, with scattered trees and a vividly colored sky. The stage flat is painted in scumbled areas of green paint, against which the dancers, red-haired and in costumes tinged with a coral-orange color, are arranged. The entire color scheme is based on the juxtaposition of complementary colors, red-orange and blue-green, similar to the scheme of the Bührle Foundation's *The Rehearsal Room* (cat. no. 41), painted somewhat later, in which the blue component of the green dominates. And as in the *The Rehearsal Room,* the oil is applied in such a way as to replicate the light-shattering qualities of pastel pigments. Thus the skirts of the dancers are composed of layers of lightly

114

Cat. no. 50. *Half-Length Nude Girl* (*Torse de femme* [*étude de nue*]), c. 1895, charcoal heightened with white on tracing paper. The Syndics of the Fitzwilliam Museum, Cambridge, England.

applied, roughly brushed paint, their skin tones rendered in broad areas of pasty pigment, over which firm outlines of brown-red and dark blue are painted after the manner of charcoal drawing. These effects reflect, too, a sequence of campaigns on the canvas similar to the sequential application of pastel pigments to paper. As in a pastel, easily differentiated levels supercede each other, from the cool green ground to the brusquely applied glowing highlights, denying the liquidity of oil paint. The whole is topped off with nervous strokes that break up, like a drawing, the contours of the four figures.

Exactly this kind of fracturing of contour and a concomitant breakdown of color can be seen in the pastels in this group, such as the two pastels entitled *Dancers* (M. Charles Durand-Ruel and the Art Museum, Princeton University, cat. nos. 51 and 52). In each work,

Left: cat. no. 51. *Dancers (Danseuses)*, c. 1898, pastel. M. Charles Durand-Ruel, Paris. (Illustrated in color on page 108.)

Right: cat. no. 52. *Dancers (Groupe de danseuses)*, c. 1895–1900, pastel on tracing paper mounted on wove paper. The Art Museum, Princeton University, Bequest of Henry K. Dick.

again, there is a color scheme built upon the juxtaposition of cool and hot colors. Pastel is applied to the support in vigorous parallel hatchings, layer upon layer, until a vibrating surface of interwoven hues is achieved. In the Princeton pastel, this shimmering quality is particularly apparent in an area such as the shoulder blade of the nearest dancer, where strokes of coral, red, white, and turquoise pastel are placed side by side over a dark ground. The pigment skips over the surface, adhering in tiny dots that appear as stippled color, calling to mind both the rough-textured canvases of Monet's paintings of the 1890s (particularly his paintings of Rouen Cathedral) and the fractured color of the divisionist painters Seurat and Signac.

Pastels like the Durand-Ruel and Princeton *Dancers* are among Degas' most beautiful late works. He almost completely abandoned oil painting in the last years of his life, turning more and more to pastel, a medium in which he could create elaborate, highly finished pictures as his eyesight dimmed. There are several reasons for this almost total switch to pastel after 1895. First, the pastel crayon is more easily controlled than the paintbrush, because the pigment is integral with the tool itself and is held directly in the fingers, becoming almost an extension of the artist's hand. Second, if the layers of pigment are

116

properly fixed between applications of the pastel strokes, the artist may work and rework the surface, building up complex layers of color; thus, by working in pastel, rather than oil paint, Degas could satisfy his desire to create an elaborate picture surface built up of strokes of pure color with less fear of completely covering, and thus obliterating, a prized effect of tint or texture. He invented for himself a technique of superimposing layers of pastel, through the juxtaposition of partially covered pastel strokes, which created an impression of transparency analogous to superimposed glazes in oil painting.[7] The two *Dancers* are among the most highly wrought of Degas' late pastels; there are other examples of varying degrees of finish. But perhaps the most important reason for the change to pastel is the integration of drawing and finished work that occurs in Degas' works of the 1890s, for the pastel is a finished work that is not painted but drawn.

Cat. no. 53. *A Dancer Adjusting Her Shoulder Strap* (*Danseuse rajustant ses épaulettes*), c. 1895–1900, pastel over charcoal on ivory wove paper. Private collection, New York.

118

Cat. no. 54. *Dancer* (*Danseuse*), c. 1895, pastel over charcoal drawing on tracing paper laid down on cardboard. Kunsthalle Bremen, Federal Republic of Germany.

A pastel such as the *Dancer Adjusting Her Shoulder Strap* (cat. no. 53), and the drawing *Dancer* (Kunsthalle Bremen, cat. no. 54), both began as charcoal drawings of the figure in the immediate foreground of the *Four Dancers*. The Bremen drawing, however, has been touched only lightly here and there with pastel color, whereas the other sheet is more uniformly worked. These two drawings represent different stages in the development of a pastel such as the Princeton *Dancers*, which is only slightly larger in format than either of the two less-finished sheets. It, too, almost certainly began as a drawing of a single figure (the foremost figure in red) to which auxiliary figures were added in the background.[8]

From these three works, then, the characteristic stages in the development of a highly finished pastel can be reconstructed. The Bremen sheet is the first stage, a relatively simple, sure drawing in

119

charcoal, in which tones are indicated with rough hatchings of charcoal, occasionally rubbed with a stump or with the artist's fingers to soften contours and create more *sfumato* effects. Areas of smudged charcoal might also be scraped or erased to create lines of white, revealed paper as highlights, and the sheet enhanced with a few carefully applied touches of color (as on the flowers in the dancer's hair).

Degas could attempt a more developed color scheme through the application of broader areas of pastel, as in those that color the costumes and background of the *Dancer Adjusting Her Shoulder Strap* (cat. no. 53). This pastel represents the second stage of development, in which a basic range of hues is established and the first tentative hatchings of pastel color are applied. Most important in this stage is the definition of the relationship between figure and ground, established through the juxtaposition of the lighted shape of the figure and the dark green pastel behind her. While here this juxtaposition makes the figure stand out against the colored ground, it simultaneously breaks down the figurative component suggested by the compact linearity of the simple charcoal drawing. The figure is no longer simply a torso defined by lines drawn onto a blank sheet; it becomes one shape within a more complex jugsaw puzzle of other colored shapes. This effect is most refined in highly wrought pastels like the *Dancers* (see cat. nos. 51 and 52), in which volume, perspective, and density seem to dissolve and to be replaced by pattern: an arabesque composed of adjacent light and dark tones, vivid and somber hues, in a brilliantly worked surface.

In no way does the progression noted in these works reflect a sequence of preparatory study, intermediate pastel *ébauche*, and finished work. Indeed, it seems that Degas considered both of the less-finished works as salable or presentable compositions. Both the charcoal drawing and the pastel *Dancer Adjusting Her Shoulder Strap* are signed, and both left his hands during his lifetime, the former entering the Kunsthalle Bremen in 1904, the latter passing through his dealer Durand-Ruel. Degas could halt the application of pastel pigment at any stage of a work's development, whenever the work seemed to him to have the proper balance of line and color. The distinction among three such works is not that of purpose but of surface. Each drawing holds the promise of a highly wrought pastel; each pastel was once a simple charcoal drawing.

At any stage in a work's development, while it was still a plain drawing or after it had received many layers of pigment, Degas could breed from it another composition on which to practice further experiments in the manipulation of coloristic effects. One simple method of doing this was to pull a counterproof of a charcoal drawing or lightly worked pastel. The pastel *Dancer* (cat. no. 55) probably

Cat. no. 55. *Dancer* (*Danseuse*), c. 1895–1900, pastel over charcoal on ivory laid paper, pieced at top. Bernice Richard, New York.

began as a counterproof of a drawing; it was subsequently elaborated with pastel touches. To make a counterproof, Degas applied a moistened sheet of paper to a heavily worked charcoal or pastel drawing and ran the two sheets together through a printer's press. This process makes, in effect, printed drawings. It should be recalled in this connection that Degas referred to his monotypes as *dessins imprimés;*[9] they (or counterproofs pulled from them while they were still wet) often served him as bases for highly finished pastel pictures. This printing process results in the reversal of the image on the counterproof sheet.

121

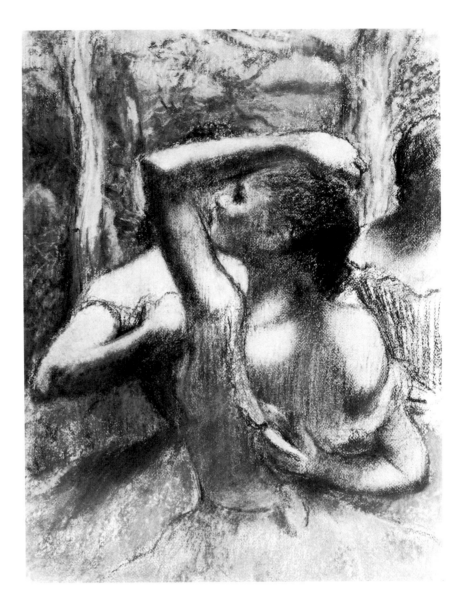

Fig. 5.5. *Dancers*, c. 1897, pastel. The Detroit Institute of Arts, City of Detroit Purchase.

Since it succeeds by transferring some particles of charcoal or pastel to the counterproof paper, the original drawing may be weakened slightly; the counterproof will often be a silvery gray color rather than a more vivid charcoal black. There is frequently the sensation that the particles on the paper have once been wet because they are often grouped in "tide lines" on the fiber of the sheet. Still, it is sometimes difficult to determine which of two related drawings is the original and which the counterproof, especially if both have been reworked in charcoal and pastel after the printing. In the case of the *Dancer*, however, the fact that the figure faces to the left suggests that this sheet is a counterproof image because this particular pose, as seen in the Bremen *Dancer* and the *Dancer Adjusting Her Shoulder Strap*, almost always faces to the right.[10]

Far more frequent than his practice of counterproofing was that of

tracing, which became habitual toward the end of Degas' career. It has been shown in reference to the frieze-format pictures, specifically the charcoal and pastel sheets from Toledo and Cologne, that Degas sometimes traced whole compositions in the course of making new bases for reworking themes. But tracing could also be employed because of the degree to which it allowed the artist to alter, rather than to repeat exactly, a compositional group. For instance, there is another finished pastel version of the Princeton *Dancers* in the collection of the Detroit Institute of Arts (fig. 5.5).[11] It is impossible to say which of these is a tracing of the other, or indeed whether they both might not be tracings of a third object. What can be established is that in making the tracings in charcoal that served as the bases for both these objects, Degas varied the relative positions of the two background figures. Thus, in the Detroit pastel, the auxiliary figures are more widely spaced apart, the right-hand dancer cropped by the edge of the frame, while in the Princeton pastel they are more compactly grouped at the center of the composition.

Degas used ordinary tracing paper, or *papier calque*, placing it over another drawing or perhaps a pastel and proceeding to redraw the composition figure by figure with heavy charcoal lines. (Thus, hypothesizing that the Detroit pastel is a tracing of the Princeton sheet, he might have begun by tracing the central dancer scratching her back.) In the event that he wanted to change a figure's position, he need only have moved the tracing paper slightly before recommencing the tracing process. To build up an entirely new grouping of figures, such as the group shown in the tracing from Oberlin (cat. no. 56), he could trace drawings of single figures (like the Bremen sheet, see cat. no. 54, itself a tracing) or incorporate portions of established figure groups.

In the process of tracing, figures often become radically simplified, rendered with bold black strokes of charcoal against a blank, neutral space. A powerful drawing from a private collection, *Dancers, Nude Study* (cat. no. 57), is therefore a simplification of the pastel *Dancers* (cat. no. 51), dated by Lemoisne to 1899. It seems likely that the traced drawing was made directly from the pastel because of the correspondence of scale and figure placement. The tracing incorporates another figure, however, the dancer with one arm upraised known from the Fitzwilliam Museum's *Half-Length Nude Girl* (see cat. no. 50). In making the tracing, Degas was forced to add a strip to the right side of the image to accommodate the arms of the dancers at the far right; another sheet was positioned at the bottom of the original sheet to make the format of the drawing vertical. The expansion of a format by the addition of strips of paper is commonly found throughout Degas' career; but in the late pastels it almost becomes the rule. Such strips were then glued, together with the principal sheet,

123

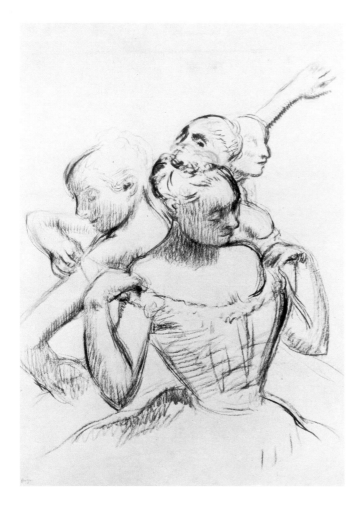 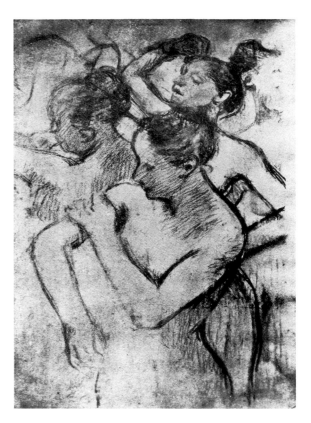

Left: cat. no. 56. *Group of Four Dancers* (*Groupe de danseuses vues en buste*), c. 1895–1900, charcoal on tracing paper mounted on cardboard. Allen Memorial Art Museum, Oberlin College, Oberlin, Ohio, Friends of Art Fund.

Right: fig. 5.6. *Dancers, Nude Study,* c. 1897, charcoal (counterproof). Present location unknown; as reproduced in *Vente* 2:376.

to a thick paper or cardboard upon which the artist continued to work. Traces of pastel were applied to the *Dancers, Nude Study* but the drawing was left in its original charcoal state. Before 1914 Degas sold it to Ambroise Vollard, who seems to have had a particular interest in this phase of the artist's draftsmanship. In his memoir of Degas Vollard described the process of tracing used in many of the late works: "Because of the many tracings that Degas did of his drawings, the public accused him of repeating himself. But his passion for perfection was responsible for his continual research. Tracing-paper proved to be one of the best means of 'correcting' himself. He would usually make the correction by beginning the new figure outside the original outlines, the drawing growing larger and larger . . ."[12]

Vollard attributes Degas' repetition of drawings and compositions to a dissatisfaction with the results of previous experiments or campaigns with a theme: he views the tracings as "corrections" of past failures. Clearly this limited way of looking at Degas' traced drawings does not explain his almost compulsive multiplication of identical images. There is in the Evergreen House Foundation in Baltimore a

124

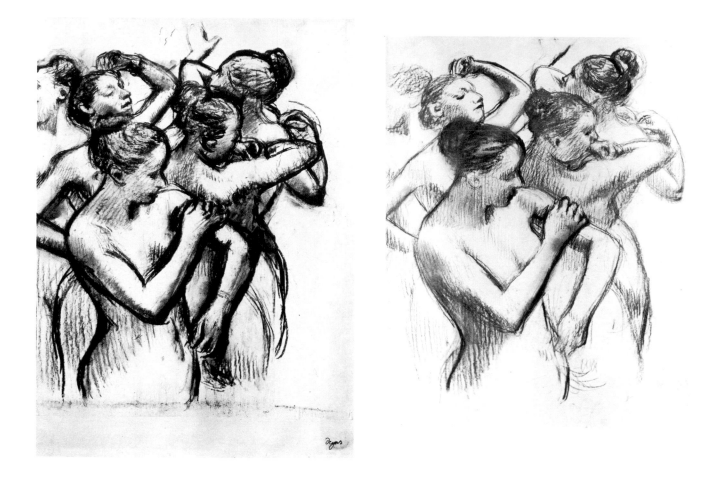

Left: cat. no. 57. *Dancers, Nude Study* (*Danseuses*), c. 1895–1900, charcoal and pastel on tracing paper mounted on cream-colored wove paper. Private collection.

Right: cat. no. 58. *Group of Dancers* (*Quatre danseuses*), c. 1895–1900, charcoal and pastel on tracing paper mounted on ivory wove paper. On loan from Evergreen House Foundation, Baltimore.

traced drawing (cat. no. 58) that is surely made from the *Dancers, Nude Study*. If the existence of this slightly later drawing means only that Degas was dissatisfied with the earlier one, how can the counterproof taken from the *Dancers, Nude Study* (fig. 5.6) be explained?[13] The point of Degas' repetition was not, of course, the correction of old mistakes but the exploration of new, uncharted fields of possibility.

This is not to say that Degas was ever entirely satisfied with the scope of what he had done in the past. We have seen that from the very beginning of his mature career repetition had been the most important of his working methods, whether it was the repetition of a whole composition or merely of one figure. The personality that motivated this obsessive artistic introspection was unquestionably a complex one. To attribute this pervasive habit of mind to insecurity would be tempting, particularly in light of Degas' well-known letter, written in 1890 to his dear friend Evariste de Valernes:

I want to beg your pardon for something that comes up often in your conversation and more often in your thoughts: . . . that I have been, or have seemed to be *hard* with you . . . I was or I seemed hard with everyone, on

account of a certain tendency towards brutality which came to me from my doubts and from my bad humour. I felt myself so ill-made, so vulnerable, so soft, while it seemed to me that my *calculations* in art were so right. I sulked against everybody and against myself. I really ask for your pardon if, under the pretext of this damned art, I have wounded your very noble and very intelligent spirit, maybe even your heart.[14]

But Degas' continual return to his own art for inspiration is no more morbid than it is narcissistic. It reflects a lack of complacency with his accomplishments and a knowledge that in doing a subject ten times or a hundred times the artist was more likely to achieve something really great. But even if we can see the principles at work in Degas' art and can describe minutely both the mechanics of his working methods and the iconography of his pictures, Degas seldom lets us see him behind the surface of the picture. What emerges to us most vividly is a picture of Degas as a thoughtful artificer—the perfect criminal, to paraphrase one of his famous aphorisms. His works are the result of those collaborations between the imagination and memory of which he spoke.

Still, we can feel that his art is the embodiment not only of his intellect, but his sentiments as well. For if Degas was a man who chose to depict subjects taken from the visible parade of his life—the life of an upper-class Parisian man, witty, sophisticated, urbane—still his manner of studying them mirrors his own self-probing, introspective personality. On the surface, his pictures may be blithe, ironic, or light in tone, like the letter he wrote in 1883 to his friend Ludovic Halévy:

My dear Halévy,
 You must know what it's like when a dancer wants you to put in a good word for her. She comes around twice a day to find out if you've seen anyone, written to anyone. . . Are you feeling better? If you have the courage or the strength, write a word to Vaucorbeil [the director of the Opera] or to Mérante, not about her physical charms, for that would be stupid, but about her dancing, her past, and her future.
 I've never seen anyone in such a state of excitement. She wants everything done right away. And she'd take you in her arms in a blanket and carry you off to the Opera if she could!

 Amitiés—Degas.[15]

But we know that Degas' pictures are not tossed off like the bon mots for which he was so famous. Instead, their complex origins reveal to us a more contemplative side of his character, a side he seldom revealed in words. To the sculptor Bartholomé, a cherished friend of his old age, he wrote:

I speak about the past, because, excepting the heart, it seems to me that everything is getting older in me proportionally. And even the heart has something artificial about it. The dancers have sewn it up in a sack of pink satin, pink satin a little bit worn, like their dancing slippers.[16]

126

NOTES

1. For example, Rewald 1944, no. 66.

2. For example, *Bather*, Washington, The Phillips Collection, Lemoisne no. 1204.

3. The problem of dating Degas' late work is notorious. Lemoisne, attempting to catalogue some 1,500 paintings, pastels, and drawings, was frequently constrained only to guess at dates. Some of his many errors have been subsequently corrected, but the late works are almost never dated by Degas, and one must resort, therefore, to giving only an approximation of a chronology. We do not even know when the artist stopped working altogether: there is evidence of his working still in pastel as late as 1907 (Guérin 1945, 241), but it seems unlikely that he worked much after the relocation of his studio in 1911.

4. Lemoisne no. 512. The painting is dated by Lemoisne c. 1878–1880, but it must have been finished before 1876, as it was shown at the second impressionist exhibition that year, where it was seen and described by J.-K. Huysmans (Reff 1976b, 1:125 [Nb. 26:74]). Other pictures incorrectly dated which may be linked with this painting are Lemoisne nos. 617, 783, and 784, all of which Lemoisne dates after 1880. Their facture indicates a date of c. 1875–1878.

5. Cabinet des Estampes, Bibliothèque Nationale, Paris. The Cabinet des Estampes possesses no vintage proofs from these negatives, and it is unclear whether their apparent solarization is the result of chemical changes in the salts on the plate or a deliberate alteration in negative/positive values made during the development of the plate. To further compound the problem, the Bibliothèque Nationale has made available what appear at first to be photographs taken from the negatives, but are actually photographs of the negatives themselves seen against a light source. These appear with a small black dot in an upper corner (actually a label on the plate seen against the light source). Proofs properly taken from the negatives show this opaque label as a white spot.

6. It should be noted that this pose had been current in Degas' repertoire since the early 1870s. Such a figure appears, for instance, in the left-hand group in the *Rehearsal of a Ballet on Stage* (Metropolitan Museum of Art, fig. 1.9).

7. Denis Rouart, *Degas à la recherche de sa technique* (Paris, 1945), 34.

8. A charcoal drawing, retouched with pastel, is *Vente* 2:295; Lemoisne catalogues three other versions of the pastel, nos. 1311, 1313, and 1314. This configuration of figures also finds a parallel in the pastels, nos. 1278–1281.

9. An *impression en noir* formed lot 349 of *Vente* 4; it was probably a counterproof of the *Dancer Adjusting Her Shoulder Strap* (cat. no. 53). Lemoisne subsequently referred to it as a "Monotype" (see cross-reference in Lemoisne no. 1235, *Dancer*, cat. no. 55). Another pair of cognates can be identified in *Vente* 3:185 and *Vente* 4:368.

10. In this case, the original drawing might be Lemoisne no. 1269 or 1272, known to me only in reproduction. The unusual pose of the hand turned back on the hip and its relation to the elbow of the other arm are very similar in the two images, though perhaps the position of the lifted hand in no. 1272 is closer to the pastel in question. Either 1269 or 1272 might also be a tracing of the sheet to which cat. no. 55 is cognate.

11. Lemoisne no. 1311.

12. Ambroise Vollard, *Degas* (New York, 1937), 62–63.

13. Lemoisne no. 1355 bis. See also Eugenia Parry Janis, in Charles Scott Chetham, ed., *Modern Painting, Drawing, and Sculpture Collected by Louise and Joseph Pulitzer, Jr.* [exh. cat. Fogg Art Museum, Harvard University] (Cambridge, Mass., 1971), 398–401.

14. Guérin 1945, 178–179. (translation GTMS)

15. Guérin 1945, 72–73. (translation GTMS)

16. Guérin 1945, 118. (translation GTMS)

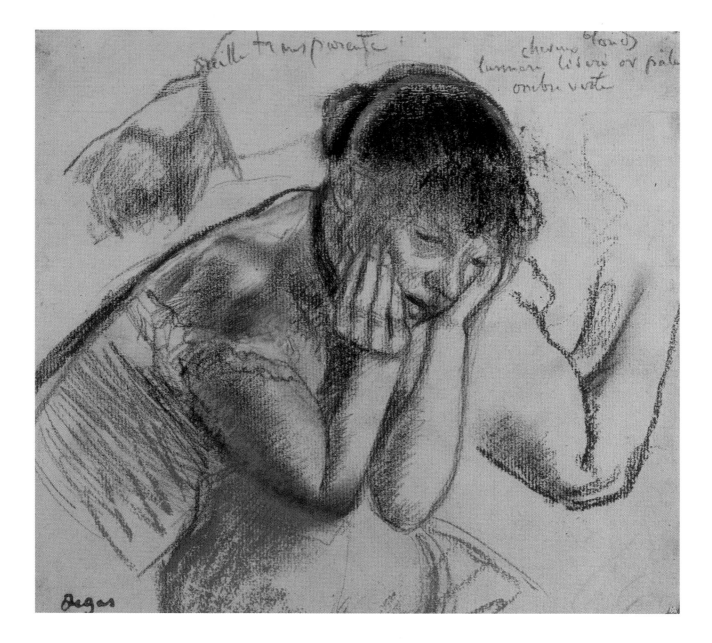

Checklist of the Exhibition

NOTE TO THE READER

THIS CHECKLIST is intended to be a guide for the reader of the catalogue, providing a description of each work in the exhibition, including its provenance, bibliography, and exhibition history to the extent of my knowledge. When a work comes from a public collection, its inventory number has been included. It follows the order in which the works are discussed in the text. Since this order is not strictly chronological, and since I have appended no critical material to the entries here, the checklist will be best used in conjunction with the catalogue's five chapters. Two bibliographic references should be clarified in this note: the sales of the contents of Degas' atelier at the time of his death, cited in the provenance as *Vente*, followed by the number of the sale and the lot number of the work; and Lemoisne's catalogue raisonné of Degas' works, cited in the checklist as *Lemoisne*, followed by his catalogue number. The French titles given in the checklist are those assigned by Lemoisne or those given in the *Vente* catalogues, and are not always direct translations of the English titles. The stamp of Degas' signature applied to the unsigned works sold in the atelier sales (as catalogued and described in Fritz Lugt, *Les marques de collections de dessins & d'estampes*, Amsterdam, 1921, no. 658) is referred to here as *signature stamp*. A work bearing this stamp, almost without exception, bears an oval stamp of the atelier (Lugt no. 657) on its verso; because I was not always able to examine the verso of an object, this stamp has not been cited in this checklist. Full citations of short references above and in the checklist may be found in the bibliography; important exhibition catalogues are cited by both author and city.

Left: cat. no. 36. *Bust-Length Study of a Dancer* (*Femme accoudée, vue à mi-corps*), c. 1880, black chalk and pastel on beige laid paper. Narodni Muzej, Belgrade.

1. *The Orchestra of the Opera* (*L'orchestre de l'opéra*), 1868–1869

oil on canvas
56.5 x 46.2 cm. (22¼ x 18¼ in.)
signed *Degas* lower right
Musée d'Orsay (Galerie du Jeu de Paume), Paris
RF 2417

Provenance
Désiré Dihau, Paris; Mlle. Marie Dihau, Paris; Musées Nationaux, France, 1924 (life interest retained by Mlle. Dihau); Musée du Louvre, Paris, 1935

Literature
Lemoisne no. 186 (with a summary of the bibliography up to date of publication); Paul Jamot, "La peinture au Musée du Louvre, école Française, XIXᵉ siècle (3ème partie)," *L'Illustration* (Paris, 1928), 54–57; Browse 1949, 335, pl. 4; Cabanne 1957, 109, no. 38; Adhémar 1958, no. 68; Germain Bazin, *Trésors de l'Impressionnisme au Louvre* (Paris, 1958), 113; Boggs 1962, 28–30, 92 no. 40–43; Bouret 1965, 60; Rewald 1973, 274; Reff 1976a, 76; Reff 1976b, 1:119–120, 122–123; Dunlop 1979, pl. 64.

Exhibitions
Lille 1870–1871 (exhibited at an unknown dealer during the Commune); Paris: Galerie Durand-Ruel, 1871; Paris 1924, no. 30; Paris 1931, no. 44; Philadelphia 1936, no. 12; Paris 1937, no. 9; Paris 1969, no. 16; Paris/New York: *Impressionism: A Centenary Exhibition*, Réunion des Musées Nationaux; Metropolitan Museum of Art, 1974, no. 12.

2. *The Ballet from Robert le Diable* (*Le ballet de Robert le Diable*), 1872

oil on canvas
66 x 54.3 cm. (26 x 21⅜ in.)
signed *Degas/1872* lower right
The Metropolitan Museum of Art, New York, Bequest of Mrs. H. O. Havemeyer, 1929. The H. O. Havemeyer Collection

Provenance
Albert Hecht, Paris; Durand-Ruel, Paris, 1886; Jean-Baptiste Faure, Paris; Durand-Ruel, Paris and New York, 1894; H. O. Havemeyer, New York, 1898

Literature
Lemoisne no. 294; Browse 1949, 337, pl. 8; Mayne 1966, 148–156; Sterling and Salinger 1967, 3: 66–68 (for selected references, annotated, before 1967); Reff 1976a, 221; Reff 1976b, 7–19; Moffett 1979, 7, 9–10, pl. 13.

Exhibitions
(See Sterling and Salinger, above, for complete citations of pre-1967 exhibitions.)
London: *Fourth Exhibition of the Society of French Artists*, Durand-Ruel (at 168 New Bond Street), 1872, no. 95; New York: *Works in Oil and Pastel by the Impressionists of Paris*, National Academy of Design, 1886, no. 17; New York: *The H. O. Havemeyer Collection*, Metropolitan Museum of Art, 1930, no. 50; New York 1949, no. 23; Sydney/ Melbourne/ New York: *Modern Masters, Manet to Matisse*, Art Gallery of New South Wales, National Gallery of Victoria, Museum of Modern Art, 1975, no. 25; New York: *Degas at the Metropolitan*, Metropolitan Museum of Art, 1977.

3. *Ballet Dancer* (*Danseuse*), c. 1878

pastel over monotype
36 x 22 cm. (14¼ x 8¾ in.)
signed *Degas* lower left
Private collection, New York

Provenance
Mme. Angelot; M. Knoedler and Co., Paris; Robert Osgood, Boston

Literature
Lemoisne no. 449.

Exhibitions
Paris: *Degas*, Galerie Georges Petit, 1924, no. 114 (from the collection of Mme. Angelot).

4. *Ballet* (*Avant le ballet*), c. 1877

pastel (possibly over a monotype base)
32.4 x 25.4 cm. (12¾ x 10 in.)
signed *Degas* lower left
The Corcoran Gallery of Art, Washington, William A. Clark Collection 26.71

Provenance
Charpentier collection, Paris; Adolphe Tavernier, Paris (sale, Paris, Galerie Georges Petit, 6 March 1900, no. 117); Durand-Ruel, New York Senator William A. Clark, Washington; The Corcoran Gallery of Art, Washington, 1926

Literature
Lemoisne no. 500; Lafond 1919, 2:36–37; J. B. Manson, *The Life Work of Edgar Degas* (London, 1927), pl. 63; Camille Mauclair, *Degas* (New York, 1941), 152; Browse 1949, 384, pl. 139; Corcoran Gallery of Art, *Illustrated Handbook, W. A. Clark Collection* (Washington, 1932), 43, no. 2071.

Exhibitions
New York: *Masterpieces of the Corcoran Gallery*, Wildenstein and Co., 1959; New York: *100 Years of Impressionism*, Wildenstein and Co., 1970, no. 44; Washington: *The William A. Clark Collection*, Corcoran Gallery of Art, 1978.

5. *Dancers Backstage* (*L'entrée en scène*), c. 1875

oil on canvas
24.2 x 18.8 cm. (9½ x 7⅜ in.)
inscribed *Degas* upper right
National Gallery of Art, Washington, Ailsa Mellon Bruce Collection
1970.17.25

Provenance
Théodore Duret, Paris (sale, Paris, Georges Petit, 16 March 1894; no. 12); Durand-Ruel, Paris; Reid and Lefevre, London, 1928; Carroll Carstairs, New York; Ailsa Mellon Bruce, New York, 1948

Literature
Lemoisne no. 1024; Browse 1949, 394, pl. 175; Minervino 1970, no. 859; Walker 1975, 483; Theodore Reff, "Degas and de Valernes in 1872," *Arts Magazine* 56, no. 1 (September 1981), 126–127; Reff 1982–1983, 120.

Exhibitions
New York 1949, no. 78; San Francisco 1961, no. 18; Washington 1966, no. 61; Washington 1978, no. 24.

6. *The Curtain* (*Le rideau*), c. 1880

pastel over monotype
35 x 41 cm. (10¾ x 12¾ in.)
signed *Degas* lower left and lower right
From the Collection of Mr. and Mrs. Paul Mellon, Upperville, Virginia

Provenance
Durand-Ruel; Lord Berners, Faringdon House, Berkshire, England

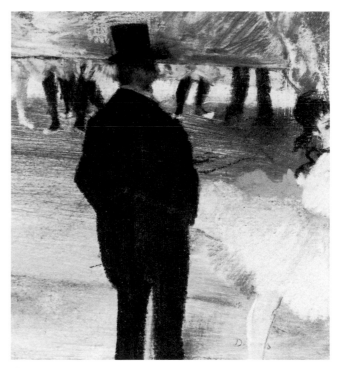

Cat. no. 6 (detail).

Literature
Lemoisne no. 652; Bouret 1965, 121; Minervino 1970, no. 772; Dunlop 1979, pl. 126.

Exhibitions
Washington 1966, no. 229.

7. *Dancers at the Old Opera House* (*L'opéra* [*Danseuses à l'ancien Opéra*]), c. 1877

pastel over monotype
21.8 x 17.1 cm. (8⅝ x 6¾ in.)
signed *Degas* lower right
National Gallery of Art, Washington, Ailsa Mellon Bruce Collection
1970.17.26

Provenance
Antonin Proust, Paris; M. Knoedler and Co., Paris; César de Hauke, New York; Andrew W. Mellon, Washington; Ailsa Mellon Bruce, New York, 1930

Literature
Lemoisne no. 432; Minervino 1970, no. 501; J. Clay, *L'Impressionnisme* (Paris, 1971), 68; Walker 1975, 483; Fletcher 1984, 53–55.

131

Exhibitions
Paris: *Exposition Universelle*, 1900; New York 1960, no. 25;
San Francisco 1961, no. 19; Washington 1966, no. 53;
Washington 1978, 26; Washington 1982–1983, no. 36.

8. *Dancers on the Stage* (*Un coin de scène pendant le ballet*), c. 1885

pastel
63.8 x 49.2 cm. (25⅛ x 19⅜ in.)
signed *Degas* lower left
Mr. and Mrs. Frank Bartholow and the Dallas Museum
of Fine Arts

Provenance
Georges Viau, Paris; Wilhelm Hansen, Copenhagen; Mr.
and Mrs. Frank H. Ginn, Cleveland; Mr. and Mrs. William
Powell Jones, Gates Mills, Ohio; Mr. and Mrs. Algur Mead-
ows, Dallas; Mr. and Mrs. Frank Bartholow, Dallas

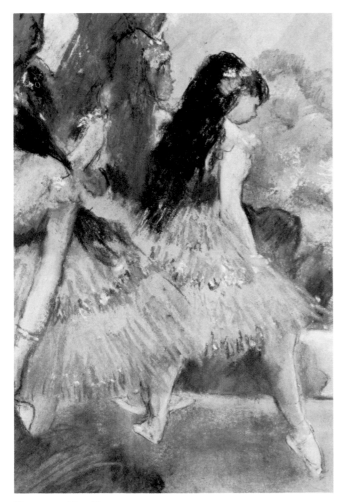

Cat. no. 9 (detail).

Literature
Lemoisne no. 720; Lafond 1918, 2: facing 26; Hoppe 1922,
52; Paul Jamot, *Degas* (Paris, 1924), pl. 62; Bouret 1965,
121; Minervino 1970, no. 796.

Exhibitions
Philadelphia 1936, no. 42; Cleveland 1947, no. 39.

9. *Ballet Dancers* (*Danseuses*), c. 1878

gouache and pastel over monotype
29.7 x 26.9 cm. (11¾ x 10⅝ in.)
signed *Degas* lower left and lower right
National Gallery of Art, Washington, Ailsa Mellon Bruce
Collection
1970.17.27

Provenance
Arnold and Tripp, Paris, 1881; Heber R. Bishop, New
York (sale, New York, American Art Association, 20 Jan-
uary 1906, no. 13); Durand-Ruel, New York; Rosenberg
collection, Paris, 1908; César de Hauke, New York; Edward
Molyneux, Paris; Ailsa Mellon Bruce, New York, 1955

Literature
Lemoisne no. 481; Minervino 1970, no. 531; Walker 1975,
483; Fletcher 1984, 53–55.

Exhibitions
Paris 1924, no. 127; Paris: *Danse et divertissements*,
Charpentier, 1948–1949; Washington/New York: *French
Paintings from the Molyneux Collection*, National Gallery of
Art, Museum of Modern Art, 1952; New York 1960, no.
27; San Francisco 1961, no. 17; Washington 1966, no. 52;
Washington 1978, 28; Washington 1982–1983, no. 37.

10. *The Dance Class* (*La classe de danse*), c. 1875

oil on canvas
85 x 75 cm. (33½ x 29½ in.)
signed *Degas* lower left
Musée d'Orsay (Galerie du Jeu de Paume), Paris
RF 1976

Provenance
Captain Henry Hill, Brighton (sale, London, Christie's,
25 May 1889, no. 27); Goupil and Co., Paris; Manzi col-
lection, Paris, 1889; Le Comte Isaac de Camondo, Paris,
1893; Musée du Louvre, Paris, 1911

Literature
Lemoisne no. 341 (with a summary of the bibliography
up to date of publication).

Browse 1949, 343, pl. 23; Adhémar 1958, no. 80; Pickvance 1963, 256–266; Bouret 1965, 82–84; Minervino 1970, no. 479; Dunlop 1979, 113, 117–118; Roberts 1982, 19.

Exhibitions
Brighton: *Third Annual Winter Exhibition of Modern Pictures*, 1876, no. 186; London: Deschamps Gallery, 1876, no. 127 (as *Preliminary Steps*); Paris 1924, no. 46; Paris 1937, no. 21; New Orleans/New York: *Masterpieces of French Painting through Five Centuries*, New Orleans Museum of Art, Wildenstein and Co., 1953–1954, no. 75; Munich: *Französische Malerei des 19. Jahrhunderts von David bis Cézanne*, Haus de Kunst, 1964–1965, no. 81; Paris 1969, no. 25.

11. *Dancing Master (Maître de danse)*, c. 1874

graphite and charcoal on tan laid paper
45.0 x 26.2 cm. (16⅛ x 11⅝ in.)
signature stamp lower left
The Art Institute of Chicago, Gift of Robert Sonnenschein II
1951.110a

Provenance
Atelier Degas, *Vente* 4:206a; Robert Sonnenschein II

Literature
Joachim and Olsen 1979, 43, no. 2G1.

Exhibitions
St. Louis 1967, no. 65; Chicago 1984, no. 23.

12. *Dancing Master (Maître de danse)*, c. 1874

black ink, watercolor, and oil over graphite on buff laid paper
41.0 x 29.8 cm. (17¾ x 10¼ in.)
signature stamp lower left
The Art Institute of Chicago, Gift of Robert Sonnenschein II
1951.110b

Provenance
Atelier Degas, *Vente* 4:206b; Robert Sonnenschein II

Literature
Lemoisne no. 367 bis; Browse 1949, 351, pl. 40a; Reff 1976a, 282; Joachim and Olsen 1979, 43, no. 2F12.

Exhibitions
St. Louis 1967, no. 66; Chicago 1984, no. 24.

13. *The Dancer Jules Perrot (Le maître de ballet)*, 1875

peinture à l'essence on tan paper
48 x 30 cm., sight (18⅞ x 11¾ in.)
signed *Degas/1875* lower right
Henry P. McIlhenny, Philadelphia

Provenance
Maurice Exteens, Paris; Petitdidier collection, Paris; Fernand Ochsé, Paris; Paul Brame, Paris; César de Hauke, New York

Literature
Lemoisne no. 364; Rivière 1922–1923, 1:pl. 26; Browse 1949, 343, pl. 24; Rosenberg 1959, 113; Boggs 1962, 56–57, 127–128.

Exhibitions
Copenhagen: *Art français*, 1914, no. 703; Paris 1924, no. 54 (as *Le régisseur Pluque)*; Philadelphia 1936, no. 78; Cleveland 1947, no. 67; St. Louis 1967, no. 73; Allentown: *French Masterpieces of the 19th Century from the Henry P. McIlhenny Collection*, Allentown Art Museum, 1977, 50–51; Atlanta: *The Henry P. McIlhenny Collection: Nineteenth-Century French and English Masterpieces*, High Museum of Art, 1984, no. 19 (with complete bibliography and exhibition history).

14. *A Ballet Dancer in Position Facing Three-Quarters Front (Danseuse vue de face)*, c. 1872

graphite and crayon heightened with white chalk on pink wove paper
41 x 28.4 cm. (16⅛ x 11¼ in.)
signed *Degas* lower right
The Fogg Art Museum, Harvard University, Cambridge, Bequest of Meta and Paul J. Sachs
1965.263

Provenance
Atelier Degas, *Vente* 1:328; Fevre collection, Paris; César de Hauke, New York; Paul J. Sachs, Cambridge, Massachusetts, 1929

Literature
Degas. Vingt dessins 1861–1896 (Paris, 1898), pl. 10; Agnes Mongan and Paul J. Sachs, *Drawings in the Fogg Museum of Art* (Cambridge, Mass., 1940), 360–361, no. 670 (includes pre-1940 bibliography and exhibition history); Browse 1949, 338, pl. 10.

Exhibitions
(See Mongan and Sachs, above, for summary of early exhibitions.)
Rotterdam/Paris/New York: *French Drawings from American Collections, Clouet to Matisse*, Museum Boymans-van Beuningen, Musée de l'Orangerie, Metropolitan Museum of Art, 1958–1959, no. 166; Cambridge/New York: *Paul J. Sachs Memorial Exhibition*, Fogg Art Museum, Metropolitan Museum of Art, 1965–1967, no. 59; St. Louis 1967, no. 70; Northampton 1979, no. 8.

15. *Dancer in Profile Facing Right* (*Danseuse vue de profil vers la droite*), c. 1874

charcoal and black chalk heightened with white chalk on beige-pink laid paper
46.2 x 30.6 cm. ($18^3/_{16}$ x $12^1/_{16}$ in.)
signature stamp lower right
Cabinet des Dessins, Musée du Louvre, Paris
RF 4645

Provenance
Atelier Degas, *Vente* 3:341a; Musée du Luxembourg, Paris; Cabinet des Dessins, Musée du Louvre, Paris, by transfer, 1930

Literature
Rivière 1922–1923, 2: pl. 76; Jean Leymarie, *Les Dessins de Degas* (Paris, 1948), pl. 2.

Exhibitions
Paris 1937, no. 84; Paris 1969, no. 170.

16. *The Dancer Jules Perrot* (*Le danseur Perrot, debout*), c. 1875

charcoal and black chalk heightened with white chalk on pinkish laid paper
47.2 x 31.4 cm., irregular ($18^5/_8$ x $12^3/_8$ in.)
signature stamp lower left; inscribed upper right: *reflets rouge de la/chemise dans le cou/pantalon bleu/flanelle//tête rose*
The Syndics of the Fitzwilliam Museum, Cambridge, England
PD.25 — 1978

Provenance
Atelier Degas, *Vente* 3:157b; Thomas Agnew, London; Lefevre Gallery, London; Andrew Gow, Cambridge, England

Literature
Browse 1949, 343, pl. 24n; Bouret 1965, facing 84 (repr.)

Exhibitions
Cambridge 1978; London 1978, no. 25; Edinburgh 1979, no. 16.

17. *The Ballet Master* (*Le maître de ballet*), c. 1874

monotype heightened and corrected with white chalk or wash
executed in collaboration with Vicomte Lepic
56.5 x 70 cm., plate ($22^1/_4$ x $27^1/_2$ in.)
signed *Lepic/Degas* upper left in plate
National Gallery of Art, Washington, Rosenwald Collection 1964
B24,260

Degas

Cat. no. 20 (detail).
Left: cat. no. 18. *The Little Fourteen-Year-
Old Dancer* (*La petite danseuse de quatorze ans*),
bronze cast of a wax original.
The Virginia Museum, Richmond.

Provenance
Ambroise Vollard, Paris; Henri Petiet, Paris; Lessing J.
Rosenwald, Jenkintown, Pennsylvania, 1950

Literature
Marcel Guérin, "Notes sur les monotypes de Degas,"
L'Amour de l'Art 5 (March 1924), 78; Eugenia Parry Janis,
"The Role of the Monotype in the Working Method of
Degas," *Burlington Magazine* 109 (January 1967), 20–27;
Jean Adhémar and Françoise Cachin, *Degas: The Complete
Etchings, Lithographs and Monotypes* (New York, 1975), 269,
no. 1.

Exhibitions
Cambridge 1968, no. 1; Kansas City: Nelson-Atkins
Museum, 1973–1974; Washington: *Lessing J. Rosenwald, Trib-
ute to a Collector*, 1982, no. 66.

18. *The Little Fourteen-Year-Old Dancer* (*La petite
danseuse de quatorze ans*), c. 1881, posthumously
cast in bronze

bronze cast of a wax original
h. 97.8 cm., without base (38½ in.)
stamped in relief CIRE PERDUE A. A. HEBRARD and HER-D
on base and again on left thigh of dancer
The Virginia Museum, Richmond

Provenance
Mlle. Jeanne Fevre, Paris (Degas' niece); Buchholz
Gallery, New York

Literature
Lafond 1918, 2:64-66; *L'Amour de l'Art* 1931, 295, pl. 71;
Rewald 1944, 6-8, 60-69, no. 20; Browse 1949, 370, pl.
96; Millard 1976, pl. facing 62, pl. 26, 28, extensive bib-
liography and exhibition reviews, 119-134; Reff 1976a,
239-248; Peter Fusco and H. W. Janson, *The Romantics to
Rodin* [exh. cat., Los Angeles County Museum of Art] (Los
Angeles, 1980), 229.

Exhibitions
Examples of this work exist in many collections and have
been frequently exhibited. The original wax was exhibited
as *Petite danseuse de quatorze ans* at the *6e exposition de peinture
par Mlle. Cassatt, MM. Degas . . .* (sixth impressionist exhi-
bition), Paris, 1881, no. 12.

19. *Four Studies of a Dancer* (*Quatre études d'une
danseuse*), 1878–1879

charcoal corrected with white chalk on rose-beige wove
paper
49.1 x 32.0 cm. (19¼ x 12⅝ in.)
signature stamp lower right; inscribed in graphite upper
left: *36 rue de Douai — Marie*
Cabinet des Dessins, Musée du Louvre, Paris
RF 4646

Provenance
Atelier Degas, *Vente* 3:341b; Musée du Luxembourg, Paris;
Cabinet des Dessins, Musée du Louvre, Paris, by trans-
fer, 1930

Literature
P.-A. Lemoisne, "Les Statuettes de Degas," *Art et Décoration*
(September-October 1919), 214; Rivière 1922–1923, 1:pl.
36; Browse 1949, 369, pl. 94; Rosenberg 1959, 113, pl.
213; Reff 1976a, 239-248, fig. 161; Millard 1976, pl. 27.

Exhibitions
London: *French Drawings from Fouquet to Gauguin*, London Arts Council, 1952, no. 49; Washington/Cleveland/St. Louis/Cambridge/New York: *French Drawings: Masterpieces from Five Centuries*, National Gallery of Art, Cleveland Museum of Art, City Art Museum, Fogg Art Museum, Metropolitan Museum of Art, 1952–1953, no. 157; Rome/Milan: *Il Disegno Francese*, 1959–1960, no. 182.

20. *Three Studies of a Dancer (Trois danseuses)*, 1878–1879

black chalk and pastel over graphite heightened with white chalk on buff laid paper
48.0 x 61.5 cm. (19 x 24 in.)
signed *Degas* lower left
The Art Institute of Chicago, Bequest of Adele R. Levy
1962.703

Provenance
Roger Marx, Paris (sale, Paris, Galerie Manzi, Joyant, 11–12 May 1914, no. 124); Bibliothèque d'Art et d'Archéologie, Paris (according to Lemoisne); Adele R. Levy, New York

Literature
Lemoisne no. 586 ter; *L'Amour de l'Art* 1931, 294; Camille Mauclair, *Degas* (Paris, 1937), 150; Rewald 1944, 62; Browse 1949, 368, pl. 91; Joachim and Olsen 1979, 40, 2F2.

Exhibitions
Edinburgh 1979, no. 76; Chicago 1984, no. 42.

21. *Two Studies of a Dancer (Deux danseuses)*, 1878–1879

black and brown chalk and pastel, worked with a brush, on gray laid paper
47.2 x 58.8 cm. (18 x 22½ in.)
signature stamp lower left
The Lord Rayne, London

Provenance
Atelier Degas, *Vente* 3:277; Cottevieille collection, Paris; A. D. Peters, London (sale, London, Sotheby's, 4 July 1962, no. 35); The Lord Rayne, London, 1962

Literature
Rewald 1944, 66; Barbara Stein Shapiro, "A Note on Two Degas Drawings," *Fenway Court* (Boston, The Isabella Stewart Gardner Museum, 1978), 14–23, fig. 8.

Exhibitions
St. Louis 1967, no. 99; Nottingham: *Degas*, Nottingham University, 1969, no. 17; Edinburgh 1979, no. 77; Tübingen/ Berlin 1984, no. 114.

22. *Study of a Nude Dancer (Etude de nue)*, 1878–1879

black chalk and charcoal on mauve-pink laid paper, slightly faded
48.1 x 30.6 cm. (19 x 12⅛ in.)
signature stamp lower left
Nasjonalgalleriet, Oslo
B.15574

Provenance
Atelier Degas, *Vente* 4:287a; Nasjonalgalleriet, Oslo, 1919

Literature
Rewald 1944, 58; Reff 1976a, 244.

Exhibitions
Edinburgh 1979, no. 74; Tübingen/Berlin 1984, no. 113.

23. *Three Studies of a Nude Dancer (Etudes de femmes nues)*, c. 1879

charcoal heightened with white chalk on gray wove paper
48 x 63 cm. (18½ x 24½ in.)
signature stamp lower right
Private collection, London

Provenance
Atelier Degas, *Vente* 3:386

Literature
L'Amour de l'Art 1931, 294, pl. 68; Rewald 1944, 58; Dunlop 1979, 178, pl. 169; The Arts Council of Great Britain, *The Sculptures of Degas* (London, 1982), 8.

Exhibitions
Edinburgh 1979, no. 73.

24. *Nude Study for the Little Fourteen-Year-Old Dancer (La petite danseuse de quatorze ans)*, c. 1881, posthumously cast in bronze

bronze cast of wax original
h. 37.5 cm. (14¾ in.)
signature stamp on base near dancer's right foot;

Cat. no. 26 (detail).

stamped in relief CIRE PERDUE A. A. HEBRARD and $\frac{56}{O}$
on base behind dancer's left foot
From the Collection of Mr. and Mrs. Paul Mellon, Upperville, Virginia

Provenance
Hector Brame, Paris; Mr. and Mrs. Paul Mellon, 1967

Literature
L'Amour de l'Art 1931, 294; Rewald 1944, 6–8, 57–61, no. 19; Browse 1949, 370, no. 95; Minervino 1970, no. S37; Millard 1976, pls. 23–24; Reff 1976a, 239–248; Dunlop 1979, 178.

25. *The Dance Lesson (La leçon de danse)*, c. 1879

oil on canvas
38 x 88 cm. (15 x 34¼ in.)
signed *Degas* lower right
From the Collection of Mr. and Mrs. Paul Mellon, Upperville, Virginia

Provenance
G. G. Keansward, Boston, through Mary Cassatt and Durand-Ruel, Paris; Reverend George S. Fiske, Boston; Mrs. Esther Fiske-Hammond, Santa Barbara

Literature
Lemoisne no. 625; Joris-Karl Huysmans, *L'Art Moderne* (Paris, 1883), 114; Meier-Graefe 1923, pl. 52; J. B. Manson, *The Life and Work of Edgar Degas* (London, 1927), 46; Camille Mauclair, *Degas* (New York, 1941), 13; Browse 1949, 378, pl. 120a; Minervino 1970, no. 786; Reff 1976b, 1:137 (Nb. 31:70).

Exhibitions
Paris: *5ᵉ Exposition de peinture . . .*(fifth impressionist exhibition), Durand-Ruel, 1880, see Reff 1976b, 1:137 (Nb. 31:70); Boston: St. Botolph Club, 1903; Boston: Museum of Fine Arts (extended loan from Fiske collection), 1930s; Paris 1937, no. 39; Washington 1966, no. 55.

26. *A Seated Dancer and a Head of a Girl (Tête de femme — Etude de danseuse)*, c. 1878

black chalk and pastel on pink laid paper, slightly faded, laid down
47.5 x 31.3 cm. (18⅛ x 11¾ in.)
signature stamp lower left
Private collection, on loan to the Museum Boymans-van Beuningen, Rotterdam

Provenance
Atelier Degas, *Vente* 3:209a

Literature
Rivière 1922–1923, 2:pl. 75.

27. *Standing Dancer (Danseuse)*, c. 1878

black and white chalk on gray laid paper
48.8 x 30.6 cm. (19¼ x 12¹/₁₆ in.)
signature stamp lower left;
inscribed upper right: *petits noeuds roses/aux épaules*
Staatliche Kunsthalle Karlsruhe, Federal Republic of Germany
1980—12

Provenance
Atelier Degas, *Vente* 2:349; Georges Viau, Paris (sale, Paris, 11 December 1942, no. 54); E. Jannink, Paris; Galerie Nathan, Zurich

Literature
"Staatliche Kunsthalle Karlsruhe, Erwerbungsbericht 1980," *Jahrbuch des Staatlichen Kunstsammlungen in Baden-Württemberg* 18 (1981), 142, pl. 15.

Cat. no. 31 (detail).

Exhibitions
London: *French Art 1200–1900*, Royal Academy, 1932, no.
829; Paris/Amsterdam: *Le dessin Français dans les collections Hollandaises*, Institut Néerlandais, Rijksmuseum
Prentenkabinet, 1964, no. 185.

28. *Seated Dancer (Danseuse assise)*, c. 1878

black chalk heightened with white on blue laid paper,
squared
48 x 29 cm. (18⅞ x 11½ in.)
signature stamp lower left
Private collection, New York

Provenance
Atelier Degas, *Vente* 3:358b; Hazlitt, Gooden, and Fox,
Ltd., London

Exhibitions
London: *Nineteenth-Century French Drawings*, Hazlitt,
Gooden, and Fox, Ltd., 1982, no. 56.

29. *Dancer Seen from Behind and Studies of Feet
(Danseuse vue de dos et trois études de pieds)*, c. 1878

black chalk and pastel on blue-gray laid paper
45.6 x 59.8 cm. (19 x 24 in.)
signature stamp lower left
National Gallery of Art, Washington, Gift of Myron Hofer
1945
B12,510

Provenance
Atelier Degas, *Vente* 2:190; Durand-Ruel, Paris; Myron
Hofer, Washington

Literature
Lemoisne no. 912; Browse 1949, 368, pl. 90.

30. *Dancers in the Rehearsal Room with a Double
Bass (Danseuses au foyer)*, c. 1885

oil on canvas
39 x 89.5 cm. (15⅛ x 35¼ in.)
signed *Degas* lower left
The Metropolitan Museum of Art, New York, Bequest
of Mrs. H. O. Havemeyer, 1929. The H. O. Havemeyer
Collection

Provenance
Alexander Reid, Glasgow, 1891; Arthur Kay, London, 1892;
E. F. Milliken, New York (sale, New York, American Art
Association, 14 February 1902, no. 11, as *Les coulisses*);
Durand-Ruel, New York, 1902; H. O. Havemeyer, New
York

Literature
Lemoisne no. 1905; Browse 1949, 377, pl. 118; Sterling
and Salinger 1967, 84–85 (with selected references, annotated, before 1967); Minervino 1970, no. 836; Moffett
1979, 12; Roberts 1982, 23.

Exhibitions
(See Sterling and Salinger 1967, for complete citation of
exhibitions.)
London: *A Small Collection of Pictures by Degas and Others*,
La Société des Beaux-Arts, Mr. Collie's Rooms, 1892, no.
20; London: Grafton Galleries, 1893, no. 301a (as *The
Rehearsal*); Pittsburgh: *First Annual Exhibition*, Carnegie
Art Galleries, 1896, no. 86 (as *Repetition of the Dance*); New
York: *The H.O. Havemeyer Collection*, Metropolitan Museum
of Art, 1930, no. 54; Richmond 1978, no. 12; Edinburgh
1979, no. 26.

31. *Ballet Rehearsal (La salle de danse)*, c. 1885

oil on canvas
38 x 90 cm. (14⅛ x 34½ in.)
signed *Degas* lower left
Yale University Art Gallery, New Haven, Gift of Duncan
Phillips, B.A. 1908
1952.43.1

Provenance
Durand-Ruel, Paris; Clarke collection, New York; Duncan
Phillips, Washington

Literature
Lemoisne no. 1107; Lafond 1918, 1: pl. 85 (as *Salle d'exercices
de danse*); Meier-Graefe 1923, pl. 52; *L'Amour de l'Art* 1931,
280, pl. 34; Browse 1949, 376, pl. 114; Minervino 1970,
no. 1059; Huyghe 1974, 95, fig. 84.

138

Exhibitions
New York 1949, no. 79; Los Angeles: *Degas*, Los Angeles County Museum of Art, 1950, no. 60; Baltimore 1962, no. 50; New York 1978, no. 46.

32. *The Dancing Lesson (La leçon de danse)*, c. 1880

oil on canvas
39.4 x 88.4 cm. (15½ x 34¹³/₁₆ in.)
signed *Degas* upper right
Sterling and Francine Clark Art Institute, Williamstown, Massachusetts
562

Provenance
M. J. Drake del Castillo; George Heontschel, Paris; Galerie Barbazanges, Paris; M. Knoedler and Co., Paris; Robert Sterling Clark, New York, 1924; Sterling and Francine Clark Art Institute, Williamstown, Massachusetts, 1955

Literature
Lemoisne no. 820; Browse 1949, 377, pl. 116; Minervino 1970, no. 819; Varnedoe 1980, 105–107.

Exhibitions
Exposition Universelle et Internationale de Gand, 1913, group II, no. 121 (as *La répétition de danse*); Williamstown: *Exhibit 5: French Paintings of the 19th Century*, Clark Art Institute, 1956, no. 101; Williamstown: *Exhibit 10: Edgar Degas*, Clark Art Institute, 1959, no. 3; Williamstown: *Degas*, Clark Art Institute, 1970, no. 7; Northampton 1979, no. 3.

33. *Dancer Adjusting Her Stocking (Danseuse assise)*, c. 1880

black chalk and pastel on cream-colored laid paper
23.8 x 32 cm. (9½ x 12⅝ in.)
signature stamp lower left
Frau Sabine Helms, Munich

Provenance
Atelier Degas, *Vente* 2:218b; Bucholz Gallery, New York; Mrs. Louis Ranschoff, Cincinnati

Literature
Browse 1949, 381, pl. 130.

34. *Dancer Adjusting Her Stocking (Danseuse rajustant son maillot)*, c. 1880

black chalk, squared for transfer with charcoal and touched with white chalk
24.2 x 31.3 cm. (9½ x 12⁵/₁₆ in.)
signed *Degas* lower right
The Syndics of the Fitzwilliam Museum, Cambridge, England
PD.23—1978

Provenance
Atelier Degas, *Vente* 3:109d; Arthur Tooth, London; Andrew Gow, Cambridge, England, 1939

Literature
Browse 1949, 382, pl. 130a.

Exhibitions
Cambridge 1978; London 1978, no. 26; Edinburgh 1979, no. 31; Tübingen/Berlin 1984, not in catalogue (shown in Berlin only).

35. *Before the Ballet (Le foyer de la danse)*, c. 1885

oil on canvas
40 x 89 cm. (15¾ x 35 in.)
signed *Degas* lower left
National Gallery of Art, Washington, Widener Collection
1942.9.19

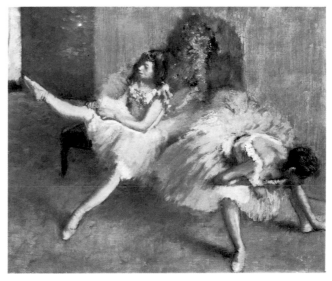

Cat. no. 35 (detail).

139

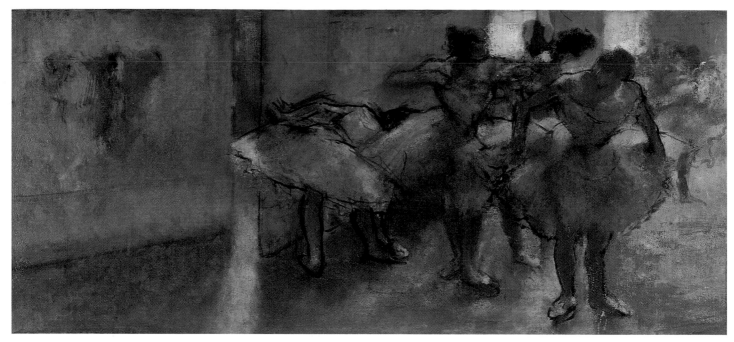

Cat. no. 41.

Provenance
Durand-Ruel, Paris; P.A.B. Widener, Philadelphia, 1913;
Joseph Widener, Philadelpha

Literature
Lemoisne no. 941; Lafond 1918, 1: facing 76; *L'Amour de
l'Art* 1931, 280, pl. 35; Jean Alazard, *Degas* (Lausanne,
1949), 21; Browse 1949, 377, pl. 116a; Bouret 1965, 113;
Minervino 1970, no. 842; Huyghe 1974, 95, fig. 85;
Varnedoe 1980, 105–107.

Exhibitions
London: *Pictures by Boudin, Cézanne, Degas . . .* , Grafton
Galleries, 1905, no. 51; San Jose: *Mary Cassatt and Edgar
Degas*, San Jose Museum of Art, 1981.

36. *Bust-Length Study of a Dancer* (*Femme accoudée,
vue à mi-corps*), c. 1880

black chalk and pastel on beige laid paper
20.5 x 22.8 cm. (8½ x 9 1/16 in.)
signature stamp lower left; inscribed upper center: *oreille
transparente;* inscribed upper right: *cheveux blonds/lumière
liséré or pâle/ombre verte*
Narodni Muzej, Belgrade
222

Provenance
Atelier Degas, *Vente* 3:88a; Ambroise Vollard, Paris; Erih
Šlomović, Belgrade; Narodni Muzej, Belgrade, 1949

Literature
Narodni Muzej 1950, no. 39; *Jugoslavija* (Belgrade, 1952),
38, no. 6; Rouart 1964, 14, no. 15.

Exhibitions
Zagreb 1940, no. 33.

37. *Study of a Dancer Leaning on Elbows* (*Femme
accoudée*), c. 1880

black and red chalk and pastel on beige laid paper
31.4 x 23.4 cm., sight (12⅝ x 9¼ in.)
inscribed upper right: *figure rose de/sueur//omoplate/gauche;*
inscribed center right: *les coudes sont croisés*
Narodni Muzej, Belgrade
216

Provenance
Ambroise Vollard, Paris; Erih Šlomović, Belgrade; Narodni
Muzej, Belgrade, 1949

140

Literature
Narodni Muzej 1950, no. 35; Rouart 1964, 10, no. 11.

Exhibitions
Zagreb 1940, no. 37.

38. *Two Dancers (Ballerinas) (Danseuses)*, c. 1880

charcoal and black chalk heightened with white chalk on
faded pink laid paper
44.4 x 57.1 cm. (17½ x 22½ in.)
signature stamp lower right
The High Museum of Art, Atlanta
1979.4

Provenance
Atelier Degas, *Vente* 3:223; Matthiesen Ltd., London;
Lilienfeld Galleries, New York; Mrs. Ralph J. Hines, New
York; Mrs. Harry E. T. Thayer and Robert S. Pirie, Cam-
bridge, Massachusetts

Literature
Browse 1949, 375, pl. 112a.

Exhibitions
New York: M. Knoedler and Co., 1963; Atlanta: *Draw-
ings from Georgia Collections: 19th and 20th Centuries*, The
High Museum of Art, 1981, no. 16.

39. *Dancer Adjusting Her Slipper (Danseuse attachant
son chausson)*, c. 1880–1885

pastel
42.6 x 34.3 cm. (16¾ x 13½ in.)
signed *Degas* lower left
Private collection, Paris

Provenance
H. O. Havemeyer, New York; Mr. and Mrs. J. Watson
Webb, New York; Private collection, New York; Art mar-
ket, New York and London

Literature
Lemoisne no. 913; Lafond 1918, 2:75; *Degas. Vingt dessins,
1861-1896* (Paris, 1898), pl. 16; *The H.O. Havemeyer Collec-
tion* (New York, 1930), 380; Browse 1949, 378, pl. 119.

Exhibitions
New York 1978, no. 42.

40. *Dancer Adjusting Her Shoe (Danseuse ajustant
son soulier)*, c. 1880

pastel on gray paper
48.2 x 61 cm. (19 x 24 in.)
The Dixon Gallery and Gardens, Memphis
1959.2

Provenance
Durand-Ruel, Paris; M. Knoedler and Co., New York;
Mr. and Mrs. Hugo Dixon, Memphis

Literature
Lemoisne no. 826; Michael Milkovich, *The Dixon Gallery
and Gardens: Paintings and Sculpture*, vol. 1 (Memphis, 1977),
30.

Exhibitions
New York 1960, no. 44; New York 1978, no. 33; Tübingen/
Berlin 1984, no. 164.

41. *The Rehearsal Room (Foyer de la danse; Dan-
seuses au foyer)*, c. 1889 and c. 1905

oil on canvas
41.5 x 92 cm. (16¼ x 36¼ in.)
signature stamp lower right
Foundation E. G. Bührle Collection, Zurich

Provenance
Atelier Degas, *Vente* 2:11; Durand-Ruel, Paris; Private
collection, Paris; Emil G. Bührle, Zurich, 1951

Literature
Lemoisne no. 996; Pierre Cabanne, *Les Danseuses de Degas*
(Lausanne, 1960), pl. 28; Minervino 1970, no. 852.

Exhibitions
Bern: *Degas*, Kunstmuseum, 1951–1952, no. 46; Amster-
dam: *Degas*, Stedelijk Museum, 1952, no. 41; Zurich:
Sammlung Emil G. Bührle, Kunsthaus, 1958, no. 162.

42. *Standing Dancer (Danseuse)*, c. 1900

charcoal on tracing paper mounted on wove paper
42 x 42.5 cm. (16½ x 16¾ in.)
signature stamp lower left
The Syndics of the Fitzwilliam Museum, Cambridge,
England
PD 34.1979

Provenance
Atelier Degas, *Vente* 3:220; Marlborough Gallery, London;
A. S. F. Gow, Cambridge, 1945

Exhibitions
Cambridge 1978; London 1978, no. 28.

43. *Dancers at the Bar (Exercises de danse)*, c. 1905

charcoal and pastel on tracing paper mounted on wove
paper
46.4 x 101.6 cm. (18¼ x 40 in.)
signature stamp lower left
The Toledo Museum of Art, Gift of Mrs. C. Lockhart
McKelvy
50.69

Provenance
Atelier Degas, *Vente* 1:226; Georges Viau, Paris (sale, Paris,
11 December 1942, no. 73); Ethel Hughes, Versailles;
Mrs. C. Lockhart McKelvy, Perrysburg, Ohio; The Toledo
Museum of Art, 1950

Literature
Lemoisne no. 997; Toledo Museum of Art, *European Paint-
ings* (Toledo, 1976), 52–53.

44. *Dancers (Danseuses)*, c. 1905

pastel over charcoal on tracing paper laid down on wove
paper mounted on canvas
45.6 x 93.7 cm., irregular (18 x 36⅞ in.)
signed *Degas* lower right in red pastel
Wallraf-Richartz Museum, Cologne
3122

Provenance
Ambroise Vollard, Paris; Art market, New York; Wallraf-
Richartz Museum, Cologne, 1961

Literature
Lemoisne no. 998 (dated c. 1889); Vollard 1914, pl. 76;
Wallraf-Richartz Museum, *Die Gemälde des 19. Jahrhunderts*
(Cologne, 1964), 36.

45. *Three Dancers (Trois danseuses)*, c. 1880

black chalk and pastel on tan wove paper
45 x 61 cm., sight (18½ x 24⅜ in.)
signed *Degas* upper right
From the Collection of Mr. and Mrs. Paul Mellon, Upper-
ville, Virginia

Provenance
H. O. Havemeyer, New York; Electra Havemeyer Webb,
New York; Mr. and Mrs. Dunbar W. Bostwick, New York,
1932

Literature
Lemoisne no. 531; Browse 1949, 375, pl. 113; Daniel Catton
Rich, *Edgar Hilaire Germain Degas* (New York, 1951), 15;
Minervino 1970, 744.

Exhibitions
New York: Grolier Club, 1922; Richmond 1978, no. 23.

46. *Dancer Adjusting Her Slipper (Danseuse ajustant
son chausson)*, 1880–1885

black chalk heightened with pastel on ivory-white laid
paper
31.8 x 24.0 cm. (12½ x 9⁷⁄₁₆ in.)
signed *Degas* lower right in coral-pink pastel
Musée Bonnat, Bayonne, Collection Personnaz, no. 5

Provenance
Antonin Personnaz, Paris; Musée Bonnat, Bayonne,
Personnaz Bequest, 1936

47. *Ballet Scene (Scène de ballet)*, c. 1900

pastel
76.8 x 111.2 cm. (30¼ x 43¾ in.)
signature stamp lower left
National Gallery of Art, Washington, Chester Dale
Collection
1963.10.16

Provenance
Atelier Degas, *Vente* 1:210; Jacques Seligmann (sale, New
York, Hotel Plaza, 27 January 1921, no. 210); Scott and
Fowles, New York (sale, American Art Association, 19
November 1926, no. 41); Chester Dale, New York, 1926

Literature
Lemoisne no. 1459; Maud Dale, *Before Manet to Modigliani*
(New York, 1929), pl. 28; Browse 1949, 409, pl. 232;
Pierre Cabanne, *Edgar Degas* (Paris, 1958), 124; National
Gallery of Art, *Eighteenth and Nineteenth Century Painting
and Sculpture of the French School in the Chester Dale Collec-
tion*, rev. ed. (Washington, 1965), 79; Werner 1969, 52–53,
no. 17; Minervino 1970, no. 1156.

Exhibitions
New York: *Degas and His Tradition*, Museum of French
Art, French Institute in the United States, 1931, no. 5.

48. *Three Dancers* (*Trois danseuses*), c. 1900

pastel
110 x 100 cm. (43¼ x 39⅜ in.)
signed *Degas* lower left
The Ordrupgaard Collection, Copenhagen

Provenance
Winkel and Magnussens collection, Copenhagen; Wilhelm
Hansen, Ordrupgaard

Literature
Lemoisne no. 1322; Vollard 1914, pl. 26; Hoppe 1922,
55; Browse 1949, 410, pl. 234; Bouret 1965, 253; Minervino
1970, no. 1123.

Exhibitions
Copenhagen: *Art Français*, 1920, no. 38.

49. *Four Dancers* (*En attendant l'entrée en scène*),
1895–1900

oil on canvas
150 x 180 cm. (59 x 71 in.)
signature stamp lower right
National Gallery of Art, Washington, Chester Dale
Collection
1963.10.122

Provenance
Atelier Degas, *Vente* 1:10; Trotti, Paris, 1918; Wilhelm
Hansen, Copenhagen; Galerie Barbazanges, Paris; Durand-
Ruel, Paris; Chester Dale, New York, 1931

Literature
Lemoisne no. 1267; Lafond 1918, 77; Browse 1949, 407,
pl. 224; National Gallery of Art, *Eighteenth and Nineteenth
Century Paintings and Sculpture of the French School in the
Chester Dale Collection*, rev. ed. (Washington, 1965), 78;
Bouret 1965, 256; Minervino 1970, no. 1114; Theodore
Reff, "Degas: A Master Among Artists," *The Metropolitan
Museum of Art Bulletin* (Spring 1977), unpaginated; Diane
Kelder, *The Great Book of French Impressionism* (New York,
1980), 284, 306.

Exhibitions
London: *The Impressionist School and Some Great French Painters
of the Nineteenth Century*, Lefevre Gallery, 1923; Vienna:
*Die führenden Meister der französischen Kunst in neunzehnten
Jahrhundert*, 1925; Amsterdam: *Cent ans de peinture française*,
Van Wisselingh, 1928.

Cat. no. 45 (detail).

50. *Half-Length Nude Girl* (*Torse de femme* [*étude
de nue*]), c. 1895

charcoal heightened with white on tracing paper
53.9 x 38.8 cm. (21 x 15¼ in.)
signature stamp lower right
The Syndics of the Fitzwilliam Museum, Cambridge,
England
PD.35—1978

Provenance
Atelier Degas, *Vente* 3:247; Redfern Gallery, London, 1949;
Andrew Gow, Cambridge, England

Exhibitions
Cambridge 1978; London 1978, no. 50.

51. *Dancers* (*Danseuses*), c. 1898

pastel
60 x 63 cm. (23⅝ x 24¾ in.)
signed *Degas* lower right
M. Charles Durand-Ruel, Paris

Provenance
Durand-Ruel, Paris

143

Cat. no. 51 (detail).

Literature
Lemoisne no. 1352; Gustave Coquiot, *Degas* (Paris, 1924), no. 176; Browse 1949, 412, pl. 240; Minervino 1970, no. 1133; Belinda Thomson, *The Post-Impressionists* (London, 1983), 79.

Exhibitions
New York: *Degas*, Durand-Ruel Gallery, 1937, no. 11; Paris: *Degas*, Galerie Durand-Ruel, 1960, no. 60; Hamburg: *Französische Impressionisten, Hommage à Durand-Ruel*, Kunstverein Hamburg, 1970-1971, no. 14; Paris: *Hommage à Paul Durand-Ruel, Centenaire de l'Impressionnisme 1874-1974*, Galerie Durand-Ruel, 1974, no. 18.

52. *Dancers* (*Groupe de danseuses*), c. 1895–1900

pastel on tracing paper mounted on wove paper
58.8 x 46.3 cm. (23⅛ x 18¼ in.)
signature stamp lower left
The Art Museum, Princeton University, Bequest of Henry K. Dick
54-13

Provenance
Atelier Degas, *Vente* 1:275; Maurice Exteens, Paris; Pellet collection, Paris; Henry K. Dick; The Art Museum, Princeton University, 1954

Literature
Lemoisne no. 1312; Werner 1969, 40, pl. 11.

Exhibitions
New York 1949, no. 90; Princeton: *19th and 20th Century French Drawings from The Art Museum, Princeton University*, 1972, 62–63, no. 33; Northampton 1979, no. 20.

53. *A Dancer Adjusting Her Shoulder Strap* (*Danseuse rajustant ses épaulettes*), c. 1895–1900

pastel over charcoal on ivory wove paper
43 x 34.2 cm. (17 x 13½ in.)
signed *Degas* lower left
Private collection, New York

Provenance
Durand-Ruel, Paris; Martin A. Ryerson, Chicago; The Art Institute of Chicago, 1937–1948; Hatfield Galleries

Literature
Lemoisne no. 1273; Camille Mauclair, *Degas* (Paris, 1937), 135; Browse 1949, 411, pl. 237.

Exhibitions
New York 1978, no. 52.

54. *Dancer* (*Danseuse*), c. 1895

pastel over charcoal on tracing paper laid down on cardboard
47.5 x 37 cm. (18¾ x 14½ in.)
signed *Degas* upper right in black chalk
Kunsthalle Bremen, Federal Republic of Germany
04/1

Provenance
A. W. von Heymel, Bremen; Kunsthalle Bremen, 1904

Literature
Handbuch der Kunsthalle Bremen (Bremen, 1959), 76.

Exhibitions
Paris: *Impressionnistes et Romantiques Français dans les Musées Allemands*, Musée de l'Orangerie, 1951–1952, no. 28; Bremen: *Handzeichnungen französischer Meister des 19. Jahrhunderts: von Delacroix bis Maillol*, Kunsthalle Bremen, 1969, no. 60; Tübingen/Berlin 1984, no. 208.

55. *Dancer (Danseuse)*, c. 1895–1900

pastel over charcoal on ivory laid paper, pieced at top
38.4 x 26.2 cm., sight ($15\frac{1}{8}$ x $10\frac{5}{16}$ in.)
signed *Degas* lower left
Bernice Richard, New York

Provenance
Paul Petrides, Paris; M. Knoedler and Co., New York;
George Richard, New York, 1949

Literature
Lemoisne no. 1; Minervino 1970, no. 1088.

Exhibitions
New York 1978, no. 51.

56. *Group of Four Dancers (Groupe de danseuses vues en buste)*, c. 1895–1900

charcoal on tracing paper mounted on cardboard
72.6 x 51 cm. (33 x 42 in.)
signature stamp lower left
The Allen Memorial Art Museum, Oberlin College,
Oberlin, Ohio, Friends of Art Fund
40.46

Provenance
Atelier Degas, *Vente* 3:221; Réné de Gas, Paris; Marie
Harriman Gallery, New York; The Allen Memorial Art
Museum, Oberlin College, Oberlin, Ohio, 1940

Literature
Wolfgang Stechow, *Catalogue of Drawings and Watercolors
in the Allen Memorial Art Museum, Oberlin College* (Oberlin,
Ohio, 1976), 16, no. 79.

Exhibitions
New York: *Modern Drawings*, Museum of Modern Art,
1944, no. 90; New York: M. Knoedler and Co., 1954, no.
64; Ann Arbor: *Drawings and Watercolors from the Oberlin
Collection*, University of Michigan Museum, 1956; Los
Angeles: *Degas*, Los Angeles County Museum of Art, 1958,
no. 69; Milwaukee: *Men at Work—Daumier to Shahn*, Mil-
waukee Art Center, 1960, no. 11; St. Louis 1967, 148;
Bloomington: *Nineteenth-Century French Drawings*, Indiana
University Art Museum, 1968, no. 39.

57. *Dancers, Nude Study (Danseuses)*, c. 1895–1900

charcoal and pastel on tracing paper mounted on cream-
colored wove paper
78 x 58 cm. ($30\frac{3}{4}$ x $22\frac{7}{8}$ in.)
signed *Degas* lower right
Private collection

Provenance
Ambroise Vollard, Paris; Mr. and Mrs. Paul Obst, Paris;
Marianne Feilchenfeldt, Zurich

Literature
Lemoisne no. 1355; Vollard 1914, pl. 91.

Exhibitions
Cambridge: *Modern Paintings, Drawing and Sculpture Col-
lected by Louise and Joseph Pulitzer, Jr.*, Fogg Art Museum,
1971, no. 164 (catalogue by Charles Scott Chetham et
al.).

58. *Group of Dancers (Quatre danseuses)*, c. 1895–1900

charcoal and pastel on tracing paper mounted on ivory
wove paper
80.6 x 55.6 cm. (32 x 22 in.)
signature stamp lower left
On loan from the Evergreen House Foundation, Baltimore

Provenance
Atelier Degas, *Vente* 1:335; Walter Berry collection, Paris;
Mr. and Mrs. John W. Garrett, Baltimore, gift of Walter
Berry, 1928

Literature
Lemoisne no. 1357.

Exhibitions
Baltimore: *From Ingres to Gauguin*, Baltimore Museum of
Art, 1951, no. 109; Baltimore 1962, no. 65; St. Louis
1967, no. 149.

Cat. no. 55 (detail).

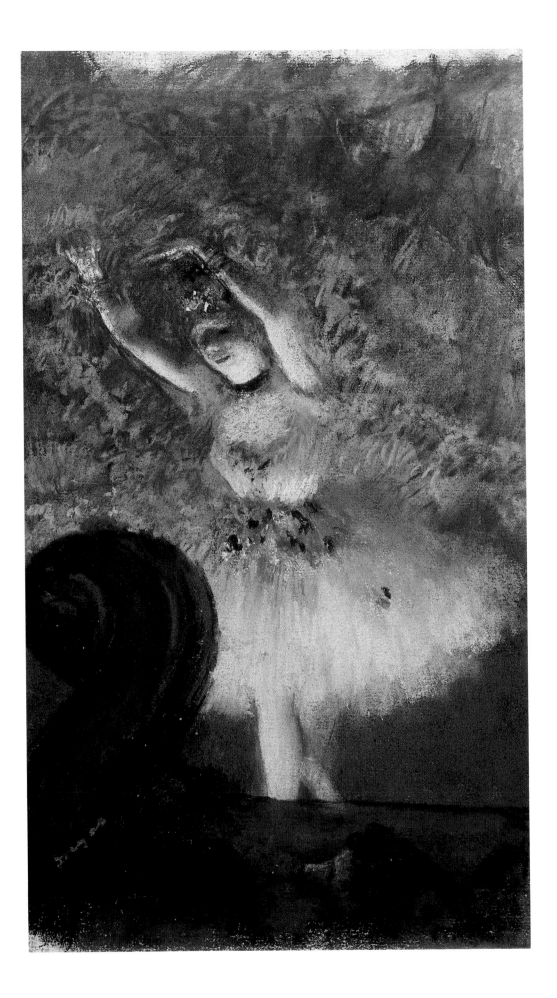

Bibliography

Adhémar 1958 — Adhémar, Hélène. *Musée du Louvre, catalogue des peintures, pastels, sculptures, impressionnistes.* Paris, 1958.

Adolphus 1895 — Adolphus, F. *Some Memories of Paris.* Edinburgh and London, 1895.

Baltimore 1962 — *Manet, Degas, Berthe Morisot, and Mary Cassatt.* Exh. cat. Baltimore Museum of Art. Baltimore, 1962.

Boggs 1962 — Boggs, Jean Sutherland. *Portraits by Degas.* Berkeley and Los Angeles, 1962.

Boggs 1967 — Boggs, Jean Sutherland. *Drawings by Degas.* Exh. cat. City Art Museum; Philadelphia Museum of Art; Minneapolis Institute of Arts. St. Louis/Philadelphia/Minneapolis, 1967.

Boime 1971 — Boime, Albert. *The Academy and French Painting in the Nineteenth Century.* London, 1971.

Bouret 1965 — Bouret, Jean. *Degas.* Paris, 1965.

Browse 1949 — Browse, Lillian. *Degas Dancers.* London, 1949.

Cabanne 1957 — Cabanne, Pierre. *Degas.* New York, 1957.

Cambridge 1968 — Janis, Eugenia Parry. *Degas Monotypes.* Exh. cat. Fogg Art Museum. Cambridge, Mass., 1968.

Cambridge 1978 — *The Andrew Gow Bequest.* The Fitzwilliam Museum. Cambridge, 1978.

Chicago 1984 — Brettell, Richard R., and Suzanne Folds McCullagh. *Degas in the Art Institute of Chicago.* Exh. cat. The Art Institute of Chicago. Chicago and New York, 1984.

Cleveland 1947 — *Works by Degas.* Exh. cat. Cleveland Museum of Art. Cleveland, 1947.

Dunlop 1979 — Dunlop, Ian. *Degas.* New York, 1979.

Duranty 1876 — Duranty, Edmond. *La nouvelle peinture.* Paris, 1876.

Edinburgh 1979 — Pickvance, Ronald. *Degas 1879.* Exh. cat. National Gallery of Scotland. Edinburgh, 1979.

Right: cat. no. 3. *Ballet Dancer (Danseuse)*,
c. 1878, pastel over monotype.
Private collection, New York.

147

Fletcher 1984 Fletcher, Shelley. "Two Monotype Pastels by Degas at the National Gallery of Art." *Print Quarterly* 1, no. 1 (March 1984), 53–55.

Guérin 1945 Guérin, Marcel, ed. *Lettres de Degas.* 2nd rev. ed. Paris, 1945.

Guest 1974 Guest, Ivor. *The Ballet of the Second Empire.* rev. ed. Middletown, Conn., 1974.

Halévy 1883 Halévy, Ludovic. *La Famille Cardinal.* Paris, 1883.

Hoppe 1922 Hoppe, Ragnar. *Degas och hans arbeten i Nordisk ägo.* Stockholm, 1922.

Huyghe 1974 Huyghe, Réné. *La rélève du réel (Impressionnisme, Symbolisme).* Paris, 1974.

Huysmans 1908 Huysmans, Joris-Karl. *L'Art moderne.* rev. ed. Paris, 1908.

Janis 1968 Janis, Eugenia Parry. *Degas Monotypes.* Exh. cat. Fogg Art Museum. Cambridge, Mass., 1968.

Joachim and Olsen 1979 Joachim, Harold, and Sandra Haller Olsen. *French Drawings and Sketchbooks of the Nineteenth Century, The Art Institute of Chicago.* Chicago, 1979.

Lafond 1918 Lafond, Paul. *Degas.* Paris, 1918.

L'Amour de l'Art 1931 "Degas." *L'Amour de l'Art* 12 (July 1931).

Lemoisne Lemoisne, P.-A. *Degas et son oeuvre.* 4 vols. Paris, 1946–1949.

London 1978 *Selected Works from the Andrew Gow Bequest.* Exh. cat. Hazlitt, Gooden, and Fox, Ltd. London, 1978.

Mantz 1881 Mantz, Paul. "Exposition des oeuvres des artistes indépendants." *Le Temps* (23 April 1881).

Mayne 1966 Mayne, Jonathan. "Degas's Ballet Scene from *Robert le Diable.*" *Victoria and Albert Museum Bulletin* 2, no. 4 (October 1966), 148–156.

Meier-Graefe 1923 Meier-Graefe, Julius. *Degas.* New York, 1923.

Millard 1976 Millard, Charles. *The Sculptures of Edgar Degas.* Princeton, 1976.

Minervino 1970 Minervino, Fiorella. *L'Opera Completa di Degas.* Milan, 1970. Introduction by Franco Russoli.

Moffett 1979 Moffett, Charles. *Degas: Paintings in the Metropolitan Museum of Art.* New York, 1979.

Muehlig 1979 Muehlig, Linda. *Degas and the Dance.* Exh. cat. Smith College Museum of Art. Northampton, 1979.

Narodni Muzej 1950 Narodni Muzej. *Novija francuska umetnost iz zbirke Umetničkog muzeja.* Belgrade, 1950.

New York 1949 *Loan Exhibition of Degas.* Exh. cat. Wildenstein and Co. New York, 1949.

New York 1960 *Degas.* Exh. cat. Wildenstein and Co. New York, 1960.

New York 1978 *Degas.* Exh. cat. Acquavella Galleries, Inc. New York, 1978.

Northampton 1979 Muehlig, Linda. *Degas and the Dance.* Exh. cat. Smith College Museum of of Art. Northampton, 1979.

Paris 1924 *Degas.* Exh. cat. Galerie Georges Petit. Paris, 1924.

Paris 1931 *Degas. Portraitiste, Sculpteur.* Exh. cat. Musée de l'Orangerie. Paris, 1931.

Paris 1937 *Degas.* Exh. cat. Orangerie des Tuileries. Paris, 1937.

Paris 1969 *Degas, Oeuvres du Musée du Louvre. Peintures, Pastels, Dessins, Sculptures.* Exh. cat. Orangerie des Tuileries. Paris, 1969.

Philadelphia 1936 *Degas 1834–1917.* Exh. cat. The Pennsylvania Museum of Art. Philadelphia, 1936.

Pickvance 1963 Pickvance, Ronald. "Degas's Dancers: 1872–76." *Burlington Magazine* 105 (June 1963), 256–266.

Pickvance 1979 Pickvance, Ronald. *Degas 1879.* Exh. cat. National Gallery of Scotland. Edinburgh, 1979.

Reff 1976a Reff, Theodore. *Degas: The Artist's Mind.* New York, 1976.

Reff 1976b Reff, Theodore. *The Notebooks of Edgar Degas.* 2 vols. Oxford, 1976.

Reff 1982–1983 Reff, Theodore. *Manet and Modern Paris.* Exh. cat. National Gallery of Art. Washington, 1982–1983.

Rewald 1944 Rewald, John. *Degas, Works in Sculpture, A Complete Catalogue.* New York, 1944.

Rewald 1973 Rewald, John. *The History of Impressionism.* rev. ed. New York, 1973.

Richmond 1978 *Degas.* Virginia Museum of Fine Arts. Richmond, 1978.

Rivière 1922–1923 Rivière, Henri. *Les dessins de Degas reproduits en facsimile.* Paris, 1922–1923.

Roberts 1982 Roberts, Keith. *Degas.* rev. ed. London, 1982.

Rosenberg 1959 Rosenberg, Jakob. *Great Draftsmen from Pisanello to Picasso.* Cambridge, Mass., 1959.

Rouart 1964 Rouart, Denis. *The Unknown Degas and Renoir in the National Museum of Belgrade.* New York, 1964.

San Francisco 1961 *French Paintings of the Nineteenth Century from the Collection of Mrs. Mellon Bruce.* Exh. cat. California Palace of the Legion of Honor. San Francisco, 1961.

St. Louis 1967 Boggs, Jean Sutherland. *Drawings by Degas.* Exh. cat. City Art Museum; Philadelphia Museum of Art; Minneapolis Institute of Arts. St. Louis/Philadelphia/Minneapolis, 1967.

Sterling and Salinger 1967 Sterling, Charles, and Margaretta M. Salinger. *French Paintings: A Catalogue of the Collection of the Metropolitan Museum of Art.* New York, 1967.

Tübingen/Berlin 1984 Adriani, Götz. *Degas: Pastelle, Ölskizzen, Zeichnungen.* Exh. cat. Kunsthalle Tübingen; Nationalgalerie. Tübingen/Berlin, 1984.

Varnedoe 1980 Varnedoe, Kirk. "The Ideology of Time: Degas and Photography." *Art in America* (Summer 1980), 96–110.

Vente *Vente Atelier Degas. Catalogue des Tableaux, Pastels et Dessins par Edgar Degas et Provenant de son Atelier.* Galerie Georges Petit. Paris, 6–8 May 1918 (vente 1); 11–13 December 1918 (vente 2); 7–9 April 1919 (vente 3); 2–4 July 1919 (vente 4).

Viel' Abonné 1887 Un Viel' Abonné. *Ces demoiselles de l'Opéra.* Paris, 1887.

Vollard 1914 Vollard, Ambroise, ed. *98 reproductions signées Degas.* Paris, 1914.

Walker 1975 Walker, John. *The National Gallery of Art.* New York, 1975.

Washington 1966 *French Paintings from the Collection of Mr. and Mrs. Paul Mellon and Mrs. Mellon Bruce.* Exh. cat. National Gallery of Art, Washington, 1966.

Washington 1978 *Small French Paintings from the Bequest of Ailsa Mellon Bruce.* Exh. cat. National Gallery of Art. Washington, 1978.

Washington 1982–1983 Reff, Theodore. *Manet and Modern Paris.* Exh. cat. National Gallery of Art. Washington, 1982–1983.

Werner 1969 Werner, Alfred. *Degas Pastels.* New York, 1969.

Zagreb 1940 *Francuska umetnost iz kolekcije Eriha Šlomovića.* Exh. cat. Zagreb, 1940.

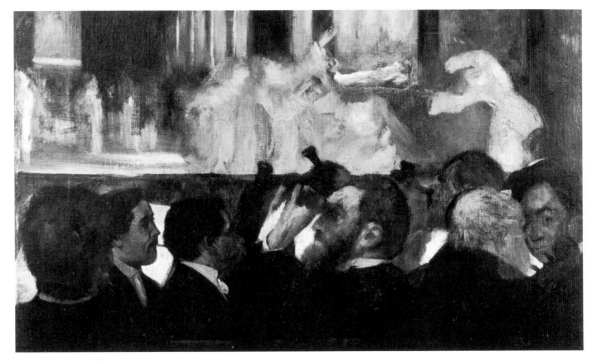

Cat. no. 2 (detail).

150

PHOTOGRAPHY CREDITS

Most of the photographs reproduced in this book were provided by the owners of the works and are used with their permission. We are most grateful for their cooperation. In addition, the following photographic credits are noted: